SCIENCE ON ICE

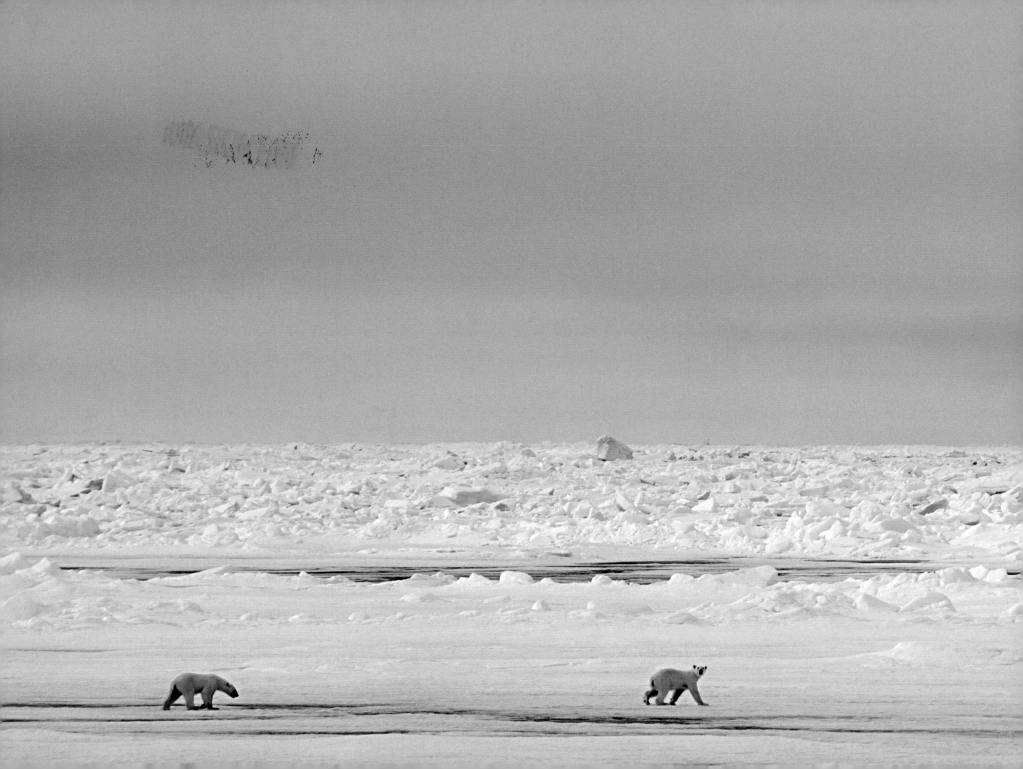

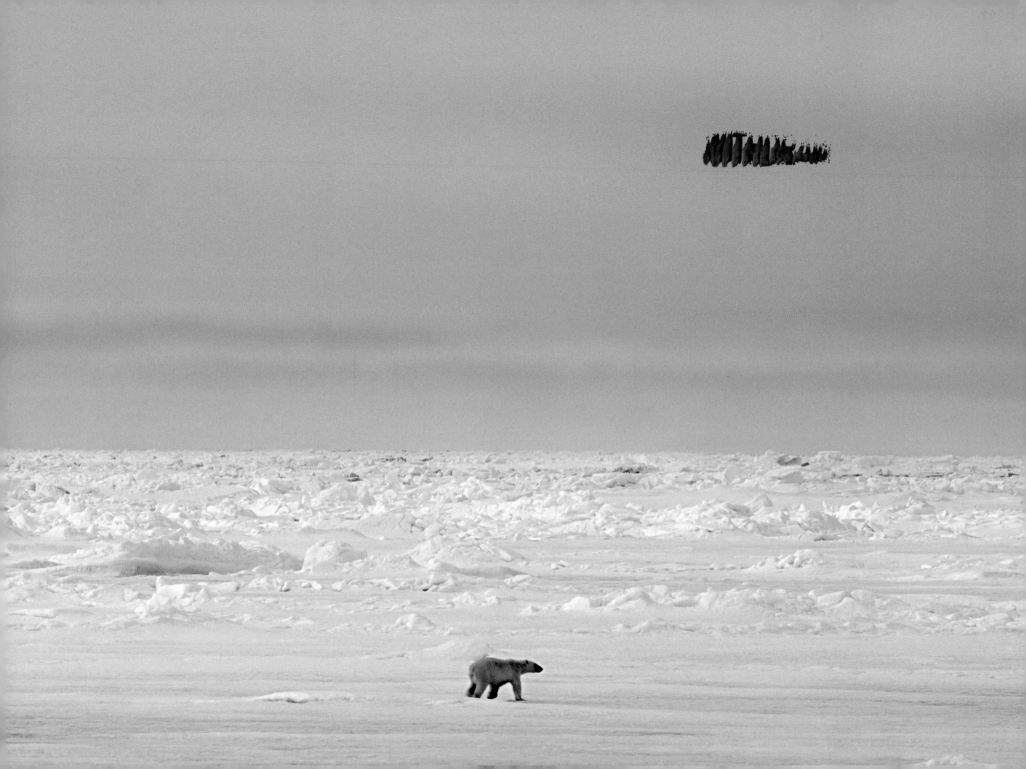

CHRIS LINDER

with Helen Fields, Lonny Lippsett, Amy Nevala, and Hugh Powell

THE UNIVERSITY OF CHICAGO PRESS • CHICAGO AND LONDON

SCIENCE ON ICE

Four Polar Expeditions

Chris Linder is a research associate in the Woods Hole Oceanographic Institution's Physical Oceanography Department and a professional freelance photographer.

The University of Chicago Press, Chicago 60637 | The University of Chicago Press, Ltd., London | © 2011 by The University of Chicago
All rights reserved. Published 2011 | Printed in the United States of America
20 19 18 17 16 15 14 13 12 11 1 2 3 4 5
ISBN-13: 978-0-226-48247-7 (cloth) | ISBN-10: 0-226-48247-2 (cloth)

Illustration credits: all photographs by Chris Linder, WHOI, unless otherwise noted. Pages 19, 22, 34, 51, 243: Chris Linder Photography.
Pages 181, 182–83: AGAVE science team, WHOI. Page 249 (Linder photo): Mike Carlowicz, WHOI. Page 250 (Lippsett photo): Zoe Lippsett. Page 250 (Nevala photo): David Nevala.
Maps by Jack Cook and XNR Productions.

Library of Congress Cataloging-in-Publication Data
Linder, Chris.
 Science on ice : four polar expeditions / Chris Linder with Helen Fields, Lonny Lippsett, Amy Nevala, and Hugh Powell.
 p. cm.
 Includes bibliographical references.
 ISBN-13: 978-0-226-48247-7 (cloth : alkaline paper)
 ISBN-10: 0-226-48247-2 (cloth : alkaline paper) 1. Polar regions—Description and travel. 2. Adélie penguin. 3. Glaciers—Greenland. 4. Spring—Bering Sea. 5. Ocean bottom ecology—Arctic Ocean. I. Fields, Helen. II. Lippsett, Lonny. III. Nevala, Amy. IV. Powell, Hugh D. W. V. Title.
 G590 .L553 2011
 910.911—dc22 20110 10291

♾ This paper meets the requirements of ANSI/NISO Z39.48-1992 (Permanence of Paper).

To Eva, who was born a week before the start of the fourth International Polar Year.
Never stop asking questions.

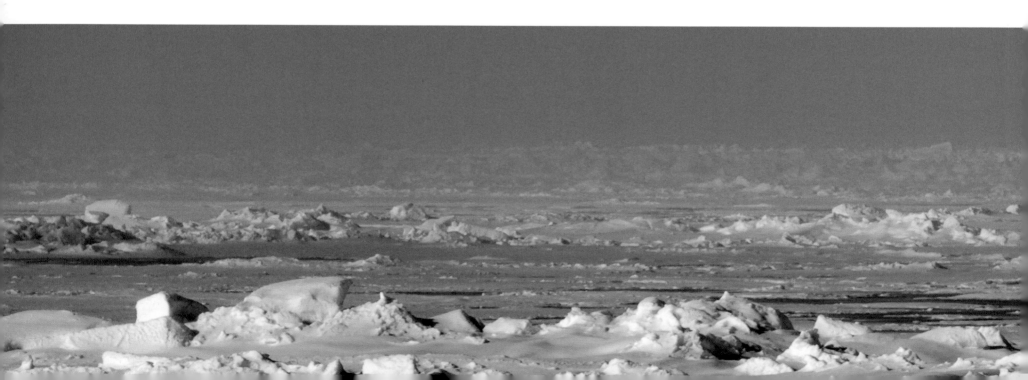

CONTENTS

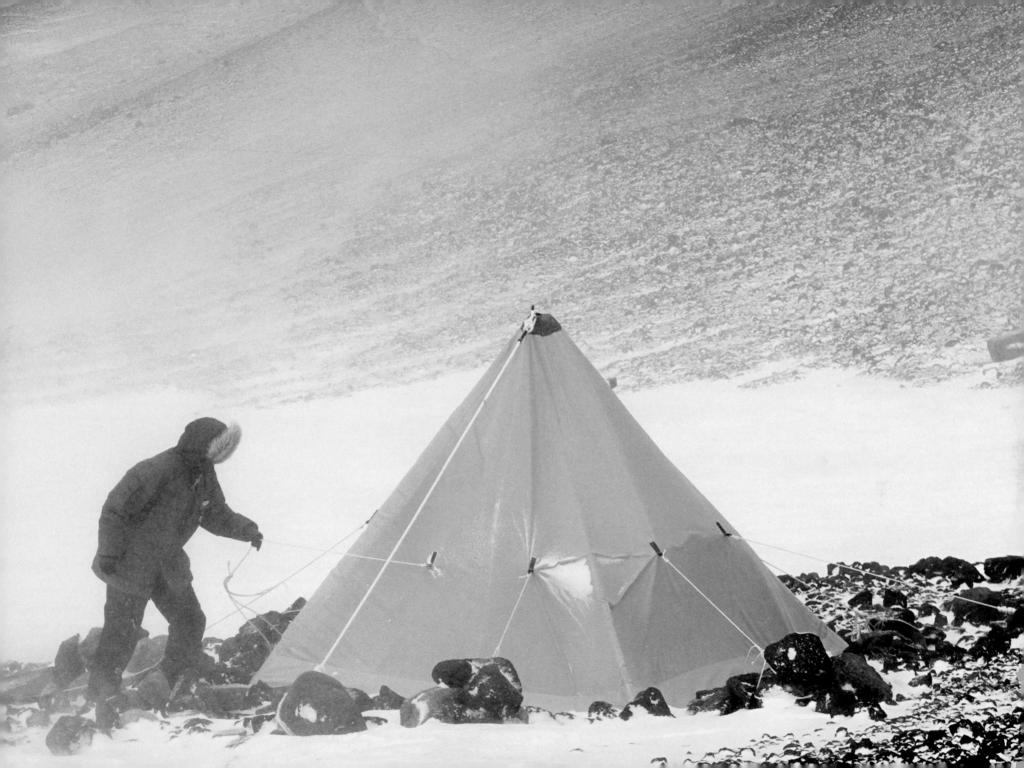

INTRODUCTION

Chris Linder

SCIENCE BEGINNINGS

When I started working as a researcher at the Woods Hole Oceanographic Institution (WHOI), I had no idea that within a few years I would be photographing, rather than conducting, scientific research. In the summer of 2001, I embarked on my first oceanography cruise for WHOI, spending a month aboard the 177-foot-long research vessel *Oceanus* to study the turbulent waters east of Greenland. My job was to stand a science watch, which entailed wrangling unwieldy instruments over the side of the ship and ensuring that all of the equipment recorded data properly.

When I wasn't on watch, I burned through rolls of film documenting both the sights outside and inside our research ship. It turns out that what caught the chief scientist's eye weren't the photographs of pilot whales and icebergs, but rather the images of people working aboard the ship. As a member of the science team, I was able to capture candid moments of the crew working on deck, analyzing water samples, driving the ship, or playing cards. At the time, I didn't fully appreciate the value of these images. When something caught my eye, like the light silhouetting a deckhand or the intensity on the captain's face as he piloted the ship, I pressed the shutter release. The photographs were used in press releases, calendars, and magazine articles. I was opening up a previously hidden world: what life was like at sea on a research vessel.

The following year, the same scientist enlisted me to document his three-year project studying the currents and water masses along the northern and western coasts of Alaska. In addition to taking photographs, I wrote daily online essays describing the experience and answered questions from inquisitive schoolchildren who eagerly followed our website. I had discovered the power of photography as an educational tool and carved a new niche for myself—that of field photographer and education specialist. The experience also kindled my love affair with the polar regions.

LURE OF THE ICE

I will never forget the first time I saw sea ice. I was standing on the deck of the *Polar Star*, a four-hundred-foot-long U.S. Coast Guard icebreaking ship, watching the sea slide past. The goal of our science team, led by Bob Pickart of WHOI, was to understand the fate of Pacific water that enters the Arctic Ocean. As we steamed to our first water sampling location north of the Bering Strait, the water reflected the broken clouds overhead, making the sea gleam like a sheet

SNOW-COVERED SEA ICE STRETCHES TO THE HORIZON IN THE
Bering Sea in springtime.

3

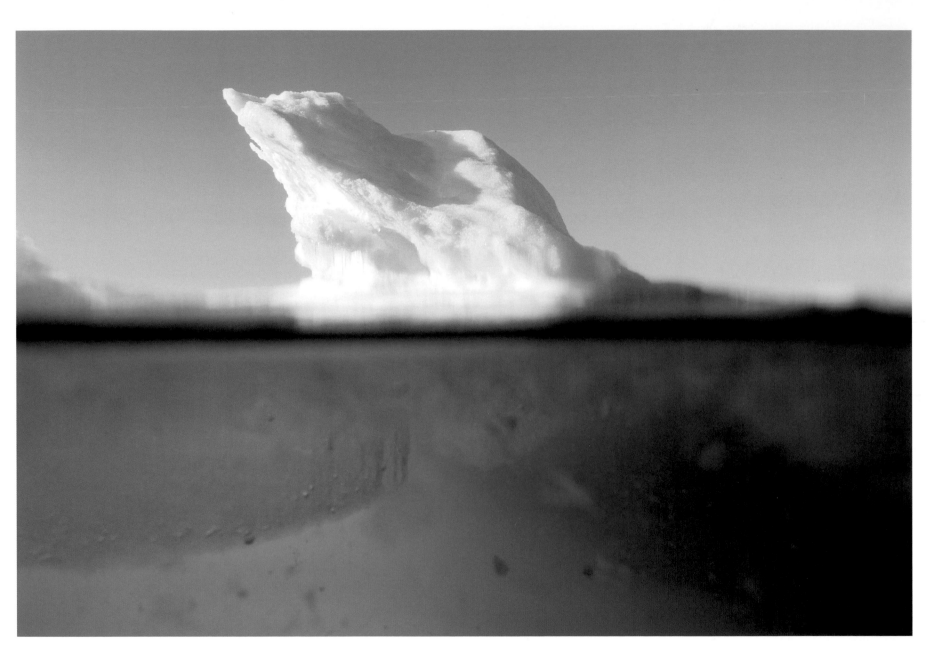

BROKEN-UP SLABS OF SEA ice known as brash ice collide and grind together.

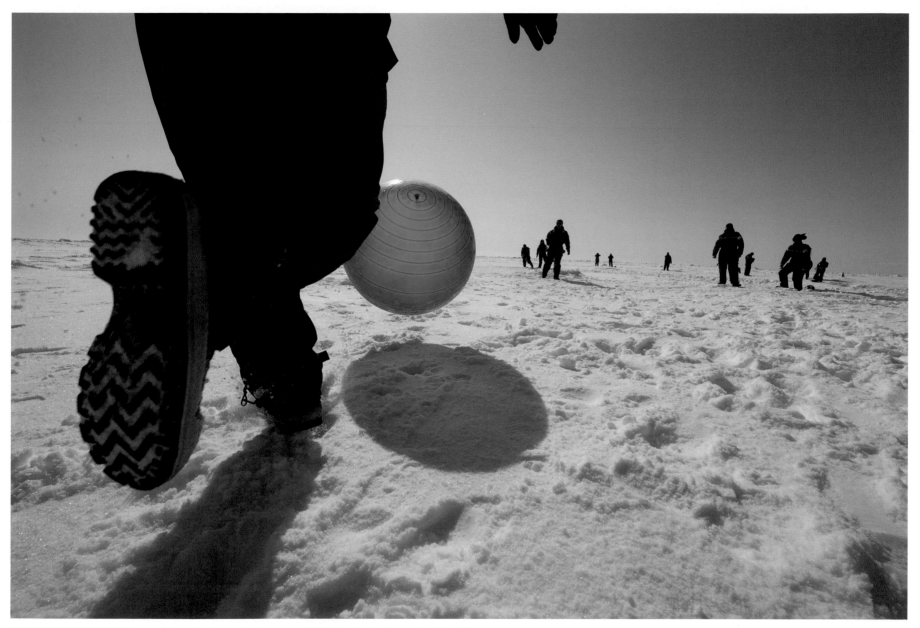

THE SCIENCE PARTY AND crew of the icebreaker *Healy* enjoy a game of kickball on the ice during a day of "ice liberty."

of steel. Only the foamy white tail of our wake broke the mirrorlike surface. The gray clouds on the horizon ahead were tinged white on their undersides—an optical effect that meant ice was near.

As I stood on the bow, marveling at the vastness of this still ocean, kitchen-table-sized chunks of ice began to drift by. Some had been eroded by waves from below and resembled giant mushrooms, while others were curved like puzzle pieces. The color of the ice chunks ranged from sediment- and algae-stained reddish brown to aquamarine to snowy white. On the surface of the larger floes, melted snow and ice collected into electric blue pools. When the floes passed close to the ship, I could see sharp keels disappearing into the clear, dark water. Having previously sailed only on research vessels in the temperate seas, the sight of ice bobbing in the water made me feel like I had traveled to another planet.

The stillness was broken as our ship made contact with the floes. The ice thundered off the ship's hull. As we broke larger floes, their jagged edges screeched along the side of the ship. The broken chunks rolled and bobbed in our wake, sending up waterfalls of spray and the occasional fish. Open water was gradually replaced by more and more ice, until an eerie white icescape stretched from horizon to horizon. I remember taking photo after photo until my fingers were numb from the cold, but I couldn't help smiling at the beauty and mystery of this unique place. As days became weeks, I never lost my fascination for ice. I would often walk the decks well after midnight, when the sun would brush the horizon and tint the floes pink and magenta.

But ice was only a small part of the experience. New stories and images were abundant on the ship. When we stopped at a science station, high-tech instruments would plunge into the freezing water and researchers would crowd around their computers, expectantly watching the data come in. I alternated my science reporting with stories about the 150 Coast Guard crew members that kept the *Polar Star* underway and our bellies full. I spent hours on the bridge, in the engine room, even in the galley, where the ship's cooks fed the entire crew four times a day. By the end of the cruise, I felt like I had explored every square inch of the icebreaker, yet all I could think of was returning the next year to continue the story.

HOW THIS BOOK CAME ABOUT: THE LIVE FROM THE POLES PROJECT

Four summers working on icebreaking ships as a photojournalist taught me how hungry the public was for science stories. Sobering climate change impacts—receding Arctic sea ice, retreating glaciers, thawing permafrost—focused media and public attention on the polar regions. In the October 2008 issue of *Scientific American*, John Holdren, a Harvard physicist and President Obama's White House science advisor, wrote that "the ongoing disruption of the earth's climate by man-made greenhouse gases is already well beyond dangerous and is careening toward completely unmanageable." Scientists are at the front lines of this climate change battlefield, measuring the changes already well underway and struggling to assess how the effects will be felt around the world. But polar fieldwork is logistically intensive, requiring ski-equipped planes, helicopters, and icebreaking ships. In 2007, the International Council for Science (ICSU) and the World Meteorological Organization (WMO) organized the fourth International Polar Year (IPY), a historic two-year period of cooperative polar exploration and research. The largest group of polar scientists ever assembled would study over two hundred physical, biological, and social research topics from pole to pole. Never would there be a better time to educate the public about polar science.

The National Science Foundation (NSF), recognizing that the IPY would be an ideal opportunity to educate the public, created a special funding oppor-

COAST GUARD CREW MEMBERS work under red lights at night on the bridge of the icebreaker *Healy*.

MARK BEHN IS NOT your typical scientist.

tunity for educators to communicate IPY science. I teamed up with WHOI's director of communications to answer NSF's solicitation. We enlisted a talented group of writers, graphic designers, and video editors from WHOI; eight natural history and science museums across the United States; and prominent media partners, including *Scholastic Magazine* and National Public Radio's *Science Friday*. Our idea was to embed a media team (myself as photographer plus a science writer) in four polar expeditions to create daily photo essays about the science as it happened. Through satellite technology, we posted these updates to the Polar Discovery website (polardiscovery.whoi.edu) from the field (on the Greenland Ice Sheet, near a penguin colony in Antarctica, or on an icebreaker in the Arctic Ocean). Our stories focused not only on scientific results but also on the day-to-day challenges of working, surviving, and thriving in the coldest places on the planet. We also answered online questions from readers and hosted a series of live question-and-answer sessions via satellite phone with museum audiences across the United States. We called the project *Live from the Poles*. This book is the culmination of that project—a selection of photographs and stories from two years of documenting science in the polar regions.

SCIENCE ON ICE

This book will give you a glimpse into a world that very few people will ever experience—the inner workings of four major research expeditions to the Arctic and Antarctic. "Behind the scenes" moments—overcoming logistical hurdles, deploying instruments, and simply surviving in the polar regions—are all important stories that are seldom covered by traditional media. With this book, I hope not only to communicate these science stories but also to convey the excitement of science as a career and the beauty and fragility of the polar environment.

I believe that scientists suffer from a branding problem. What do you think of when you hear the word "scientist"? When I was growing up, I envisioned white-bearded men scribbling obtuse formulas on blackboards or huddling over bubbling test tubes—but that's not what I saw on the expeditions I photographed. The men and women at WHOI and other earth science research institutions braved punishing weather conditions to collect their data. I photographed oceanographers working in the Gulf Stream off Cape Hatteras in winter, when thirty-foot waves threw our ship around like a child's toy. I trudged alongside glaciologists as they explored miles of rugged terrain on the Greenland Ice Sheet. The scientists I know are as tough as the ships they sail on. By photographing scientists working in the field, I hope to create a new stereotype, or at least challenge the one I once knew. By extension, I hope that readers, particularly students, will develop a stronger interest in science as a career.

My final goal is to document the polar environment, which, while widely perceived as harsh and unforgiving, can be equal parts delicate and vulnerable. The animals and plants that inhabit the polar regions have adapted to a narrow band of environmental conditions. As temperatures rise, species must adapt, relocate, or perish. Only a handful of people will ever have the good fortune of seeing a place like Antarctica's Cape Crozier Adélie penguin colony or the ice-covered surface of the Bering Sea in springtime. These photographs are an eyewitness account of what we stand to lose if the march of rising temperatures continues unchecked.

9

CHAPTER 1. ADÉLIE PENGUINS: LIFE AT THE EDGE OF POSSIBILITY BY HUGH Powell. David Ainley of H. T. Harvey and Associates and his colleagues have been studying the Adélie penguins of Ross Island, Antarctica, for over a decade. During the summer breeding season, researchers observe the penguins at four different colonies as the birds build nests, forage for krill and fish, evade leopard seals and skuas, and raise their chicks. Using a high-tech array of tools, including embedded microchips, satellite tags, and automated weigh stations, researchers are discovering for the first time where and how often penguins are hunting for food, in addition to monitoring how the penguins are adjusting (or not) to warming temperatures. Drawing on a long history of behavioral observations and a thirty-thousand-year record of penguin remains, scientists now know more about how Adélie penguins are reacting to rapid climate change than almost any other creature on Earth.

CHAPTER 2. SEARCHING FOR SPRING IN THE

Bering Sea by Helen Fields. The Bering Sea is one of the most productive ecosystems on the planet. In the spring, the sea ice retreats just as sunlight and ocean currents deliver energy and nutrients to the water. These perfect conditions fuel an explosion of life for the tiny plants and animals at the base of the food web. These organisms are eaten by fish, which are in turn eaten by marine mammals and humans. As climate change causes temperatures to rise in the Bering Sea, how will this delicately balanced ecosystem respond? This expedition aboard the icebreaker *Healy* was aimed at understanding the complex relationship between the organisms at the base of the food chain and the sea ice they depend on.

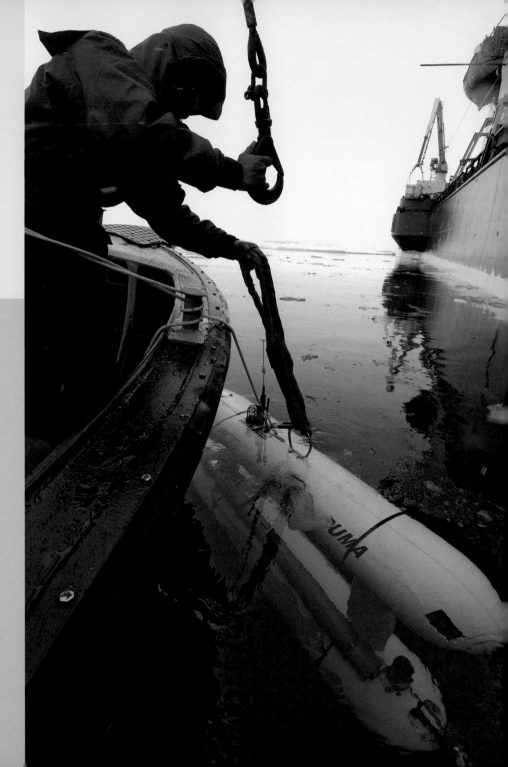

CHAPTER 3. EXPLORING THE ARCTIC SEAFLOOR BY LONNY LIPPSETT.

In July 2007, an international science team led by WHOI set out to plumb the secrets of the
Arctic seafloor, which lies beneath ten feet or more of ever-shifting ice and more than two miles
of water. The team's mission was to explore the Gakkel Ridge, a range of volcanic mountains
that looms underwater between Greenland and Siberia. They searched for evidence of volcanic
activity and seafloor hydrothermal vents, where geysers of superheated, mineral-rich fluids
spurt out, nourishing unusual life forms. To glimpse what lay hidden under ice and ocean,
engineers created a pair of free-swimming robotic vehicles and a tethered vehicle equipped
with cameras and sampling devices. The team successfully recovered samples of previously
unidentified microbes thriving on the seafloor and found evidence of explosive eruptions that
scientists had thought to be impossible in volcanoes under the pressure of such great depths.

CHAPTER 4. GREENLAND'S GLACIAL LAKES BY AMY NEVALA (opposite).

Greenland is home to the second-largest ice sheet in the world. If this ice sheet, which is
over two miles thick at its center, were to melt, global sea level would rise by seven meters
(twenty-three feet). The last decade has seen disturbing changes in Greenland's outlet glaciers,
which funnel ice to the sea. The rate of their flow has increased considerably, resulting in more
glacier ice being released into the ocean. In addition to the threat of sea-level rise, circulation
of the world's oceans—and thus global climate—could be altered by this sudden injection
of fresh water. Satellite images have revealed a network of freshwater lakes forming and
disappearing high on the ice sheet during the brief summer season. Where does this water
go, and how does it affect the speed of the ice sheet? A team of glaciologists from WHOI and
the University of Washington has been monitoring the formation and draining of these glacial
lakes and the ensuing ice-sheet response using an array of long-term measuring devices.

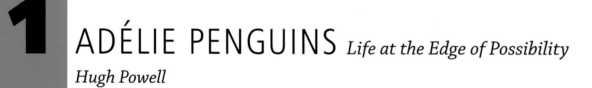

1

ADÉLIE PENGUINS *Life at the Edge of Possibility*

Hugh Powell

FROM A HELICOPTER FIVE HUNDRED FEET OFF THE DECK, THE PENGUINS are too small to see. All that stands against the whiteness of Antarctica are long rolls of volcanic rock, sliced with fissures like loaves of pumpernickel. This is Ross Island, the most southerly beach in the world, wedged into the south end of frozen McMurdo Sound. Even now, on December 1, 2007—midsummer—the sound is frozen stiff, flat, and white all the way to the peaks on the western horizon.

Beige guano stains on Cape Royds' black slopes are the first reminder that penguins are down there. Next the penguins pop out; they're the dark specks like poppy seeds among the rocks, the dotted lines stringing northward over the ice to open water.

The helicopter tilts left toward the landing spot and the sun bears down through the starboard window. Two tents come into view: a long semicircular Rac-Tent like a diminutive Quonset hut, and a yolk-yellow Scott tent shaped like a pyramid, just big enough for two people to lie down in. Outside the Rac-Tent, facing south, is a solar array. A wireless dish points at McMurdo Station, chattering at the Internet. Next to it, in the lee of the tent, are two orange fifty-five-gallon drums, for wastewater, and a bucket with a toilet seat on it. This is the research station of penguin biologist David Ainley, where he has lived every summer for the last twelve years.

The helicopter touches down barely a rotor's sweep away. Outside, hands tucked into red parkas, is the entire staff: outreach specialist and former teacher Jean Pennycook and Ainley himself, one of the longest-running penguin researchers still alive. Pennycook, skinny, fifty, with long curly reddish hair, hugs the helicopter pilot and presses him for gossip. Ainley, gray haired and weathered, checks for access permits, goes over the ground rules, and points to the colony.

The ground is reminiscent of a barbecue grill, littered with brown gravel approaching the size of honeydew melons and pocked with bubbles from the day it erupted. The path out of camp squeezes into a pinched gully and opens onto a tableau of Antarctic history.

Here is the first Adélie penguin colony ever studied—by members of Ernest Shackleton's first Antarctic expedition, in 1908. The still air hangs with the sound of distant Adélie greetings and, when the wind shifts, it carries the fishy smell of the colony. Off to the left, tucked under a ridge, Shackleton's hut still stands. Its timbers have been blasted gray and grainy by the wind. Dog kennels are still stacked outside the entryway.

The colony begins nearly on Shackleton's doorstep. There's a rank pool of snowmelt, clotted with algae on a small snowfield, and then Cape Royds proper rises into a double hump of rock. Here, two thousand pairs of penguins totter past each other, returning from or leaving for the sea ice. The ones headed to sea are grubby from lying over their nests; the ones they pass are wet and gleaming. The skin on the undersides of their flippers glows pink like the cheeks of an ice skater.

They're curious. One stops to size up Ainley, flippers held at a lax 45 degrees from the body, head turned to one side. A thick white eye ring accentuates an expression of surprise. The bird's head is bullet shaped, and feathers along the first half of the bill give it a snubnosed look. The body and wing feathers are emphatically black and white; the bird looks like an ink print.

In protest to this marvel of streamlining are two feet that could belong to an ogre: thick, fleshy, and pink with long black toenails. The bird takes a double hop to get started, stretches out its wings, and throws itself first left and then right, leaning out over its short legs. The toenails clack against the rock. "You can tell the ones that have been out at sea a while," Ainley says. "Long toenails."

Antarctica is the coldest, windiest, driest, emptiest place on Earth. Its size is disorienting; immensity revealed in the smallness of things. Mountains a hundred miles away are clearly visible in air uncluttered with humidity. Looking off toward the pole, an ice sheet seven hundred miles long ends abruptly at the horizon, just beyond arm's reach. Sledgers from early expeditions used to report toiling for hours toward a distant outcrop, only to discover it was a discarded tin.

So you might be forgiven for misjudging the two-foot-tall Adélie penguin: an animal it's impossible not to anthropomorphize, a toddler in a tuxedo. In fact, it's the largest land animal in Antarctica (emperors are larger, but nest on sea ice and rarely touch land). About five million Adélies breed along Antarctica's

coastline, and if you encounter an animal any farther inland you'll need a microscope to look at it. Adélies are vertebrates living at the edge of what's possible.

If they survive their first year (80 percent don't), they spend the next few years at sea just learning how to feed themselves, giving no thought to breeding. Those that breed along the Ross Sea migrate more than two thousand miles round trip each year, chasing to keep up with sunlight and the sea ice they use for rest stops and hunting grounds. After learning how to stay alive, they return to their natal colony, often to within a hundred meters of where they hatched, and spend the next several years learning how to build a nest, find a mate, and work as a pair. Adélie penguins live about twenty years, and they don't even have the luxury of being at the top of their food chain. Skuas eat their eggs and chicks, and leopard seals take the adults.

Adélies shrug off hardships that are beyond the experience of other penguin species. Popular ideas of penguins aside, Adélies are one of only two species that breed only in Antarctica (the emperor is the other). Relatives like the gentoo and chinstrap live on islands farther north. They breed on largely icefree coasts and forage in open water. Adélies spend 10 percent of their lives on land, and 90 percent either standing on floating sea ice in the Southern Ocean, or hunting beneath it. They can hold their breath for three minutes while swimming, and this exceptional ability gives them more range under the ice than either gentoos or chinstraps.

While gentoos and chinstraps are penguins of land, and emperors are penguins of the sea ice, Adélies have to live in both worlds. They come ashore to nest on dry, rocky hillsides, grudgingly walking over several miles of ice to reach

16

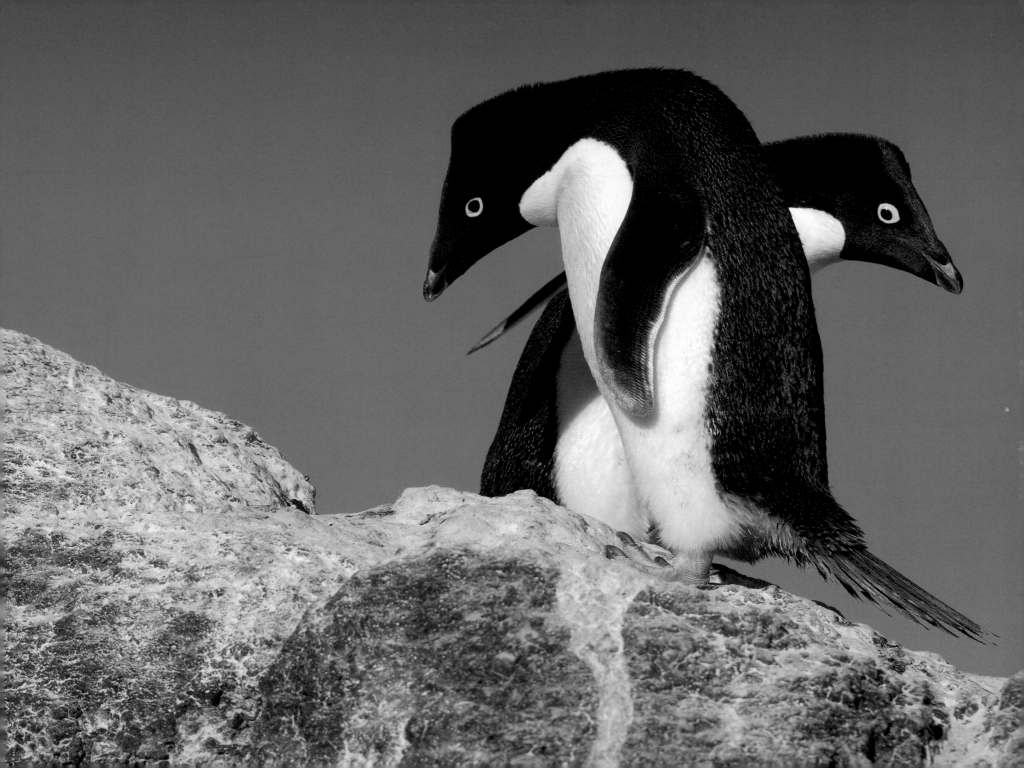

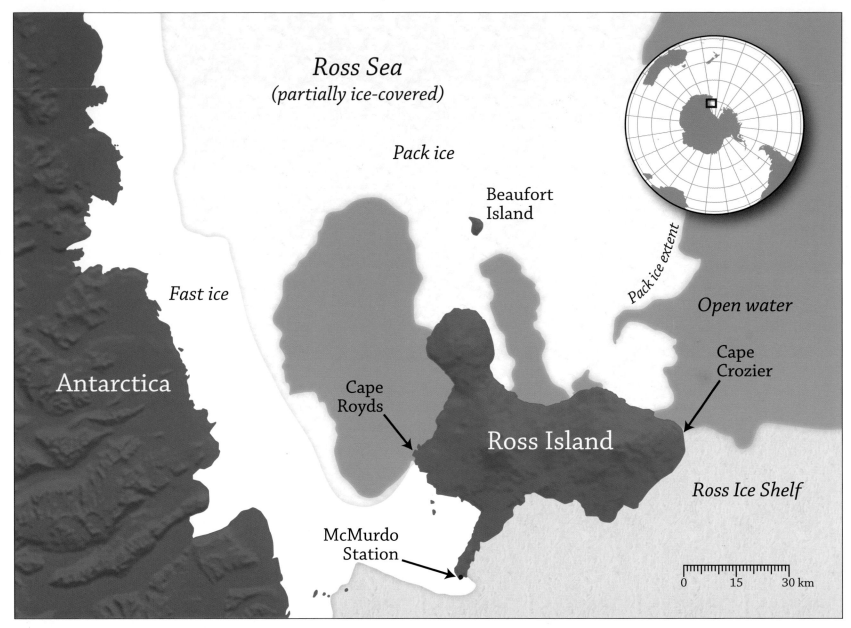

Ross Sea
(partially ice-covered)

Pack ice

Beaufort
Island

Fast ice

Pack ice extent

Open water

Antarctica

Cape
Royds

Ross Island

Cape
Crozier

McMurdo
Station

Ross Ice Shelf

0 15 30 km

18

DECEMBER 2007 SEA ICE extent from satellite data courtesy NASA/GSFC, MODIS Rapid Response.

SCIENTISTS BOUND FOR MCMURDO Station
fill the belly of an Air Force C-17 transport plane.

land. After laying two eggs each, females return to sea to refuel. The males stay behind to incubate, and they fast for the week their mates are gone—another feat of endurance that separates them from other species. Time pressures them, too: parents have about two months of summer in which to fatten their chicks to forty times their birth weight. It's this staggering capacity for survival that brings biologists like David Ainley to Antarctica.

Ainley first came to Antarctica in the late 1960s, as a graduate student at Johns Hopkins. Early on, he studied Adélie behavior, hoping to learn how they survive in the face of such exacting conditions. Now a senior biologist at H. T. Harvey and Associates in California, he is the architect of a wide-ranging penguin study in the Ross Sea, with colleagues including Katie Dugger of Oregon State University, Grant Ballard of the Point Reyes Bird Observatory, Phil Lyver of Landcare Research Ltd. in New Zealand, and Stanford graduate student Viola Toniolo. While much of what the team does finds its way into the scientific literature, Pennycook takes their studies directly to classrooms by tending the group's popular website, www.penguinscience.com. She posts photographs and time-lapse videos, answers questions, and helps teachers and pupils follow the fates of individual nests from day to day.

Begun in 1996, the project follows penguins at their nests, out at sea, and from season to season at four colonies: Cape Royds, Cape Bird, Beaufort Island, and Cape Crozier. It began as an attempt to understand what caused the four colonies to grow or shrink over the years. But as the study progressed, Ainley realized what he was seeing was the Adélies' relationship, resilient but tenuous, with climate.

To study an Adélie penguin is to study sea ice, for example, and sea ice obeys the wind. On land, Adélies need bare rock slopes and thimble-sized pebbles. Summer snowfall can mean catastrophe even though winter snow is nothing to a penguin. Ice, wind, rock, snow—the Adélie occupies the knife-edge between too much and too little of each. So in this one respect, everyone's first reaction to Adélies—that they look like little humans—is worth exploring. They've been living at the edge of what's possible for about three million years, through cycle after cycle, epoch after epoch, of warm and cold. They must have something to teach us about climate change.

Ainley has been coming to Antarctica long enough that he doesn't even notice the crazed bustle of McMurdo Station any more, except in negative. "You have to do a whole different adjustment to get into the society of McMurdo" is how he explains spending as little time as possible there. "It's much easier to stay with the penguins," he says.

But like all newcomers, the Polar Discovery team had to go through standard McMurdo initiation—a week of packing and safety training that feels like being the new kid in high school while going Christmas shopping and filing your taxes, in a blizzard.

The first day is great. Everyone arrives in the belly of a C-17 freight aircraft. Seats line the aircraft's bare walls, and heavy equipment—a drill bit eight feet in diameter, for instance—is chained to the center aisle. During the five-hour flight from Christchurch, New Zealand, veterans doze or read *Harry Potter*. Newcomers finger informational handouts and think about the orientation film they were shown before takeoff: "You are going to remember the next forty-eight hours for the rest of your life. But when you get off that plane and see Antarctica for the first time, you will need to have your sunglasses on and your parka zipped up."

The plane lands on the flattest thing around—the frozen surface of McMurdo Sound itself. (The older the ice, the more pockmarked and bumpy, so the planes land on fresh, one-year-old sea ice as long as it's more than six and a half feet thick.) People descend the aircraft steps in a stream of standard-issue "Big

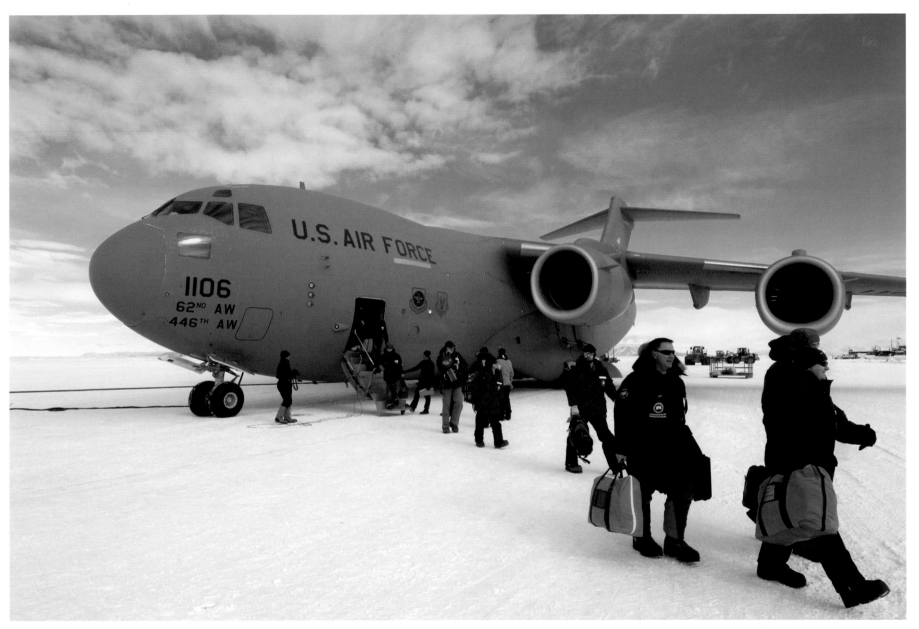

PASSENGERS STEP ONTO THE ice of McMurdo Sound for the first time.

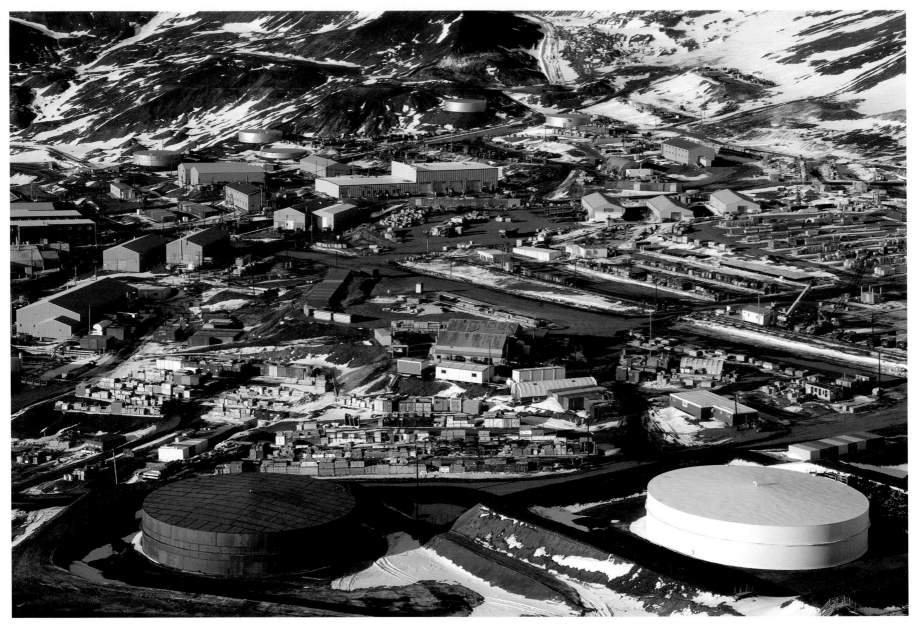

THE URBAN SPRAWL OF McMurdo Station.

HAPPY CAMPER STUDENTS SIMULATE a rescue in whiteout conditions.

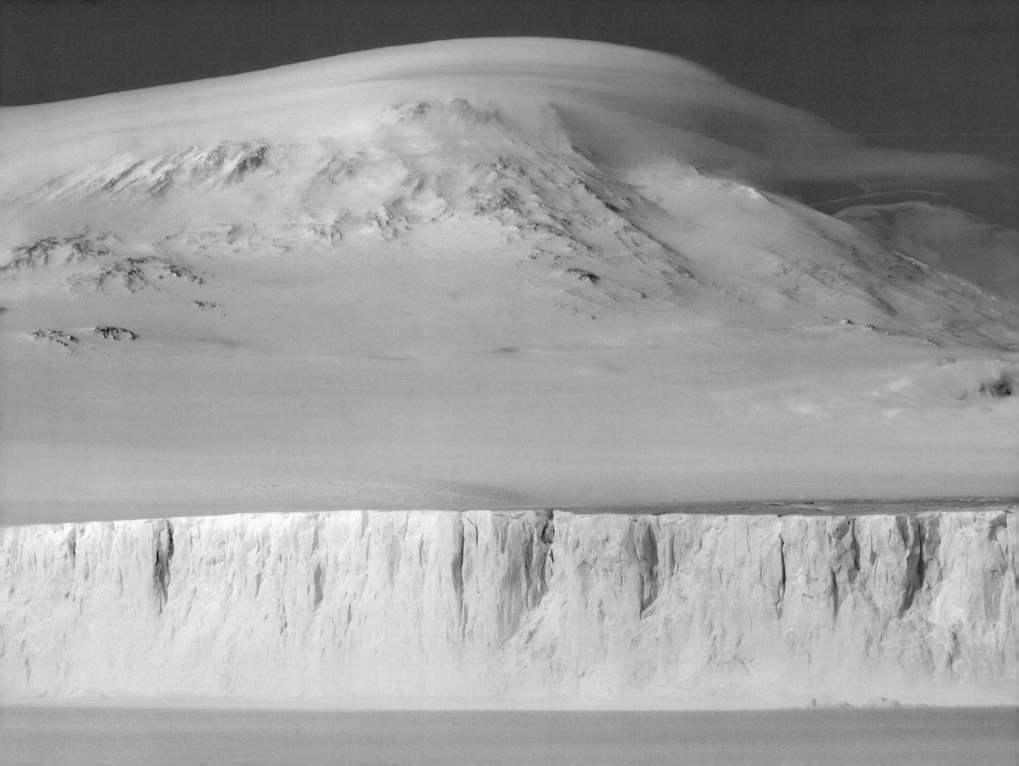

Red" parkas, blinking in the sunlight, and climb onto a monstrous red vehicle, its wheels five feet tall, nicknamed Ivan the Terra-Bus.

No amount of background reading or study of photographs is sufficient preparation for the beauty and scale of Antarctica. The snow squeaks; the air is scentless; the ice plain is low and flat; the mountains lounge in the distance like game animals on the savanna. The historical landmarks are no longer parceled onto separate pages of a book, but joined together right outside Ivan's windows: there's White Island, where Scott and his men hung a right and sledged on to the Beardmore Glacier; adjacent to it is Black Island, due south, where the storms come from. To the northeast are the cliffs of Castle Peak and the point of Observation Hill, where Scott's Cross stands, with McMurdo Station and Scott's first hut nestled on the far side. Beyond and above, the blunt triangle of Mount Erebus trails a thin plume of smoke from the lake of lava at its summit, at 12,400 feet.

Thirty minutes later, Ivan chugs onto land in the gray cinder town of McMurdo Station, summer population about a thousand. It consists of forty-seven buildings plus associated fuel tanks and storage sheds hanging onto a hillside. Here, scientists get outfitted for missions ranging from coring ice sheets, to building the world's largest neutrino detector in the ice, to jackhammering for rock samples, to sampling Weddell seal milk, to scuba diving in sub-thirty-two-degree water.

It's not McMurdo's fault that it reminds everyone, depressingly, of a mining town. The buildings are utilitarian; the gravel roads are lined with dirty plowed snow; gray meltwater rushes through brown gouges in the earth; the sound of diesel engines and bulldozers backing up fills the air; and tangles of telephone lines block the views. And this is Antarctica, so nothing grows on the bare scree slopes. But McMurdo isn't about scenery, it's about logistics.

The Berg Field Center is like an REI store filled with used gear and professional mountain guides. By the time scientists arrive, all the field gear they requested in their research proposal has been pulled and stacked in a warehouse cage with their names on it. More than eight hundred scientists pass through McMurdo each year, and the three-level Crary Science and Engineering Center provides them office and lab space. The library, where visitors can drink hot chocolate and watch the light change over the Royal Society mountains, has the best view in McMurdo. A half dozen C-130 aircraft parked out on the frozen sound help set the scale. Up the hill, among the fuel tanks, is a small hydroponic greenhouse full of lettuce, basil, cucumbers, and tomatoes. The produce doesn't stretch very far in the dining hall, but the greenhouse doubles as a getaway for homesick staff. It's bright and the air is humid and fragrant. There are a couple of hammocks and a dingy plaid armchair, but no windows.

McMurdo's social center is the dining hall, an echo of high school but with better bread. It has the same plastic trays, dry-erase menu boards, and reconstituted juice tureens. Air Force crews in their flight suits sit at round tables up front, mountain guides and helo techs trade war stories farther back, and bespectacled scientists file past, tray in hand, wondering who to sit with. For everyone, atmospheric physicist to dozer mechanic, the highlight is a soft-serve ice-cream machine called Frosty Boy. The rainbow sprinkles come in gallon containers, and there's a pager number in case of breakdown.

Ainley has spent more time in Antarctica than some of McMurdo's buildings, so he and Pennycook move pretty much straight to Cape Royds upon arrival. New visitors spend a day and a half at Happy Camper school, a crash course in how to stay mostly alive out in the open. Topics include how to cut snow bricks with a saw, the proper way to anchor tent stakes in seventy-five-mile-

per-hour winds, how to anticipate bad weather (in Antarctica it always comes from the south), the importance of hot drinks, and a sobering rescue drill in a simulated whiteout (everyone fails it). That night, visitors stay in the shelters they constructed in order to get an idea of how well they did. It's most people's first opportunity to take broad-daylight photos at 2 a.m.

The instruction continues after Happy Camper, because McMurdo is intent on avoiding the needless deaths that gave Antarctica's early years their name: the Heroic Age. There's snowmobile training, spill-avoidance training, toilet training (put it this way: everything gets packed out); radio training; sat-phone training; and sea-ice safety training, which includes the news that it's okay to drive a snowmobile over any crack less than half the width of the machine, but for best results travel in a Hägglund tracked vehicle, which floats.

In between checking off safety lectures there's outfitting and packing. McMurdo's commissary has its share of freeze-dried stroganoff, but in a place where weather can strand people inside for days at a time, it helps to have cooking options that challenge the imagination. If someone wanted to serve salmon braised in Thai red curry with fresh-baked dinner rolls, they could. For quicker energy, Operations recommends two Cadbury bars per person per day. All this arrives on the once-a-year provisioning visit by an ice-breaker ship (fresh veggies for the dining hall trickle in by plane), so it's wise to check expiration dates. In 2007 there were still premillennial Clif bars floating around.

Once packed, bags are weighed on a pallet scale so that helicopters can be evenly loaded. Then the bags are lugged down a gravel road and over a catwalk to the helo pad. McMurdo's four helos (nobody calls them helicopters) haul scientists and their gear to nearly all the field camps, but for safety they only fly when visibility is more than five miles and winds are less than thirty knots. To help with scheduling there's a Magic 8-Ball on the front desk.

On its seaward edge, in December, Cape Royds is a steep bluff with its feet in the frozen ocean. Open water is a half mile away, but the ice heaves against the cliffs twice a day with the tide, and the lower twenty feet of rock is jagged with frozen spray. Chunks of ice pile against the shore and refreeze in broken chandeliers, and penguins file through this landscape like miniature mountaineers on the Khumbu icefall.

It's as if they don't even feel the cold of the ice as they set off across it in groups of three or twenty, toenails clacking. Progress is alternately enthusiastic and methodical; they tackle level ground at a run, but stop short to inspect any crack or lump. First the head curves down on its graceful neck, peering at the ice, and then the bird looks around to poll its companions. Eventually, it clears the crack in a two-footed leap, and sets off again, wings out, scampering.

Scientifically speaking, understanding a species isn't so much about measuring it as measuring how much it varies in response to differing situations. That's why Ainley and his colleagues have been studying four colonies, ranging from very small to very large, for the past twelve years. The largest colony (Cape Crozier) requires penguins to deal with a huge amount of competition among themselves. Tiny Royds is less frenetic, but its physical attributes are more severe. As for the decade-plus time commitment, it's not much different from trying to understand *Moby-Dick*: you ought to at least give it one full run-through before you make any final judgments. In Ainley's estimation, the project won't be complete until he's followed at least one full generation of penguins, start to finish.

Even a penguin's full lifetime—about two decades—leaves precious little time to catch climate change in action. So the arrival at Cape Crozier of an iceberg the size of Jamaica, right in the middle of the study, must be regarded as a stroke of luck for the researchers, if not for the penguins. Iceberg B-15 was 180 miles long and 25 miles wide when it calved off the Ross Ice Shelf in 2000. By early 2001 it had broken roughly in half, scraped its way westward over the

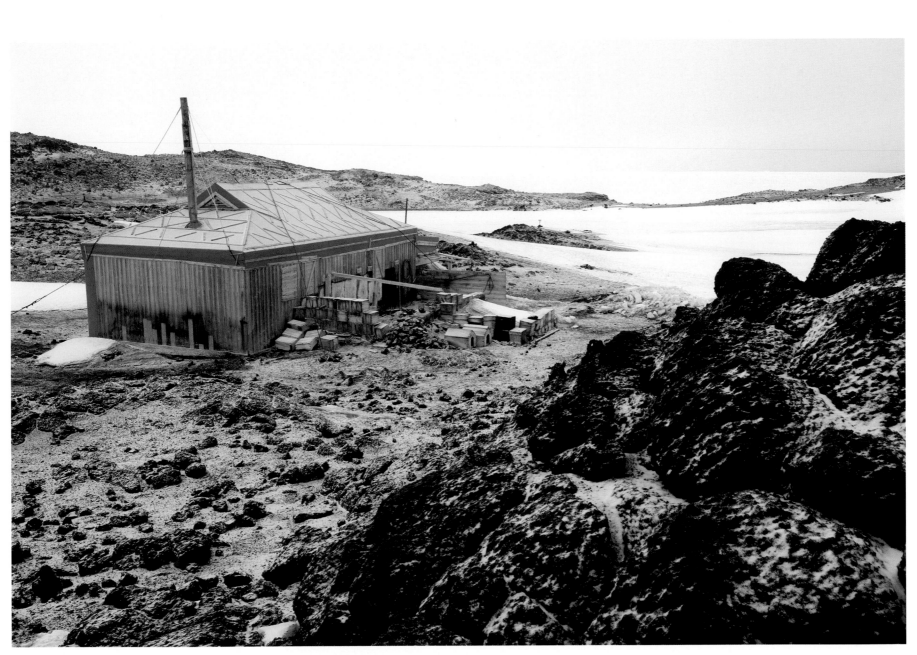

SHACKLETON'S HUT AT CAPE Royds with the penguin colony on the rocks behind it.

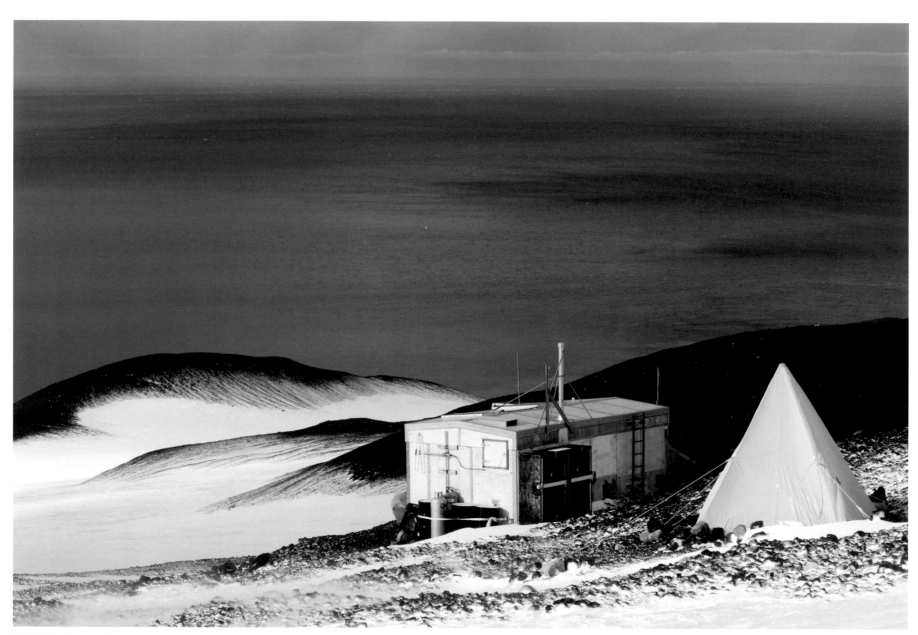

THE HUT AT CAPE CROZIER.

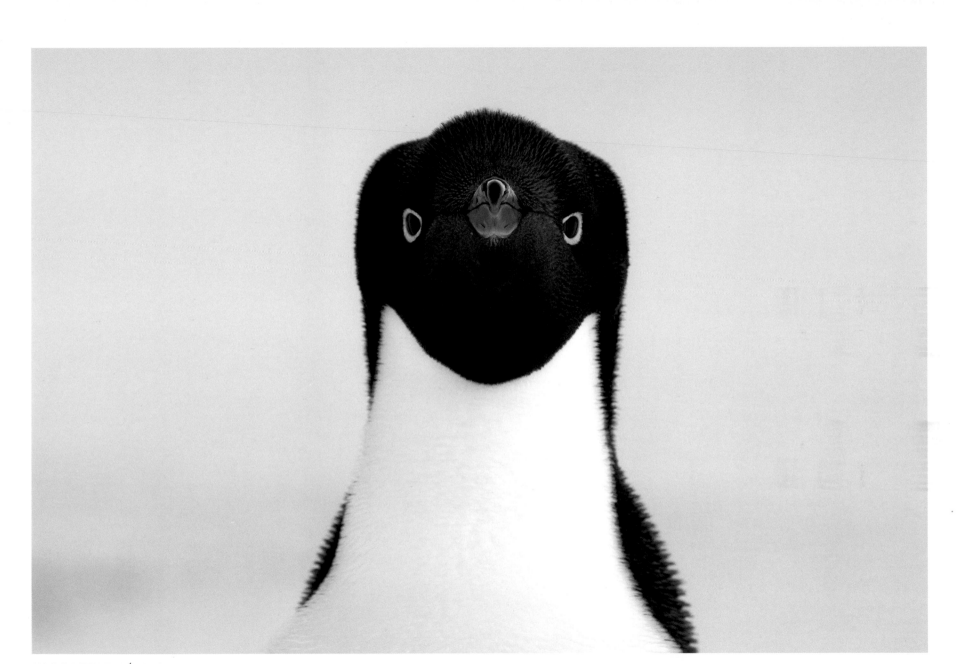

AN INQUISITIVE ADÉLIE PENGUIN.

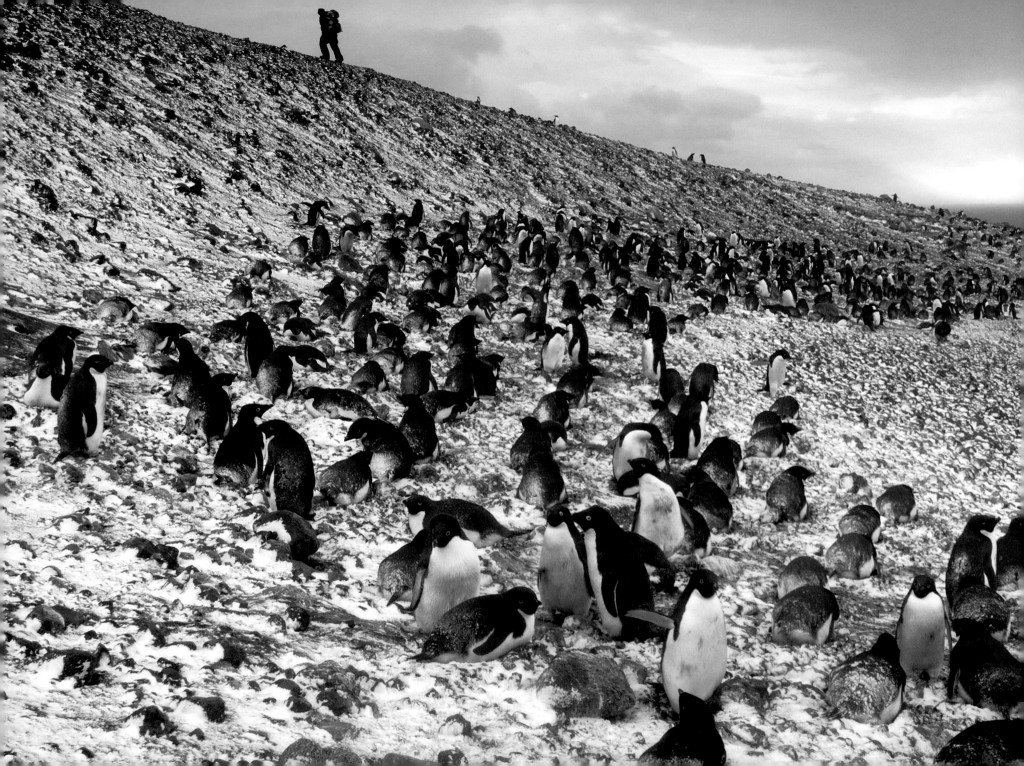

A SUBCOLONY OF ADÉLIES IN FRESH SNOW AT CAPE CROZIER.

31

seabed on coastal currents, and lodged against Ross Island. B-15 blocked off normal ocean currents into McMurdo Sound, and for the next five years the late summer breakup of sea ice on which penguins depend simply didn't happen. Nests failed, starving parents abandoned their chicks midsummer, and the number of new chicks fledged each year fell by more than 75 percent. Cape Royds, where penguins faithfully crossed forty miles of solid ice to return to their nest sites, was hardest hit. In 2006, the iceberg fractured again and floated away, and most of the penguin colonies began to recover. To Ainley, it seemed that they had just been witness to a fast-forward version of what must have happened during glacial periods, when the Antarctic ice sheets crept northward and blocked off many coastal nesting sites.

Ainley is reflective, and he clearly enjoys the solitude at Cape Royds. He writes e-mails in long paragraphs, but in person he speaks haltingly, in a high, raspy voice, often flashing the faintest of frowns as he prepares a thought, thinks better of it, and starts again. His hair and mustache are long and silvery. His face is weathered and stern, his eyes deep set. In his free time he skate-skis over the sea ice, leaning on his ski poles now and then to watch the mountains across the sound. At night he simply lies down on the wood floor of his Rac-Tent, pulls a fleece headband down over his eyes, and goes to sleep next to the pile of boots by the door. In the morning, he answers e-mails, drinks coffee and downs a bagel burger, and heads out to check on the penguins.

Pennycook is constantly in touch with classrooms and teachers in the outside world. Thanks to the wi-fi setup at Royds, she can give lectures to students, occasionally talking to more than one continent at once. Otherwise she photographs nests every day, uploads the images, and asks students to note what may be different today. Classrooms send her more than five thousand self-addressed postcards before each season begins. Pennycook takes them with her, stamps each with a penguin cachet, and sends them back, a message from Antarctica.

For the penguins the season begins in late October, when the first returnees walk up onto Cape Royds. The sea ice they cross on the way in is frozen "fast" to the shore, so it's called fast ice. The birds depend on it melting out by the time their chicks are growing; otherwise it takes too long for them to make it back from sea with food. Sea ice that's free from land is called pack ice, and Adélies have the opposite relationship to it: they depend on it. They use the leads between floes the way forest birds use gaps in a canopy, as a way in to their hunting grounds. With their breath-holding ability, every crack in the ice represents a new radius of opportunity for feeding. Pack ice is a nursery for two of their main foods, a shrimplike crustacean known as krill and a small fish called Antarctic silverfish.

Adélie eggs take a month to hatch, and chicks take about six weeks to reach fledging age. The short summer will begin to fade by February, so Adélies have no time to lose. Longtime pairs have the benefit of knowing what to expect. They arrive at the colony early, reestablish their bond with a ritualized greeting, and then get down to nest building. Younger birds arrive later and take longer to find mates and learn how to behave in the welter of busy penguins. Ainley and Ballard have a loose system for classifying penguin experience levels. They affectionately call the youngest birds "gapers." These are three- and four-year-olds, just returning to the colony for the first time. Though to the untrained eye penguins are indistinguishable, to them a gaper looks like a farmhand visiting Manhattan. They stand alone at the edge of a group of nests, backing away at any approach, and keep their crest feathers slicked back in submission.

Gapers have poor prospects for successful mating their first year, but over the next few years they'll learn to build what Ainley rates an Sc (scrape) or a PB (poorly built) nest, and they may learn not to chase off a prospective mate showing interest. These birds know roughly where nests should go and that they should contain a few rocks, but their technique needs practice.

Ainley studies a penguin through his binoculars. A glint of silver shines off a thin band just above the joint in its left flipper, and Ainley reads it: PA 02235. The letters stand for *Pygoscelis adeliae*, and the numbers indicate this is an eight-year-old male. "Kind of a klutz," Ainley says. It has had a mate and has returned to the same nest site over the last three years, but the pair has never yet produced an egg. His situation is not particularly rare: in one study, a full 45 percent of six-year-old males and 17 percent of eight-year-old males did not breed.

Birds like PA 02235 will gradually improve their skills until they're making FB (fairly built) or WBN (well-built) nests. Simultaneously they'll start to synchronize with their mates. Together, they still have to learn when to lay eggs, and how to build a sturdy nest platform, foil a skua attack, and trade foraging trips fairly.

Ainley sets off again to continue his every-other-day search for banded penguins. "I try to look at every left flipper" is how he describes his day. He strides easily across the rock, feet encased in rigid red mountaineering boots. In this twenty-degree weather he wears faded olive fatigues over cross-country ski tights, and a loose red windbreaker over a stormy blue fleece. The zipper pulls are tassels made of faded yarn by friends.

Nearby, the penguins are waving their heads in the air and snarling. Over them two long-winged South Polar skuas cut the wind. Shaped like a burly gull and colored like Wile E. Coyote, skuas are smart, agile, and hungry. They nest along the edges of penguin colonies and augment their standard diet of fish with penguin eggs and chicks.

A skua in the wind is dangerous, and two skuas are deadly. The penguins stand upright, bodies shifting in unison like cornstalks in a breeze as the skuas sail over. But the skuas have time, and they have each other. One turns into the wind and stalls, then wheels downwind at twenty-five miles per hour. It dips a wing to windward and stops neatly as a hockey player. As this one distracts, its mate attacks. The skuas circle patiently and the penguins stare them down, until one eventually lunges a step too far. The skua's partner adjusts immediately, drops its neck and grasps the egg with its heavy black bill. It doesn't even put a foot on the ground. The wings reach up into the wind and the bird is away. The penguin is back on its nest, but the egg is gone.

Skuas are a constant presence at penguin colonies. A few even hang around McMurdo Station, which is desolate except for humans, and dive at unguarded sandwiches instead of eggs. Fortunately for penguins, the tag-team approach only works early in the season, before the skuas have eggs or chicks of their own to care for. Ainley studied skuas in the 1980s and regards them as a sort of preemptive scavenger rather than a predator. They steal eggs and young from inexperienced parents—young that would likely die of other causes. His impression is borne out by comparisons that show overall chick production drops by only a few percent in areas where skuas are numerous.

In midafternoon, a line of puffy, U.S. Antarctic Program "Big Red" parkas shuffles over the ridgeline. Cape Royds is less than twenty miles by snowmobile from McMurdo, and employees often get awarded a "boondoggle" daytrip as a morale booster. While the sea ice remains firm, Royds gets visitors nearly every day.

People tour Shackleton's hut, knocking off their boots at the doorstep, signing the guestbook, and snapping photos of the boiled mutton and cod roe tins that line the walls. A splintered sledge hangs in the rafters, and next to Shackleton's bed is a watercolor of a boy and girl strolling along an English garden lane, one corner smudged with candle soot. Outside again, the visitors line up at the signpost that marks the boundary of the penguin sanctuary. Faces to the wind, they breathe in the acrid colony smell and watch the penguins bustle.

Ainley and Pennycook sometimes invite these visitors to dinner. One evening a group of teachers from a nearby drilling project sits in a circle on boxes and folding chairs. The decor is mostly airing socks, and tins of fish and meat

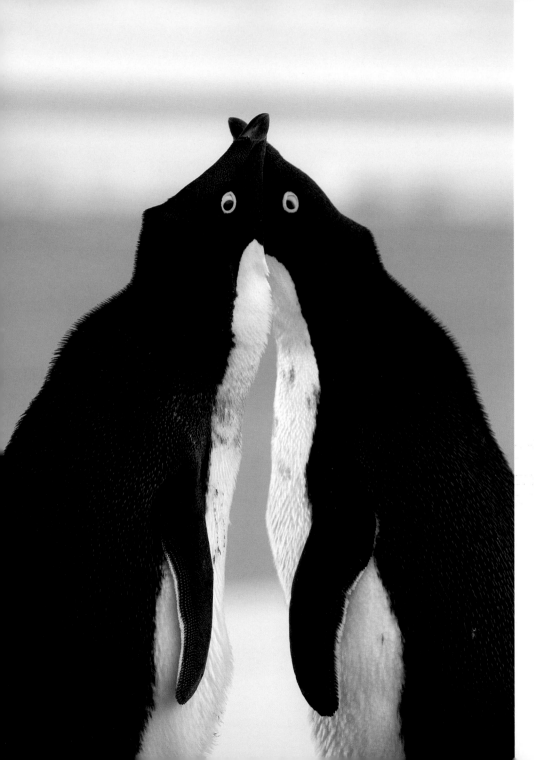

line the walls much as they do in Shackleton's hut. A slender Austrian asks, "Dr. Ainley, what made you decide to devote your life to the penguins?" It's a question he must have answered countless times (at least once earlier that day), as well as in his 2002 book, where he wrote "after some twenty-two trips to Antarctica and its surrounding oceans, no one thing embodies the spirit of [the Antarctic] struggle more than the Adélie penguin (*Pygoscelis adeliae*). Against incredible odds this little warm-blooded creature survives only by being supremely adapted, knowing what is important, and doing whatever is needed, always with amazingly defiant energy."

The year before, director Werner Herzog had asked Ainley much more flippant questions for a documentary called *Encounters at the End of the Earth*. Unaccountably, Herzog, whose film career obsesses about life at the extremes of tolerance, pursued titillating stories about homosexuality and insanity in penguins rather than ask about their intrepid lives. But Ainley answered in the same respectful tone, giving the impression he was mulling over his thoughts for the first time. In voiceover, Herzog, for once confronted with a man living at the extremes of existence to study an animal doing the same thing, was dismissive.

Long after the dinner guests disperse, the colony is still buzzing. Nighttime retains a different feel even in this twenty-four-hour light. The sun circles the sky all day long, and at three in the morning the shadows point toward Mount Erebus instead of away from it. Male penguins stand at their nests giving their "ecstatic call," slowly flapping their wings and calling out. Others shuffle their feet, pressing their eggs up against the warm, bare brood patch on their bellies. One bird climbs a nearby rock and stands atop it, looking around.

An Adélie trots by in normal pose, feet flapping, flippers waving, eyes fixed forward. Its bill is slightly agape and it grasps a small stone meant for its nest. Each nest contains about a hundred little walnut-sized rocks like these, carefully piled together to form a pedestal in which the eggs lie. Sometimes it's wide and

GREETING RITUALS IN ADÉLIE PENGUINS.

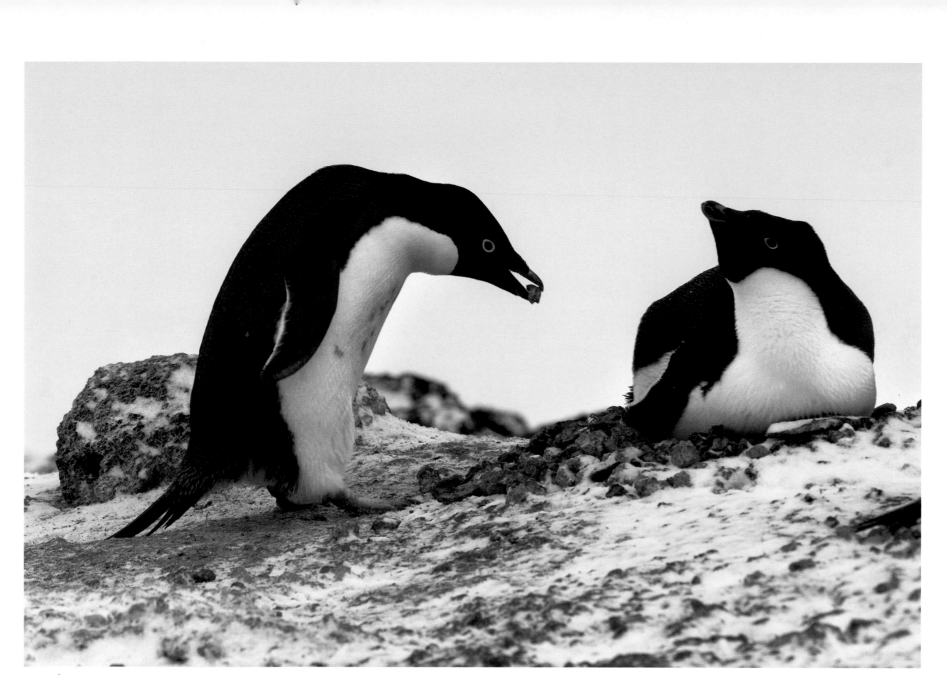

AN ADÉLIE PENGUIN PLACES a small rock on its nest to help keep the eggs and chicks safe from snowmelt.

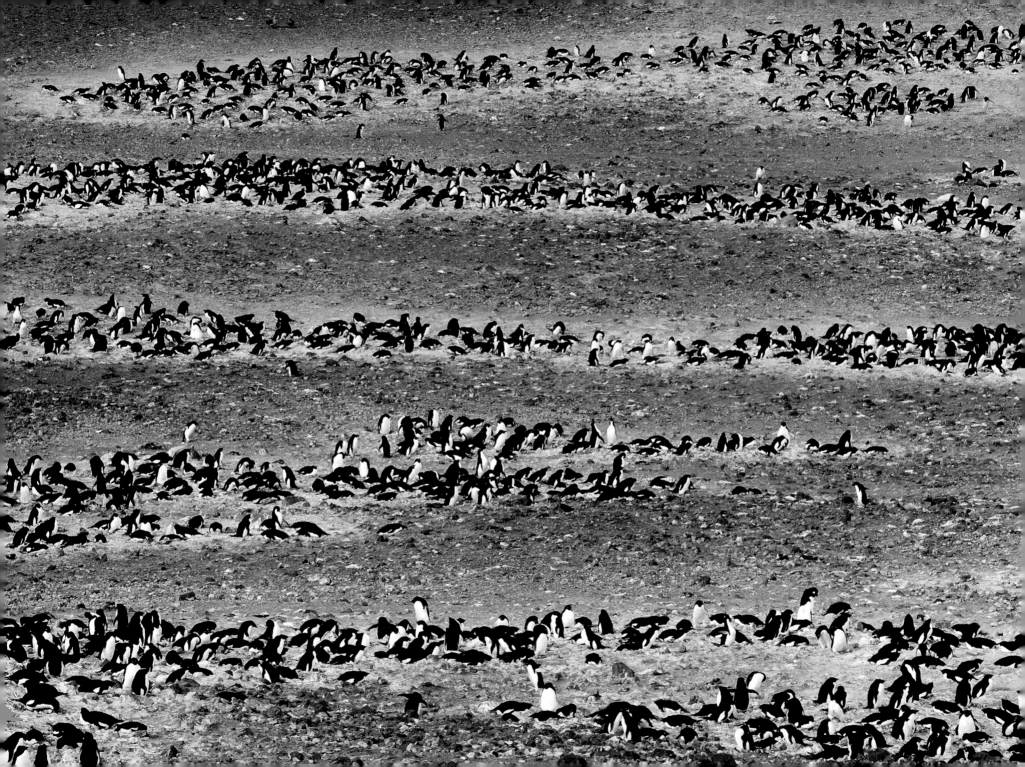

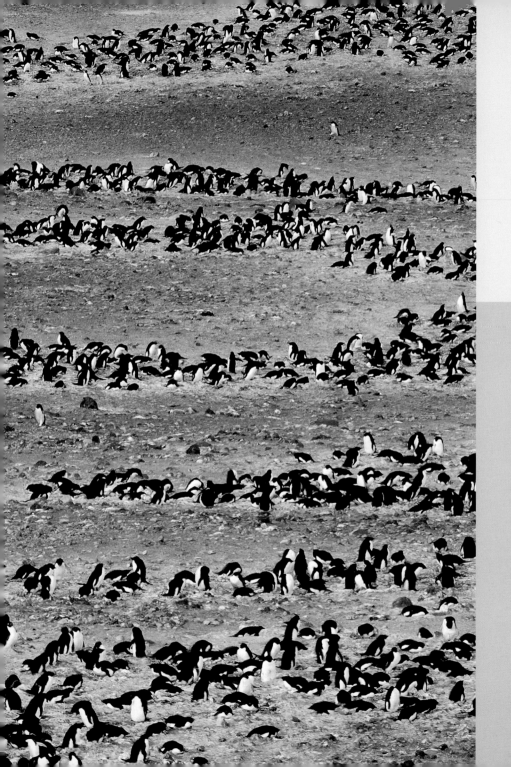

DAPPLED FIELDS OF GUANO-STAINED PENGUIN SUBCOLONIES AT CAPE CROZIER.

37

squat, an inch or so above the surrounding ground, but others are sturdy little towers several inches high.

The nests are elevated because summer in Antarctica means meltwater. Adélies build up to keep their eggs dry. It seems to be always in the back of an Adélie's mind that it should be on the lookout—good rocks are rare after a few centuries of collecting. A penguin might have spent an hour trekking back from the ice edge, but there's still time to detour for the right rock. Some penguins get theirs by stealing.

To pick one up, a penguin has to stride right up until the target is almost between his feet. Then the neck curves and the beak stretches down past the little white potbelly, flippers rising like the arms on a corkscrew, and the bill grasps the rock. Placing the stone is another meticulous operation. The bird leans forward, the bill hardly moves, and the stone drops into place.

The next day, latecomers to the colony are mating. It's a disarming sight, as options are limited for a bird with such unusual dimensions. Many birds flutter into position, but that's not possible for Adélies. The only solution, apparently, is for the female to lie on her belly and for the male to climb onto her back and stand there. Tails clock aside like railroad crossing guards and the male treads on her back to keep his balance. Here again is the concentration that marks so much of what Adélies do: the female cranes her neck backward until her bill meets the male's, curving forward. The full circle their bodies make has a delicacy that a sensitive observer might take for romance, at least until the male wobbles and falls off.

Downslope, near the meltwater pool beyond Shackleton's doorstep, Ainley shows off an ingenious contraption: the weighbridge. It's set up at the entrance to a small area of about seventy-five penguin nests encircled with waist-high green plastic fencing. Feathers and old eggshells are blown up against the downwind edge, and the only way in or out is through a low plastic archway.

"The penguins were pretty surprised when we put it up" ten years ago, Ainley says, "But in a few hours they figured out the hole in the fence. They're always investigating, and it takes a lot to keep them from their business of raising chicks. Pretty soon they were so used to it that we could take the fence down, leaving the weighbridge, and some would still go over it."

Under the platform is an electronic scale that weighs each penguin on its way in or out. The birds carry tags under their skin, each about the size of two rice grains, like the ones people use to keep track of their pets. As they cross the weighbridge, the machine bounces an echo off the tag and records the bird's identity. With a little arithmetic, that means Ainley can know when penguins leave and return, how much food they have in their stomach, how much they leave in the enclosure (i.e., how much they feed their chicks), and how long their foraging trips are. Everything gets stored on a laptop kept in a tent and fed by a solar panel. The tent is held down with many, many rocks.

About the volume of knowledge that early penguin researchers amassed, Ainley has written, "The easy part is behind us. Future progress will take ever greater effort and creativity on the part of researchers." Weighbridges, now operating at the three Ross Island colonies, and splash tags, which Grant Ballard and Viola Toniolo demonstrated a few days later at Cape Crozier, must have been the sort of thing he had in mind.

Few people are lucky enough to visit Cape Crozier. It's well off the beaten track, even for Antarctica, there isn't much shelter, and its winds at times make it positively helicopter-proof. The Polar Discovery team arrived just as the Crozier staff were emerging from several days of continuous gales.

The helicopter ride is longer than to Cape Royds. The Bell 212 banks south and east out of McMurdo, and for a while its shadow slides across the Windless Bight. This is the same route that three Englishmen took in 1911, though they

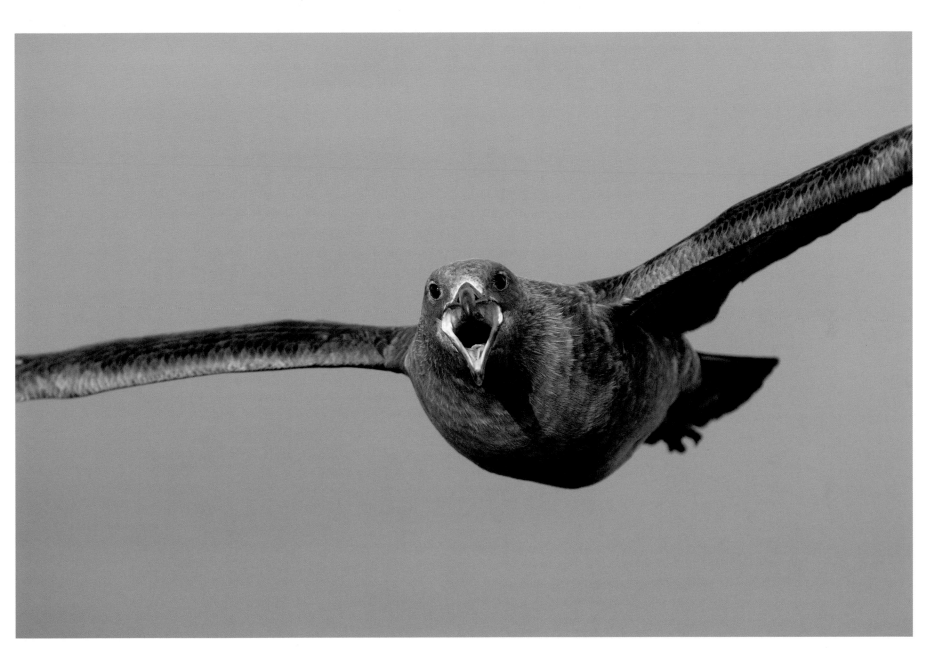

THE SOUTH POLAR SKUA is a constant presence at Adélie penguin colonies.

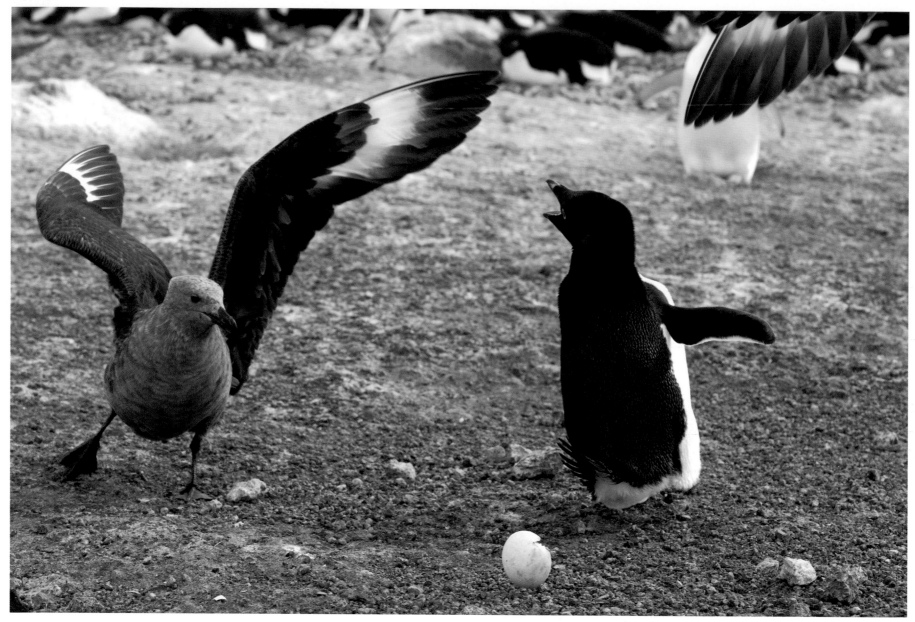

PENGUINS FIERCELY DEFEND EGGS from skuas, but two skuas working together are difficult to beat.

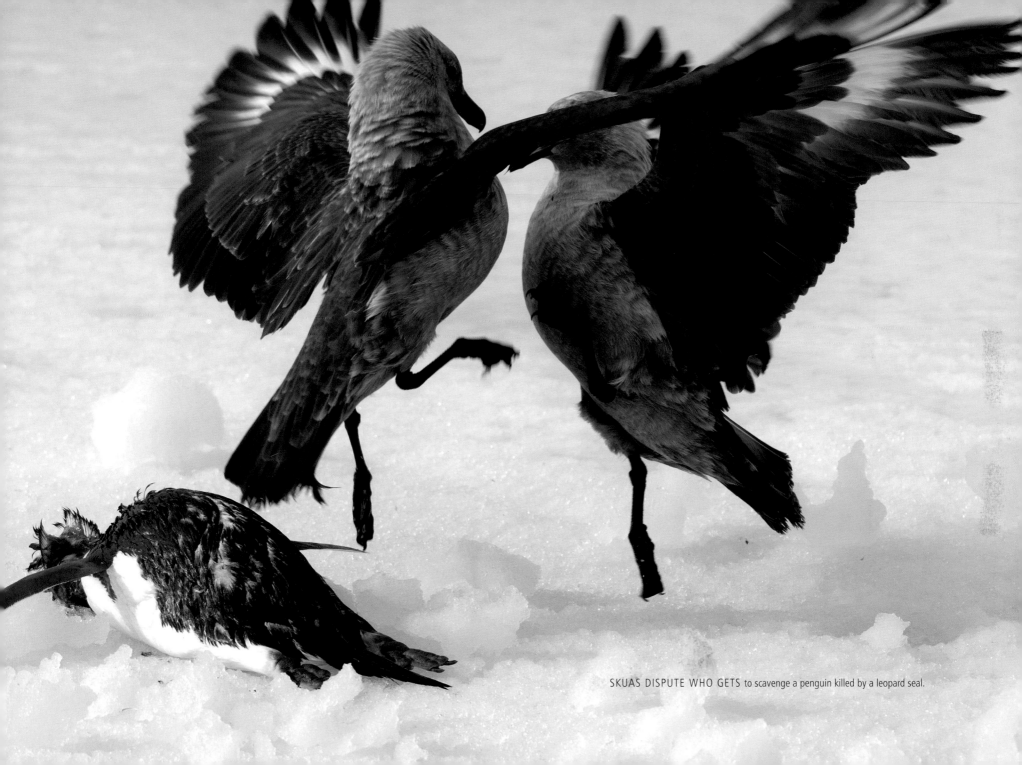

SKUAS DISPUTE WHO GETS to scavenge a penguin killed by a leopard seal.

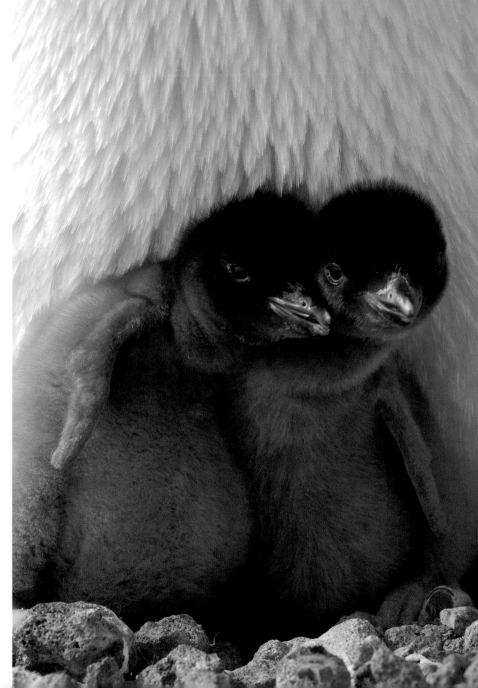

ADÉLIE CHICKS ARE BORN fluffy and gray, with slender necks and enormous bellies.

THE PENGUIN SUPERHIGHWAY AT CROZIER (opposite).

did it on foot, in the dark, at minus 70 degrees Fahrenheit, with knee-deep snow bogging down their sledge runners. (They made the journey because they were curious about the details of incubation in emperor penguins.) Later on that year, two of the men died with Scott on their way back from the South Pole, and the third, Apsley Cherry-Garrard, wrote a book called *The Worst Journey in the World*. He was referring to the trip to Crozier, not the trip to the Pole.

The Ross Sea is hidden from view until the last moments of the ride, when the chopper bursts over a saddle and the horizon turns blue. Below are two Scott tents and a cabin the size and shape of a railway car, with a small wind-power generator spinning idly in the day's light breeze. Two days from now, it will be making a sound like an outboard motor. Camp sits about seven hundred feet above the sea. A gleaming icefield skitters a quarter mile down to the cliff edge—crampons recommended. To the northwest, Franklin Island hangs like a gumdrop on the horizon, while a few supermarket-sized icebergs twist in the middle distance.

The helicopter keeps its blades turning and three people help unload gear from the back seat. They're best told apart by windbreaker color: red and scruffy is Grant Ballard, who has been coming here for twelve years; plum colored, with black shoulder-length hair, is Viola Toniolo, a six-year veteran (she and Ballard are married); lime green, with blond ponytail, is Kirsten Lindquist, an intern in her first year here. The helicopter takes off as soon as it's empty. At Crozier, nobody waits around to see how long the calm spell will last.

Antarctica is windy because the center of the continent is ten thousand feet high and very cold. Dense, frigid air seeps outward from the pole and begins

HUGH POWELL

42

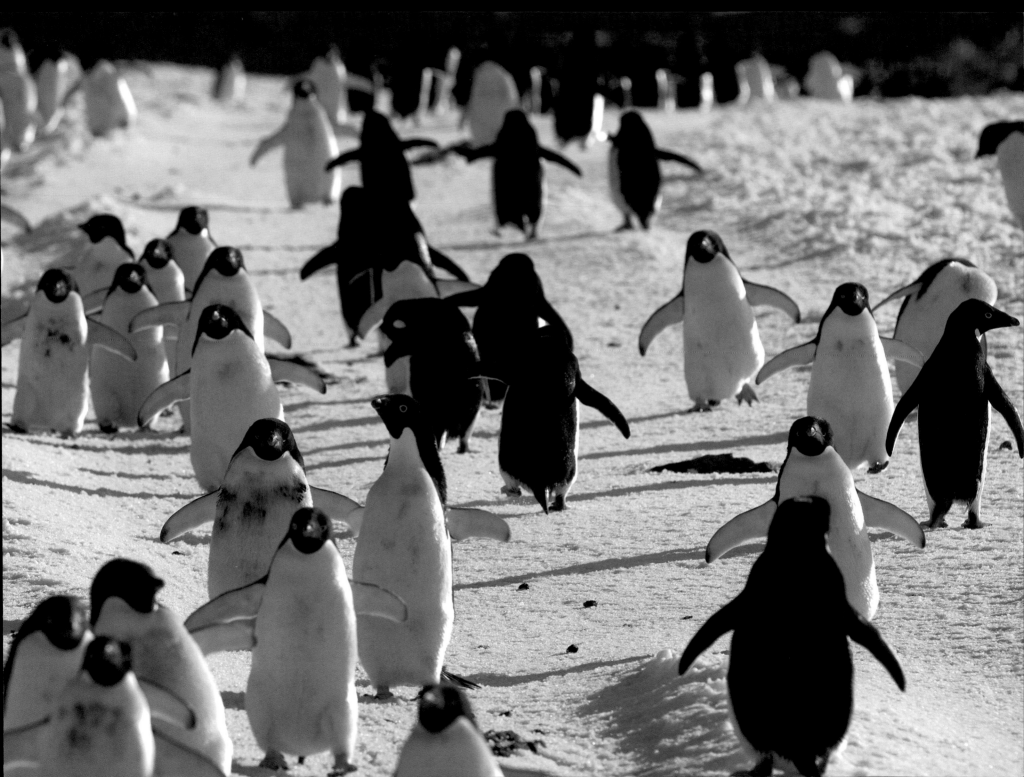

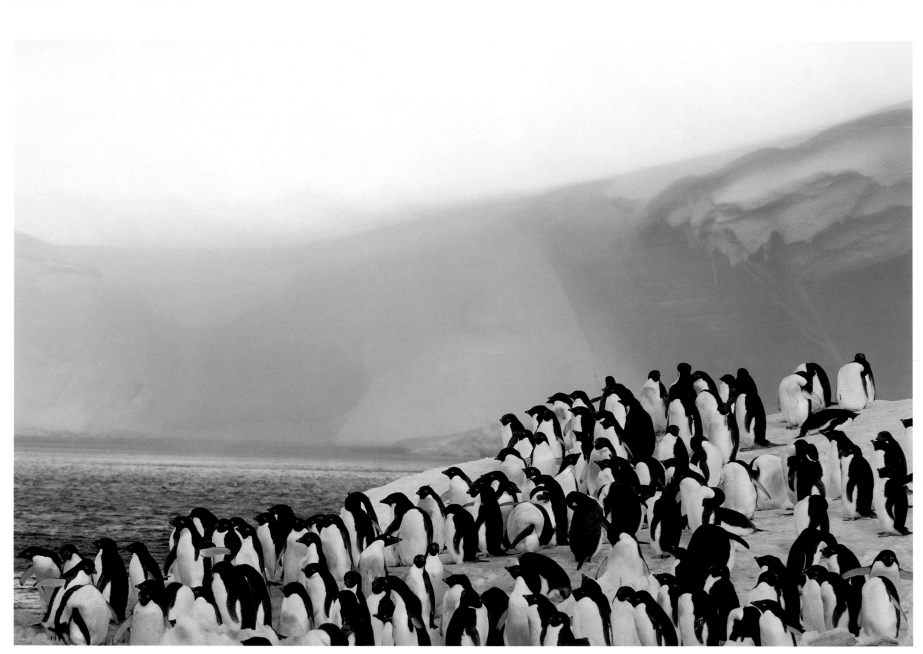

PENGUINS CROWD THE ICE edge at Cape Crozier and look down for any sign of leopard seals.

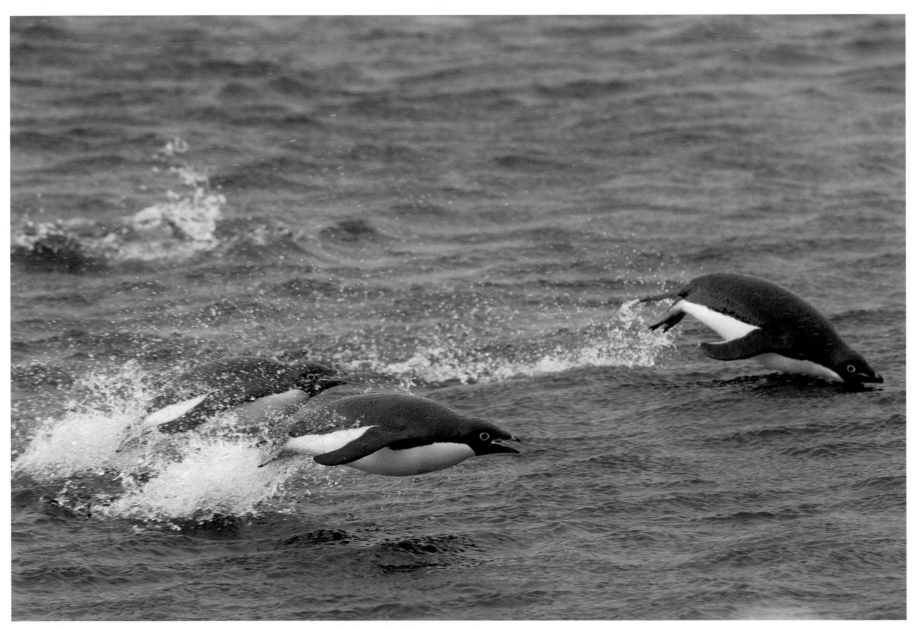

PORPOISING ALLOWS PENGUINS TO swim and breathe at the same time and is their most efficient mode of travel.

to tumble downhill, gathering into hurricane force by the time it reaches the coasts. Cape Crozier is especially fearsome because its topography, on the flank of Mount Terror, further funnels the wind. A satellite picture of Cape Crozier looks like a home plate that an umpire is sweeping clean—streaks of bare rock outlined in snowfields. The same winds that keep the rocks clear of snow also push pack ice out to sea, leaving open water that's ideal for foraging penguins. Pretty much every Adélie penguin colony in Antarctica, it turns out, sits in the path of perpetual winds.

Cape Crozier has nearly a hundred times as many penguins as Cape Royds, but none are visible yet. They're all tucked away downslope and over a low ridge called the Sugarloaf. After a half-mile hike over the ice, past a couple of outlying skua nests, a faraway hubbub emerges, like the sound of whitewater.

Penguins. The slope rolls over to reveal a broad valley, and the uppermost groups are just a dozen yards away. The birds group themselves a few hundred to thousand at a time, in roughly oval subcolonies. Their guano is sandtrap beige and in the distance, against the brown rock, it gives the hillside the dappled look of an enormous giraffe hide. A kilometer away a snowfield covers the facing slope, and penguins are nesting right up to it. To the north, penguins crowd the water's edge like kelp flies. The beach ends in an immense cornice that curves over the water in a white wave 150 feet high—and penguins are walking up it to nests on the other side. "What you're looking at here is about one-third of the colony," Ballard says. Cape Crozier is the fifth-largest Adélie penguin colony in the world. There's another expanse of nests beyond the cornice and then, beyond another snowfield, a third stretch.

Grant is rangy and good looking, with the natural ease either of someone who knows Crozier like the back of his hand, or who grew up in the Virgin Islands and then moved to the eucalyptus groves of northern California. (Both apply.) Viola Toniolo is a native of Milan but she speaks English with almost no accent. Her parents send care packages of Italian cheese, wine, and figs to her. On Christmas they talked by satellite phone, and the hut filled with vigorous Italian syllables. She is a graduate student and Ainley is one of her advisers. Kirsten Lindquist is a young field biologist who has worked at Point Reyes Bird Observatory with Grant in Stinson Beach, California. She is tall, with a face as Nordic as her name, pale green eyes, and high cheekbones.

The work at Crozier is like at Royds but more spread out. On his surveys, Ainley tries to look at every left flipper for a band. Here, where it takes a few days just to visit all the parts of the colony, Grant says, "You have to make it into a zen thing. It's like walking meditation."

If Royds was bustling, Crozier is manic. Narrow penguin pathways crisscross the slopes, trod down by flat feet and kept scrupulously clean of pebbles. Dozens of skuas are in the air at any given time. Everything seems to be happening at once; pairs reuniting and trading places on the nest, lone males still braying and flapping their wings even though no one's paying attention, chicks hatching and adding their wistful peeps to the ruckus. Down the center of the first colony penguins walk or toboggan three lanes wide across a ribbon of snow called the Penguin Superhighway. At the water's edge they jam together, since no penguin wants to be the first to test whether there's a leopard seal below. The Adélies have a special cry heard only at the water's edge, a petulant bark that means "Get on with it," and the hesitant birds at the front are constantly pushed by the masses in back. "They just stand there until somebody has the courage to go," Viola says, "and then they all go until somebody chickens out."

Immediately upon diving in, the penguins become sea creatures. No longer adorably toddling on short legs, they spread their wings and take off. Their beeline out to sea helps put them beyond the reach of leopard seals, which pick off any stragglers along the length of the landing beach. They swim in small groups,

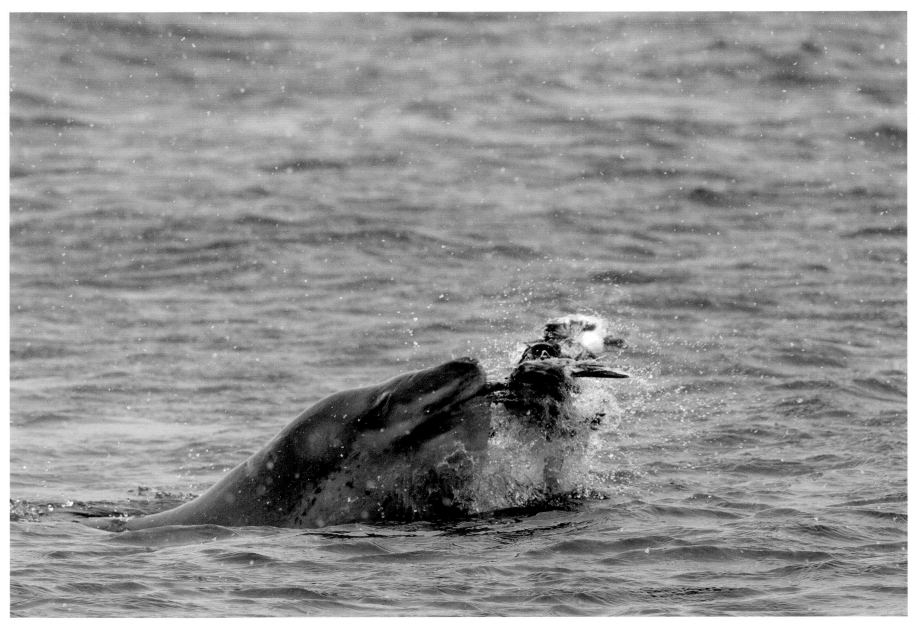

LEOPARD SEALS CHEW AT penguins to strip away the feathers and often eat only the breast muscles.

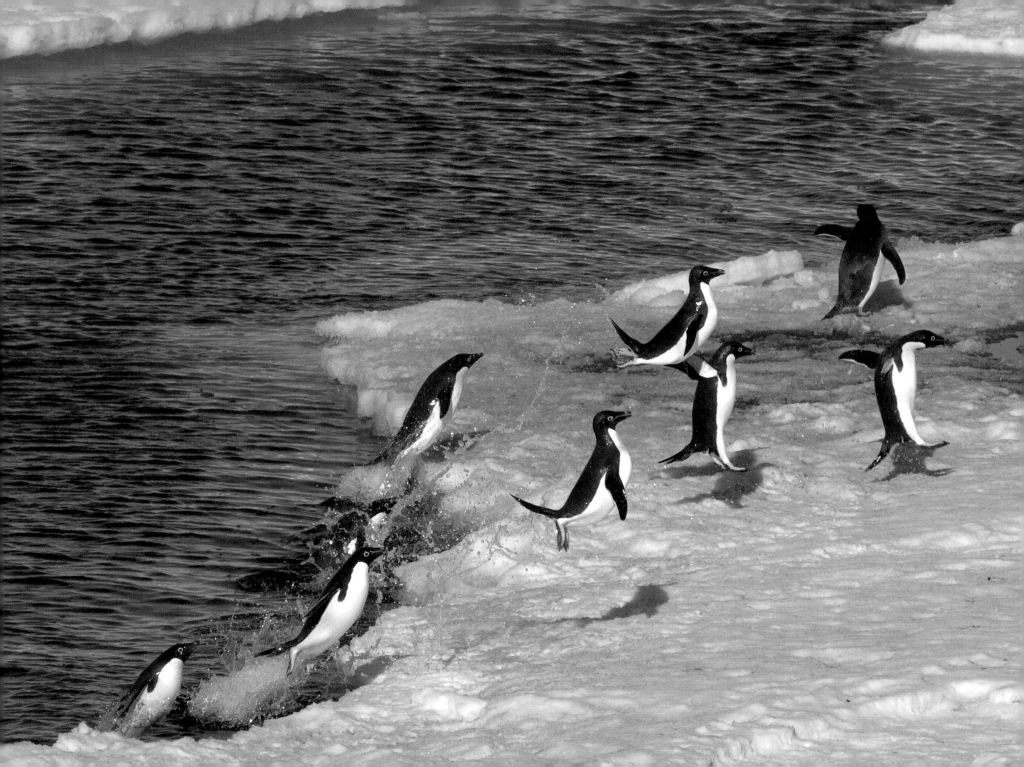

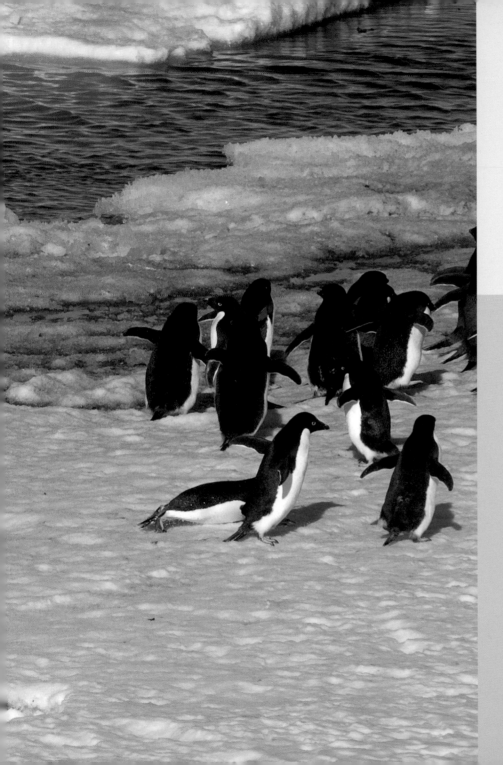

THE ICE EDGE IS THE MOST DANGEROUS PLACE FOR ADÉLIES,
and they come rocketing out of the water to heights of up to ten feet.

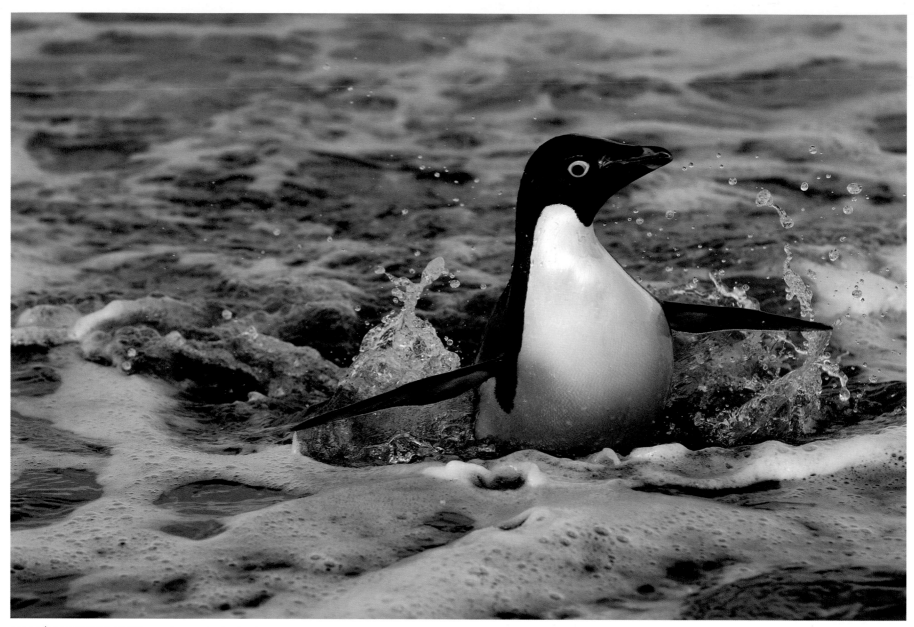

AN ADÉLIE PENGUIN SURFS in to shore at a landing beach on Cape Crozier.

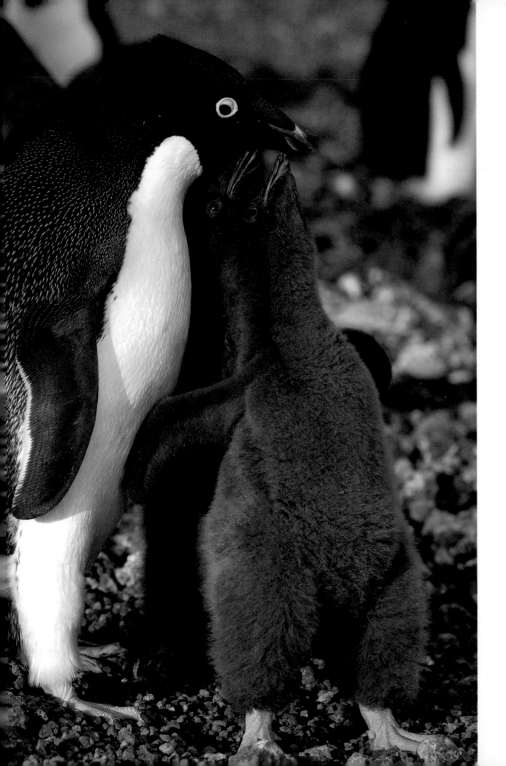

often porpoising, lofting themselves out of the water for a breath. When they stop their round bodies bob vigorously, but their heavy bones put them low in the water. At Royds the ice edge is sufficiently safe for stopping; there aren't enough penguins to attract leopard seals. They don't stop often at Crozier, though.

Here, seal kills are an almost daily sight down by the main landing beach. These big gray-green seals have graceful long necks and big heads that carry a self-satisfied expression. Most of the time they eat krill, straining it through their back teeth. They augment that with penguins, sometimes following the birds under thin sea ice and lunging through to grab them. Around 20 percent of leopard seals that have been examined turned out to have eaten penguins recently—one individual cut open in 1914 had eighteen in its stomach.

During breeding season the seals come to these narrow access points. The waters are churning with penguins that have no choice but to swim. Leopard seals have a hard time chasing down a penguin in open water, but at the ice edge, amid floating ice blocks and the congestion of penguins, they can catch several per hour. Ainley reports that up to nine leopard seals patrol Cape Crozier at any one time during the breeding season.

There's hardly a sorrier sight than a penguin being eaten by a leopard seal. The tiny penguin hangs in a limp curve from the animal's jaws, heavy feet dangling. The seal tosses the penguin's body through the air and lazes over in a sort of sidestroke to retrieve it. "They skin them and just eat the breast muscles," Ainley had said. "The rest sinks to the bottom where the crustaceans and starfish and sea urchins have a feast." Or the skuas—a dozen will fight aerial battles

51

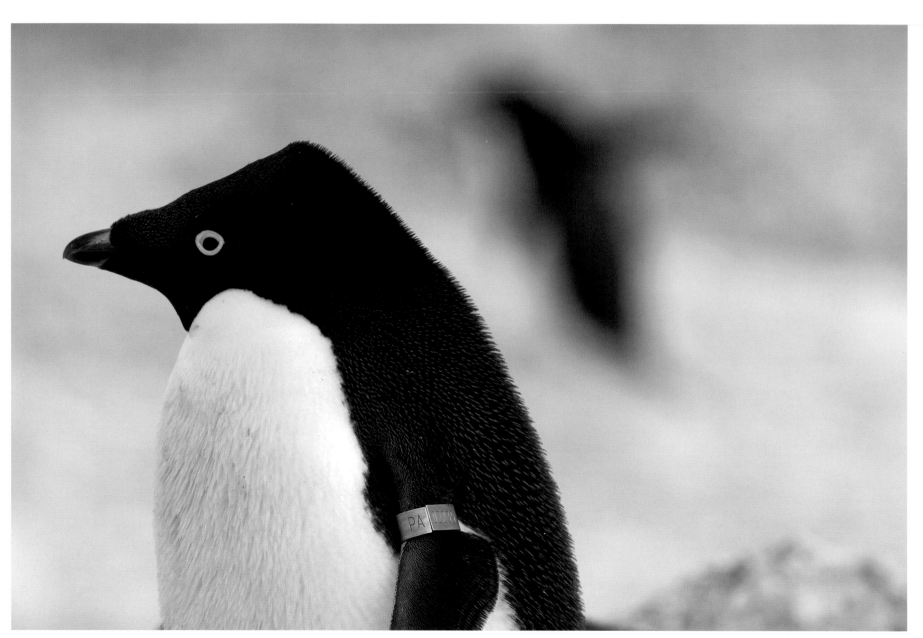

PENGUIN PA 02235 IS an eight-year-old male and "kind of a klutz."

over the scraps. Penguins quickly take to the water again, though, beelining past the carnage for the open sea.

The first place Grant and Kirsten visit is the weighbridge colony. It's a corral of 170 nests with the same design as at Cape Royds. Some of the birds in here are banded; others carry ID chips; some have both and others carry neither. The assortment helps the scientists test whether their monitoring devices have any effect on the penguins that carry them—they've learned that flipper bands do handicap a penguin somewhat over an unbanded penguin (foraging trips can be up to 8 percent longer, though banded penguins may bring back more food from such trips). Grant consults a hand-drawn map, then points out a bird he wants Kirsten to catch. She moves over in a half crouch, keeping her eyes fixed on her target amid his identical neighbors.

A standing rule at penguin colonies is that nobody walks between nests except scientists, and only then when absolutely necessary. As Kirsten approaches the subcolony, it becomes clear this is to protect scientists as well as penguins. The birds stiffen, flatten their crests, and glare with their white eye-rings stretched wide. As she steps among the nests, first a bird nips at her legs, then two rush at her shins, bashing with their rigid flippers. "Watch out for number 150," Grant calls, with a chuckle, "He hates us." That bird has learned not to waste his time with clothes, and waits until he sees an exposed wrist. Later, Kirsten's hands are bloody and her legs are black and blue.

She captures her target penguin using a one-handed grab at the feet, simultaneously wrapping the bird under her arm in the "rugby hold." She places a marker at the nest and carefully puts the penguin's two chicks into a fleece hat to keep them warm. She returns holding the adult, like a running back with a football, the bird's pink feet facing forward and its head peeking out from behind her arm. Grant uses a modified hypodermic needle to put the ID chip into an inch-thick layer of blubber on the bird's nape.

The penguin doesn't even flinch, and ten minutes later, after a suite of measurements, the bird is back on the nest. Four of the birds in the weighbridge colony are sixteen years old, among the oldest birds in the entire study. This new bird is now one more whose meals and foraging routine the weighbridge will automatically measure. This is the way, year by year, that Ainley and his colleagues learn how penguins make their breeding seasons work. They can measure what it takes to sustain a chick that adds a hundred grams of body weight a day for a month and a half straight. In records of foraging-trip duration they can see the signs of good food years and bad food years and gauge the degree to which Crozier's five hundred thousand adult penguins deplete the nearby waters of food as the season progresses. (A couple hundred thousand chicks, each needing around thirty kilograms of food to make it to fledging, adds up to a hefty seafood tab; other researchers have calculated that the world's population of Adélies eats 1.5 million tons of krill and 118,000 tons of fish and squid each breeding season.)

The weighbridge records what penguins come ashore with. Viola is working on discovering where they go to get it. The advent of splash tags in 2005 has given researchers a new window into penguin life at sea. The devices combine a satellite transmitter with three sensors, all embedded in a translucent green hunk of epoxy with a stiff gray antenna at one end. Viola attaches these to penguins with a clever latticework of adhesive tape and retrieves them after the bird returns from its next foraging trip. The $3,500 devices are reusable, and have quickly become a major part of fieldwork.

Viola has ten of them that she shuffles between penguins throughout the chick-feeding period. To keep from burdening penguins excessively, she makes sure each penguin wears a splash tag for only one foraging trip per season. She recaptures the penguin, undoes the adhesive tape and downloads the data, then swaps the tag to another penguin chosen from a randomly selected subcolony.

53

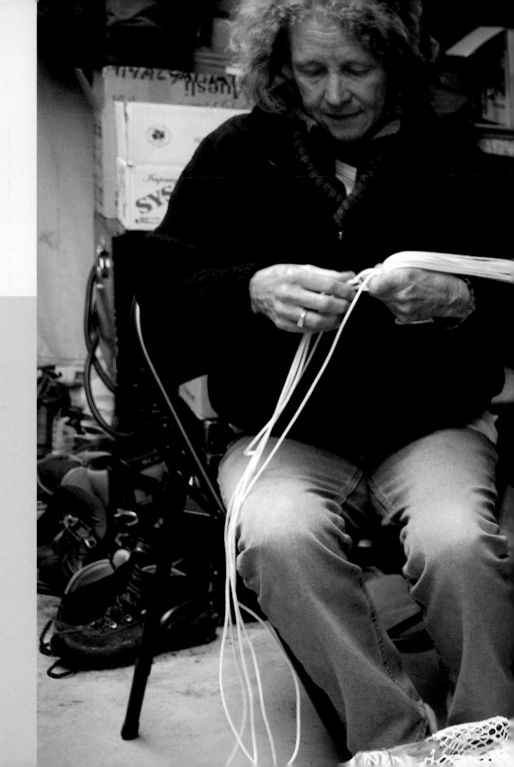

DAVID AINLEY AND JEAN PENNYCOOK MEND A PENGUIN NET AT CAPE ROYDS.

54

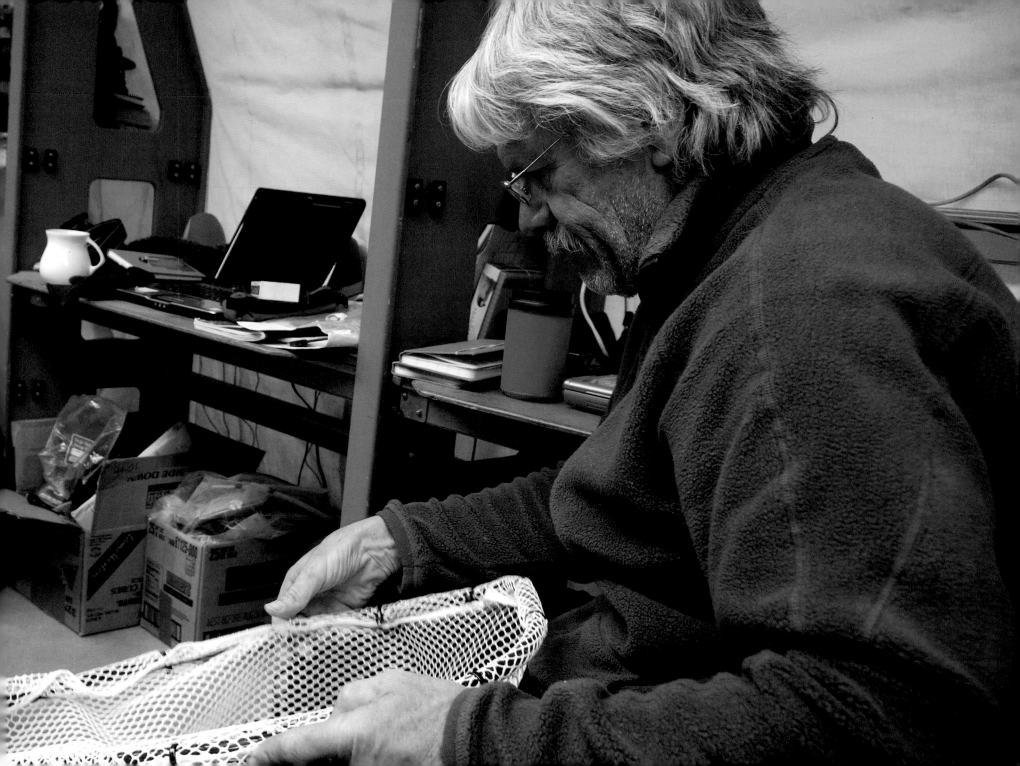

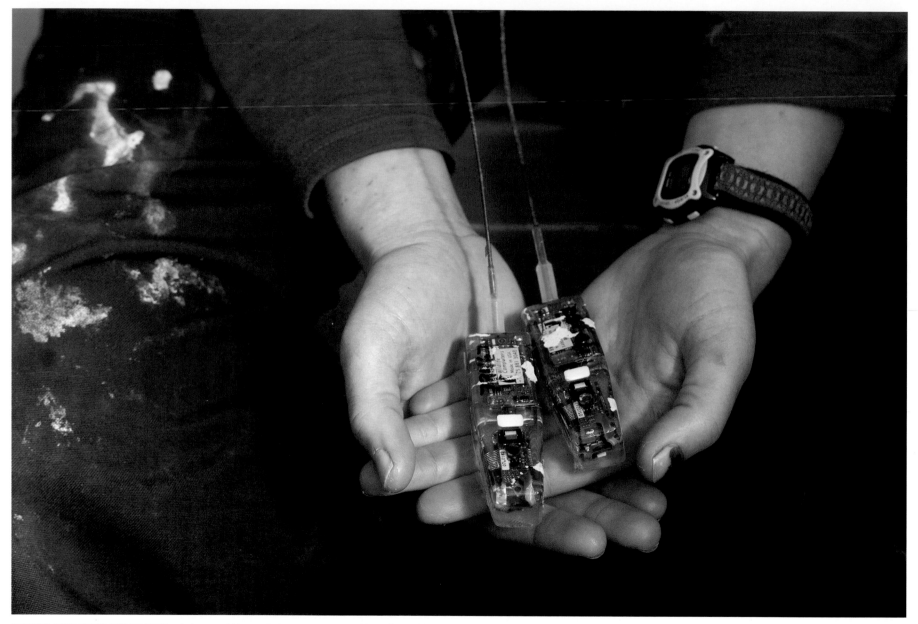

KIRSTEN LINDQUIST HOLDS TWO splash tags, which record where penguins go and how often and how deeply they dive.

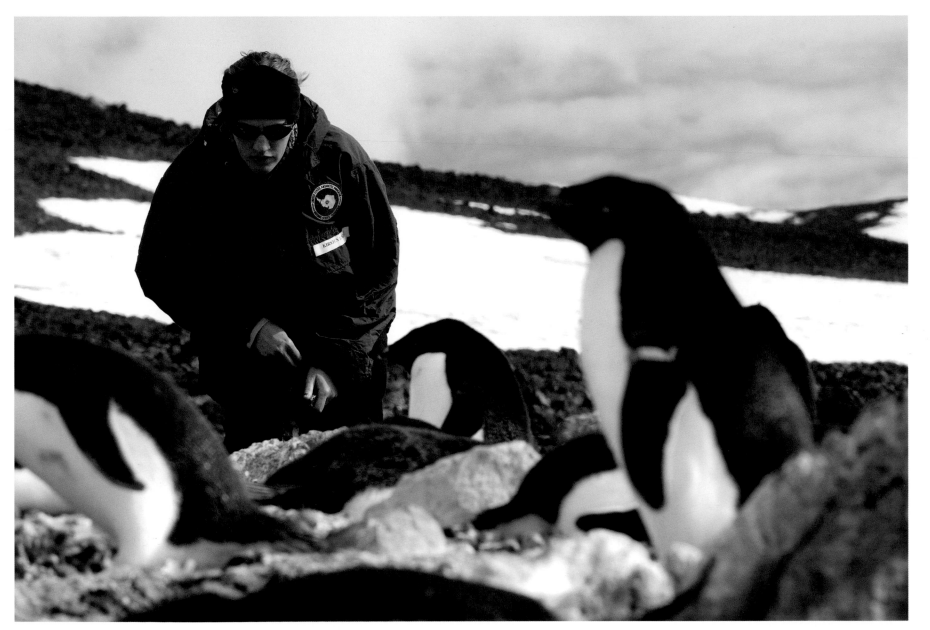

KIRSTEN LINDQUIST STALKS A penguin at the weighbridge colony at Cape Crozier.

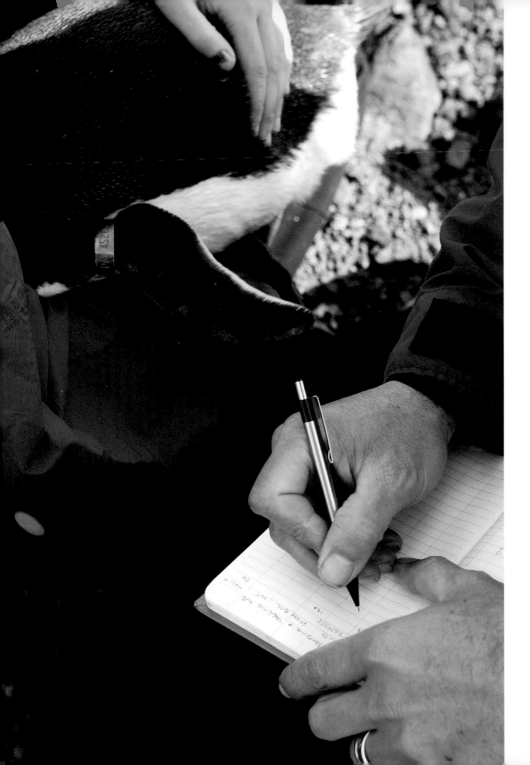

KIRSTEN LINDQUIST SECURES A penguin in the "rugby hold" while Grant Ballard takes its measurements before applying a weighbridge tag.

NEWBORN ADÉLIE PENGUIN CHICKS weigh about a hundred grams (opposite).

To choose her next penguin, she stands at the subcolony edge and scans until she sees two penguins craning their necks and braying. This is a greeting ritual, and it means that one has just returned from foraging. It will soon take over guarding the chicks, and its partner will waste no time heading out to sea. Viola double-checks that the partner appears in good physical condition—no point in burdening a weak penguin—and prepares her equipment. She hammers a tent stake into the ground and writes "H8" onto a yellow plastic tag to ensure she can relocate the nest in a few days.

The pair nudges each other a bit, bowing heads and shuffling from one foot to another until they are content that each is equally committed. Then the bird on the nest steps aside and the other steps over the two gray chicks. With a bit of shuffling the parent arranges its potbelly over the backs of the chicks and then lays a ruffle of warm white skin over their heads like the blanket on a Russian sleigh. Before the other bird can step away from the nest and become lost in the penguin crowd, Viola chucks the bird into a practiced rugby hold. Kirsten is here, and she applies a stencil that ensures she tapes the tag into position at the proper place, just behind the penguin's wide point, to reduce drag. The bird's flippers are pressed securely against its side, and its startled eyes look out behind Viola. By pulling her arm in, Viola can cover the bird's eyes with her windbreaker sleeve, and the darkness calms it down.

Penguin H8 turns out to be a small male, as determined by a combination of weight and bill length. (Males tend to be larger with proportionally longer

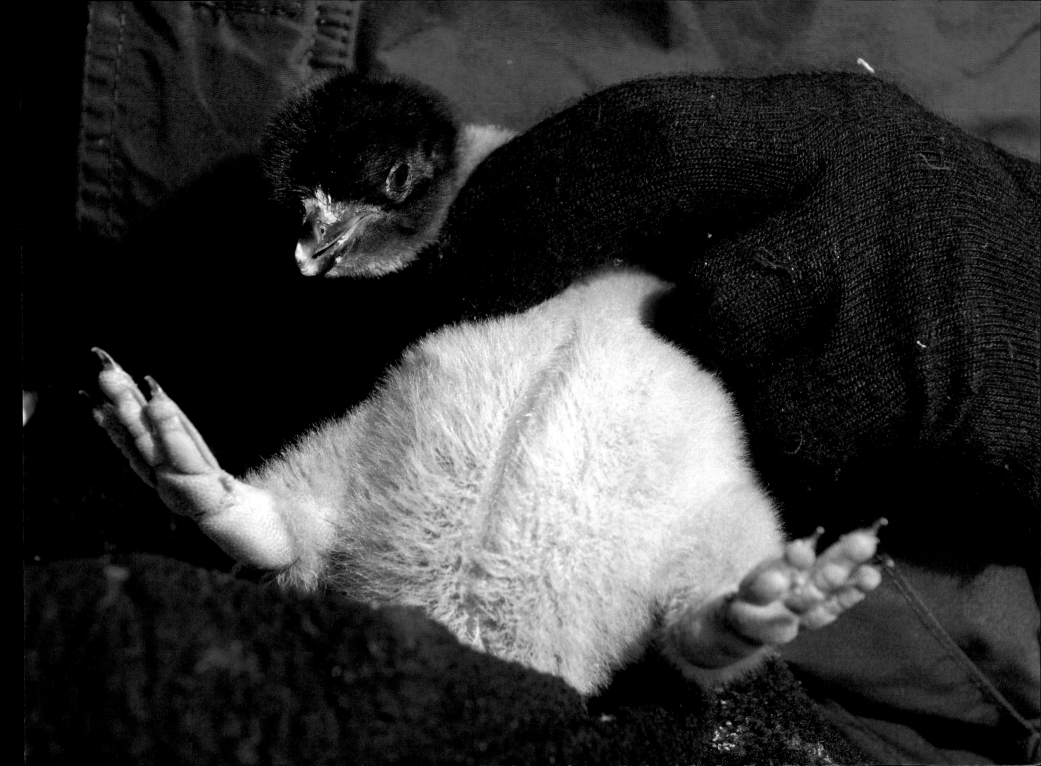

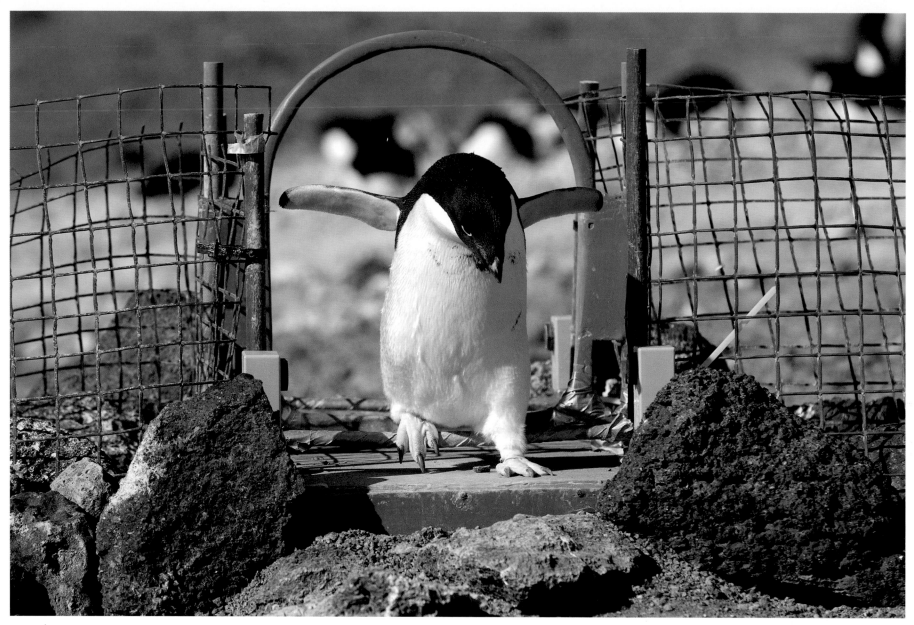

AN ADÉLIE CROSSES THE weighbridge at Cape Royds, recording its weight, identity, the time of day, and the direction it crossed (in or out).

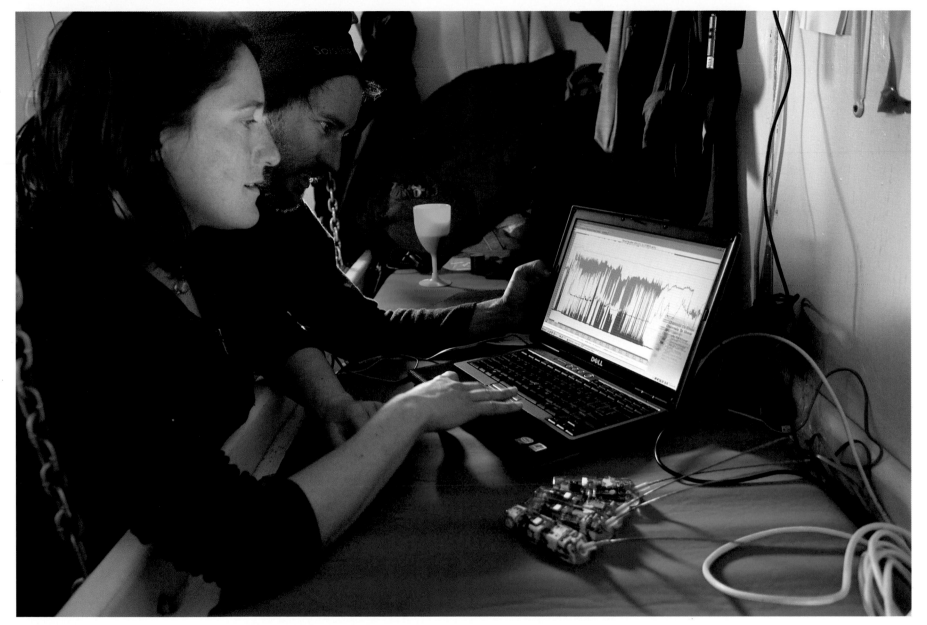

VIOLA TONIOLO AND GRANT Ballard download splash-tag data in the hut at Cape Crozier.

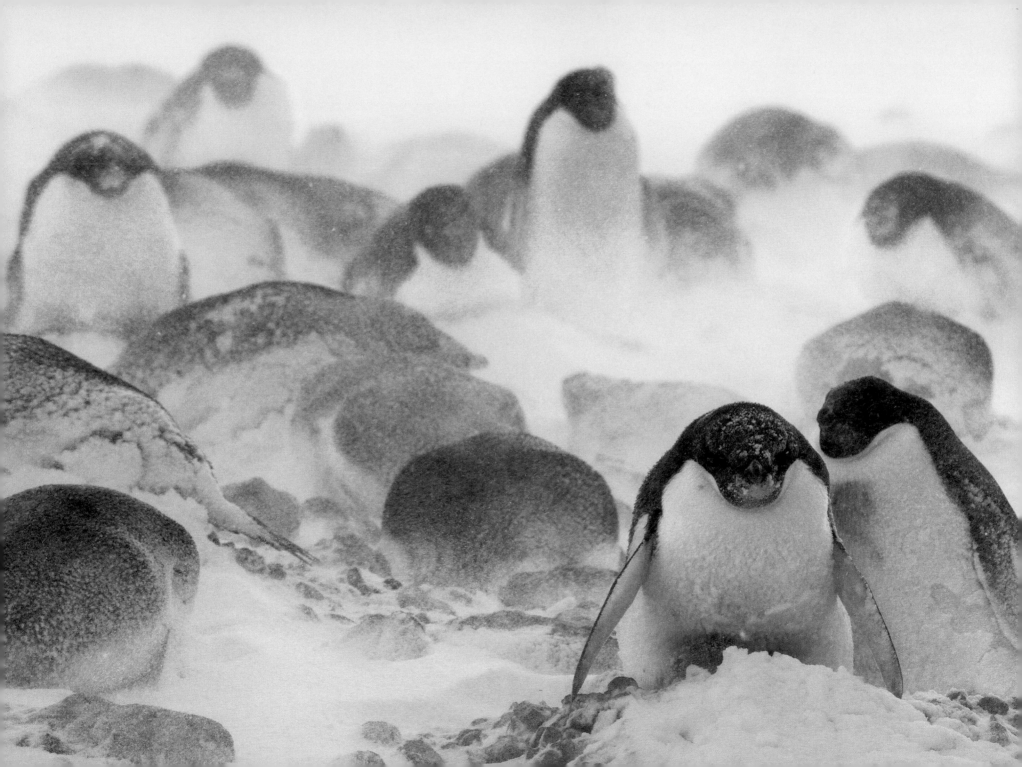

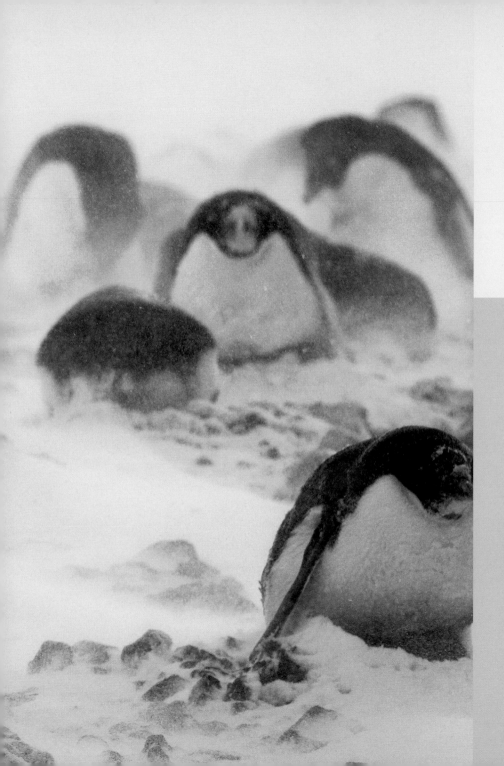

PENGUINS SHELTER THEIR NESTS DURING A SNOWSTORM AT CAPE CROZIER.

63

bills than females—a pattern Grant and Viola use to guess which member of a pair is which, though verification still requires watching who does what.) A few days later Viola downloads H8's data to her laptop back in the hut and looks at what the penguin has been up to.

H8 had had a pretty typical foraging trip. He'd been gone for 1.3 days and traveled about ninety-five miles, heading first northwest to the pack ice edge, then twenty-five miles east to open water, where he found krill. He made a total of 522 dives, going down 130 feet on average, and once down to three hundred feet. Penguins typically make two kinds of dives: "V-dives" when they're searching for prey and "U-dives" once they find prey and swim horizontally at depth catching it. H8 held his breath for between two and three minutes per dive, and logged a total of eleven hours of bottom time.

Fascinating individually, together these data clarify what life must be like at each colony. Large colonies have more room for nests and more open water for foraging. There's some safety in numbers for a single penguin among half a million (counting breeders and nonbreeders), but then again, Royds is too small for a leopard seal to set up shop there; at Crozier up to nine leopard seals patrol the landing beaches, and the skies are full of skuas. And the fishing pressure of so many penguins means that toward the end of the season at Crozier, foraging trips are longer (up to twice as long) and they return with less food than at Royds.

This has been a long-held idea in seabird biology—that breeding birds eat through the food supply in a halo surrounding their colonies, and that food availability is a major limiting force on the size of colonies. The open waters around Ross Island are up to one hundred times more productive than open ocean, which is one reason why so many penguins breed here. Even so, Viola's splash-tag data show that the multitudes of penguins at Cape Crozier clearly deplete the nearby waters. Results from Adélie penguin research form some of the strongest empirical evidence for this halo effect.

From time to time Grant and Viola talk about "the iceberg years," when pack ice occupied virtually their whole horizon, and the view from their hut ended in the sheer white side of B-15. "It came up here and chocked with one end against Cape Wood and the other all the way up at Franklin Island," some seventy miles away, Viola recalls. Before the iceberg grounded, she and Grant would sit in the Crozier hut downloading satellite imagery, following its progress and wondering when they would see it on the horizon.

For the researchers, the change that iceberg B-15 brought to Cape Crozier and Cape Royds stands in for the creep of climate change over previous millennia. They've used it as a test case to witness how Adélie colonies wax and wane as conditions change around them—at what point penguins abandon hope of breeding in a season, for instance, or how much extra time they spend foraging, and how much more the parents have to eat to make up for the extra distance they walk across the fast ice.

But of course the pressing climate question that lies ahead is opposite to the icebound situation that B-15 brought to Ross Island. The first suggestion that humans might be able to change the chemistry of the atmosphere came fast on the heels of the Industrial Revolution. Geochemists pondered the general formula for coal combustion and noticed that this new, cheap source of energy meant that extra carbon dioxide was entering the atmosphere. Rising carbon dioxide levels began to be recorded on Mauna Loa, Hawaii, by Charles Keeling in 1958. Papers gathering together evidence of a long-term warming trend began to be published as long ago as the 1980s. News channels may still ring with debate over global climate change, and politicians may waver about emissions standards, but for scientists the evidence has long been in—long enough for many to have stopped thinking about avoiding climate change and started thinking about how to cope with it.

It's in this respect that Adélies set a useful example. Here is a hardworking, immensely capable animal living within strict physical limits. At the height of the last glaciation, about twenty thousand years ago, an ice sheet two thousand feet thick sat over Cape Royds and most of the Ross Sea. The nearest Adélie nest was three hundred miles to the north. They returned to Cape Royds nearly 1,200 years ago and to Crozier about six hundred years ago, according to radio-carbon dating.

Ross Island is so far south that, to date, warming trends seem to be making conditions better for penguins, at least judged by recent increases in colony sizes. But on the other side of the continent, where the Antarctic Peninsula stretches to just north of the Antarctic Circle, Adélies are disappearing. Temperatures there are rising faster than anywhere else on Earth, as much as 5 degrees Centigrade over the last six decades. Ice shelves are disintegrating as the region warms, as in the well-publicized case of the Larsen Ice Shelf. In 2002, over the course of a month, a 1,200-square-mile region of the ice shelf crumpled and dropped into the sea.

Retreating ice shelves could be good for Adélies, since one of their strictest limitations is the lack of bare rocky slopes for colonies. But the catch is that they must also have nearby sea ice to hunt from, and that has been vanishing too. The waters west of the Antarctic Peninsula (the Bellingshausen Sea) lost a third of their sea ice between 1978 and 1996.

Nor will warming continue to paint a rosy picture in the Ross Sea, neces-sarily. It may open up coastlines there, but it will do three other things as well, all of which are problematic. First, it will change the distribution of sea ice. If winter sea ice stops forming north of the Antarctic Circle, Adélies will not have daylight to forage by in winter, even if they find ice to stand on. Second, warmer air encourages evaporation from the sea surface, which in a cold environment returns to the ground as more snowfall. Summer blizzards already occasionally bury Adélie nests, drowning eggs or forcing adults to abandon young. And the third complication is the wind, an invisible but critical part of Adélie habitat that keeps snow from piling up on nest sites and ice from clogging the coastal waters. But wind patterns are determined by temperature and pressure. They are products of climate.

We can marvel at the Adélie's adaptability—after all, humans are marvel-ously adaptable creatures too. But Ainley's and his colleagues' research doesn't end at a glad appreciation of these plucky creatures. The real lesson for humans is in understanding their relationship, at once complex and dead simple, with climate. Though the colonies Shackleton, Scott, Amundsen, and other early ex-plorers described have changed little in a hundred years, the remains of colonies scattered up and down Antarctica tell a different story. Adélie colonies seem to have been constantly on the move over the last glacial cycle, as the Ross Ice Shelf swept up and back down the coast of the Ross Sea. The giant colony at Cape Adare, at the northern end of the Ross Sea, sits well north of the farthest ad-vance of the ice sheet, and it seems to have been around for thirty-five thousand years straight. The Ross Island colonies are only about one-hundredth as old.

And yet, another colony near Terra Nova Bay, halfway between Ross Island and Cape Adare, was much larger three thousand to four thousand years ago than it is today. Similar exceptions appear in records of the Antarctic Peninsula's ancient colonies, with a hodgepodge of colony establishment instead of the smooth progression one might expect if penguins simply acted like a thermom-eter, ticking up and down the coastline in response to climate.

The understanding that has come from studying Adélie penguins on Ross Island points to the disparate ways climate shifts can manifest themselves. This is the complicated aspect of their dance with climate. For a species that requires low beaches, clear hillsides, open water, and floating sea ice, any number of climate-related upsets, from ocean currents to wind patterns to precipitation

ADÉLIE PENGUINS CLIMB AN ENORMOUS CORNICE
at Cape Crozier on their way to nests on the other side.

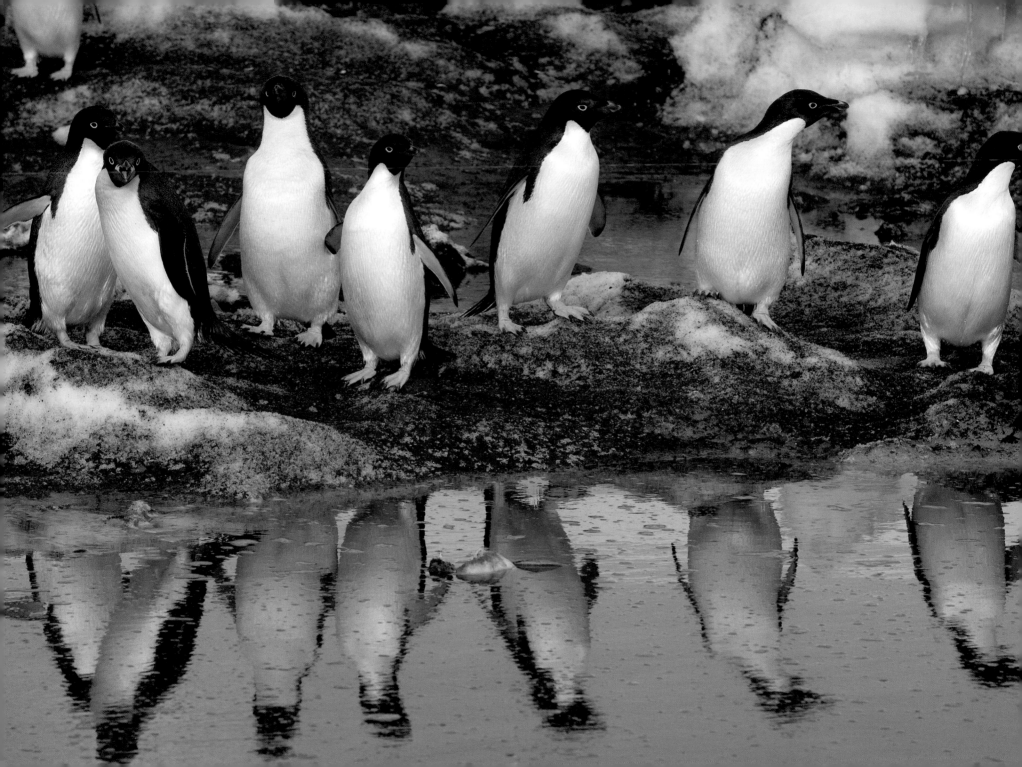

amounts, can render a longtime colony unusable. The simple part is what Adélies can do about it: move or die. "Several times in the last forty thousand years there hasn't even been a Ross Sea at all," Grant says. "It's been covered in ice, and the penguins have had to deal with that. That's what life does. It adapts, and if it doesn't adapt then it's gone."

In the same way, climate change isn't likely to cause a single calamity for humans, like a heat wave that creeps northward from the equator, toasting any city in its path. Changes are likely to happen in one or more aspects of the climate people are used to. Not so frightening in the abstract, this is likely to be a nuisance to the individual and a logistical nightmare when millions or billions of people are involved. Because for all the kinship we feel with penguins, humans depend on a whole lot more infrastructure than they do. If and when Crozier's hundred thousand pairs of penguins decide to move, they just walk away from their pile of stones. It's harder to move Manhattan.

Late in the Polar Discovery visit to Crozier, Grant was walking back from the east colony. It was about 11 p.m., and long shadows lit up intricate ridges in the snowfield, where wind had whipped ice crystals into a meringue. Viola was headed back to the hut to make Christmas dinner—fresh focaccia with risotto. Beyond the raised bills of the screeching penguins, the edge of the Ross Ice Shelf stretched into great plains of possibility, one continuous block of ice for three hundred miles east to where iceberg B-15 had calved, and another seven hundred miles south to the next visible land. Snow billowed off the ice cliffs, driven by the wind of an oncoming storm and turning the air milky against the dark sea.

This had been the scene before Scott's three men on their 1911 trek to Cape Crozier. Earlier that day, in the hut, Kirsten had read aloud Cherry-Garrard's description of the windstorm that drove the men off the cape and nearly killed them. It went, "Then there came a sob of wind, and all was still again. Ten minutes and it was blowing as though the world was having a fit of hysterics. The earth was torn in pieces: the indescribable fury and roar of it all cannot be imagined."

Twelve summers of living at Crozier seems only to have increased Grant's admiration of these early explorers. "These men had faith in science," he says. "Their whole expedition was this enormous investment. They were willing to risk everything just to get some emperor penguin eggs, to test an idea that didn't even turn out to be right. And here we are at Crozier, living this slightly dangerous, but basically comfortable existence. How committed are we to science, to understanding our world?"

His implication is that climate change will require of people today a faith in science like that of the early explorers, and a dedication to what must be done like he sees in Adélie penguins. For all the Adélie's fuzziness, its fancy clothes, and its toddlerish enthusiasm, its lasting lesson is that life at the edge of possibility requires constant attention and, in Ainley's words, defiant energy. "And that's kind of the way David sizes people up," Grant says. "By the Adélie test. If you can work as hard as an Adélie penguin, you're probably all right. But that's a tall order."

Two days after that conversation, the Polar Discovery team was back in Christchurch, New Zealand, turning in their Antarctic long johns and their Big Red parkas. They had taken some thirty-five thousand photographs and published thirty straight daily updates to the web via satellite phone. "The first thing you'll notice when you get off the plane is the smell of foliage," Viola had said. The second thing was nightfall, and the third was the enormous human population of Christchurch. Twenty-five hundred miles to the south, Adélie penguins were still leaping out of the water, bellies full of food for their chicks, and starting the climb back to their nests.

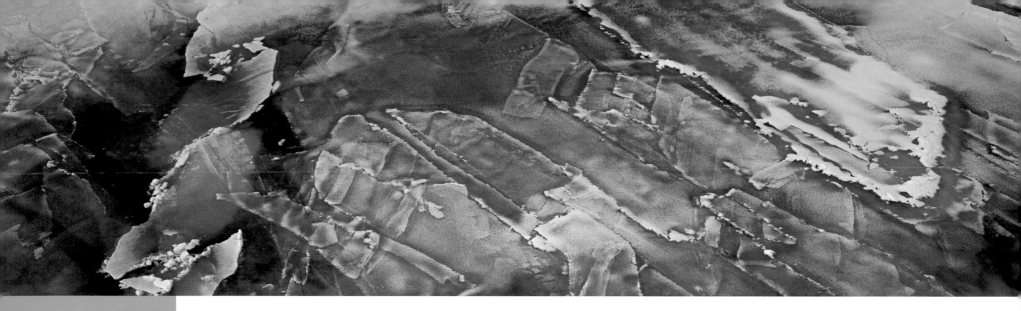

2

SEARCHING FOR SPRING IN THE BERING SEA

Helen Fields

SOMETIMES THE ICE IS SO THIN, IT LOOKS LIKE WATER—UNTIL A SEAGULL lands on it. Sometimes it's so thick that a 420-foot icebreaker with a thirty-thousand-horsepower engine has to back up and gun its engines just to break through it. In thin ice, thin slices crack and raft over each other as the ship moves through. Three-foot-thick shelves of ice break into giant blocks that tumble past the ship's sides and float away into the wake.

Every winter, sea ice spreads across the Bering Sea, not as icebergs, but as an icy layer on top of the water that forms when the temperature falls and the top layer of the ocean freezes. In a freshwater pond, water freezes at 32 degrees Fahrenheit (zero degrees Celsius). But ocean water has salt in it, and it has to be colder—about 28 degrees Fahrenheit (-2 degrees Celsius). Every fall as the days get shorter and the temperatures drop, ice starts to rise out of the ocean. It forms in the north and is blown by cold winds toward the south; as the ice moves, more open water is exposed, and freezes, and blows south, forming a conveyor belt of ice. In the Arctic, it's so cold that a lot of ice lasts through the summer to the next winter. That means the Arctic has multiyear ice—although, thanks to global warming, much less than it used to. But in the Bering Sea, summer is warm. All the Bering Sea's ice is created new every year.

And that ice melts every spring. As the Earth follows its orbit through space and the top of the planet points again toward the sun, light and warmth come back to the Bering Sea. The ice recedes, both by melting and by being blown north. For the first time in months, warm sun hits the water.

That first sunlight kicks off the event that was a focus for a spring 2009 cruise aboard the U.S. Coast Guard cutter *Healy*. When the sun hits the water, its energy spurs photosynthesis. Tiny marine organisms burst to life, reproducing and becoming food for the next level of the food chain, which is eaten by the next level—and on and on, as the Bering Sea ecosystem swings into action. The scientists on board this ship were on a quest to find that ice-edge bloom.

This six-week cruise is just one tiny part of a huge multiyear study of the entire Bering Sea ecosystem, from the single-celled organisms that float in the water to the walruses and humans that depend on the sea for food and income. The scientists on board wanted to figure out the ecosystem so they can see how it changes as the climate changes. As the Earth warms, the Bering Sea could freeze for a shorter time each winter—or even stop freezing over altogether. That would change the whole ecosystem. Krill might appear in different places

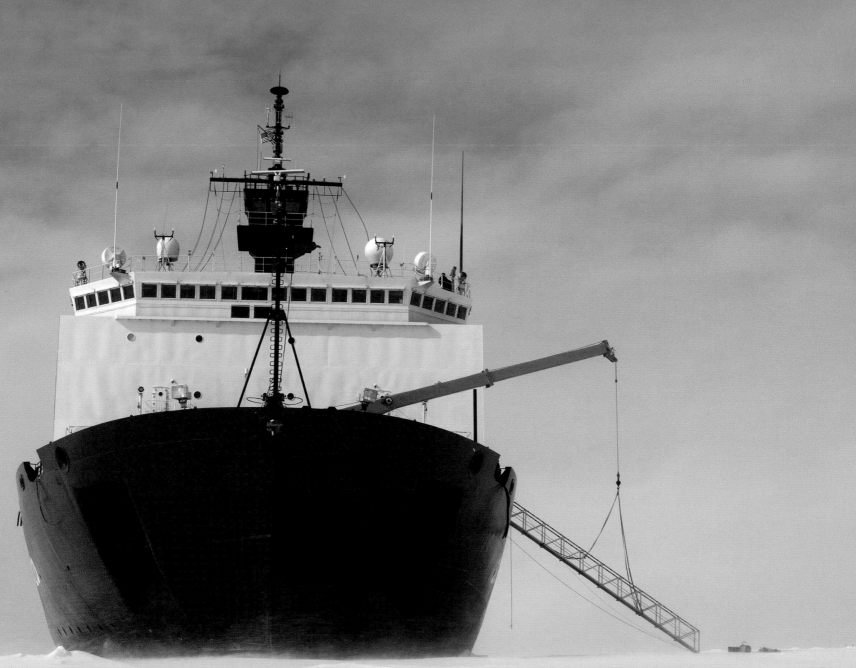

HEALY PARKS FOR AN ice station, where scientists can get off the ship and collect data on the sea ice.

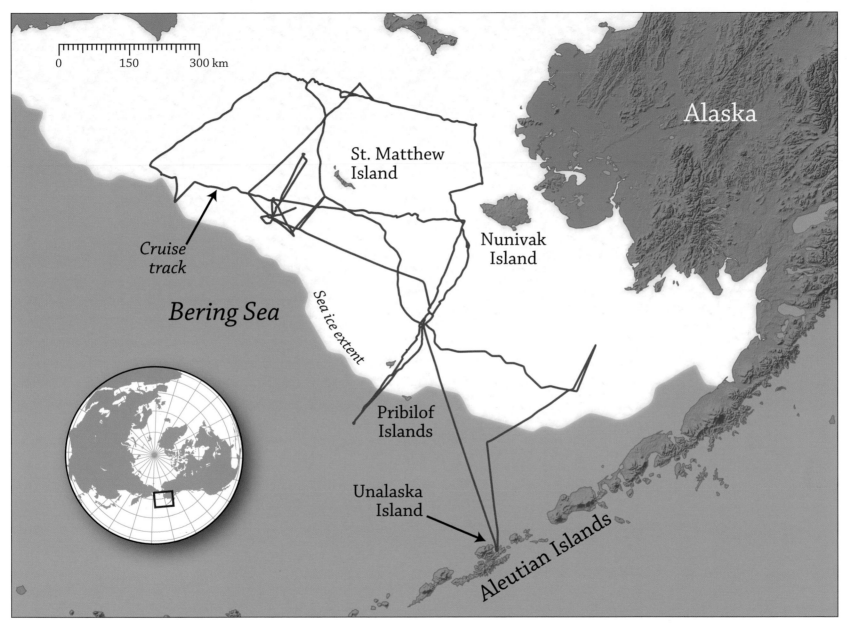

73

Alaska

Bering Sea

Cruise
track

Sea ice extent

St. Matthew
Island

Nunivak
Island

Pribilof
Islands

Unalaska
Island

Aleutian Islands

APRIL 2009 SEA ICE extent from satellite data courtesy National Snow and Ice Data Center.

or at different times. Ribbon seals and crab fishermen might have to look for seafood in different places.

As the ship crisscrossed the Bering Sea, the thirty-nine scientists on board worked around the clock, making measurements, collecting samples, and running experiments in shipboard incubators. Some looked for worms in scoops of mud from the bottom; others measured the nutrients in bottles of water; still others clutched binoculars on the ship's bridge throughout the day, counting birds and mammals. Another eighty people ran the ship, keeping its massive engines going and its crew fed for forty days away from land. The ship is like "a floating village of 130 in the Bering Sea," said Captain Fred Sommer. When all noses were counted, it was actually 122—forty-two in the science party, including the writer, photographer, and a schoolteacher, and eighty in the crew.

A small group of people stood outside the tiny Dutch Harbor airport next to a pile of luggage, waiting for a ride to the Coast Guard's dock. Twenty thousand years ago, you could have walked here from Siberia or mainland North America. Today, this town in the Aleutian Islands is a three-hour flight in a turboprop from Anchorage. Luggage is loaded from the airplane onto a forklift, then lifted up and dumped into the baggage claim area from outside. It was April 1. That morning in Seattle, fruit trees were blooming, but Dutch Harbor was still gray. Across the airport parking lot loomed steep, snow-covered peaks. An oceanographer pulled up in a pickup. Hugs were exchanged; bags were tossed in the back for the one-mile drive to the Coast Guard dock.

The U.S. Coast Guard cutter *Healy* is based in Seattle, but Dutch Harbor is like a second home during the Bering Sea cruises. Here, the *Healy* picks up cargo, scientists, and crew members temporarily assigned from other posts. Most of the scientific equipment for this, the second scientific cruise of the season, was loaded on the boat on February 24 and carried in the hold for five weeks.

At 420 feet, the *Healy* is the Coast Guard's largest ship. Construction started on the ship in 1996, and it first hit the water in 1997. The *Healy*'s primary mission is science. It goes on several science cruises each year, during which scientists ride along to drop instruments in the water and collect data; that's what this trip is.

At the Coast Guard's dock in Dutch Harbor, the *Healy* loomed, red and white, over a muddy gravel parking lot. A metal gangplank—they call it a "brow," rhymes with "cow"—rose from the puddles into an opening on the ship's red belly. Inside, paper signs duct-taped to railings pointed newbies in the right direction: "This way to the Science Conference Lounge," "This way to the Main Lab."

To the right is the rear of the ship, where most of the science goes on. The fantail—the deck out back—is filled with construction-site-yellow equipment. Two A-frames are a little like cranes; they lean out of the ship over the water, holding a heavy piece of equipment or a net, then a noisy winch lets out cable to lower the instrument down into the depths. There are regular cranes, too, used to move heavy items around on deck, or to move supplies between ship and land.

Moving toward the front of the ship, next is a big indoor area that includes the science labs, linked together by waterproof doors. Forward of that are the massive engines that generate electricity and propel the ship. Atop those areas is the flight deck and helicopter hangar, although there are no helicopters aboard for this trip. Forward of that is the living area—from the gym and laundry rooms at the bottom to the bridge and all the way up to "aloft con," a tiny room hovering at the top of two vertical ladders, ninety-three feet above the water line. And underlying it all are machine areas, with everything from the system that distills salt water into fresh for drinking, to the sewage tanks, to the bow-wash system that's supposed to make it easier for the ship to break ice but has never worked properly.

On the day the ship left, scientists were assembling their equipment, staking out and arranging their lab space, and making final preparations. On the

THE SCIENCE TEAM JOINED the *Healy* in Dutch Harbor, a port in the Aleutian Islands of southwestern Alaska. The rich waters of the Bering Sea make Dutch Harbor the top fishing port in the world by volume of catch. These buoys are used to mark the locations of crab pots, stacked high in the background.

WAVES RIPPLE THROUGH DINNER-PLATE-SIZED "pancakes" at the edge of the ice.

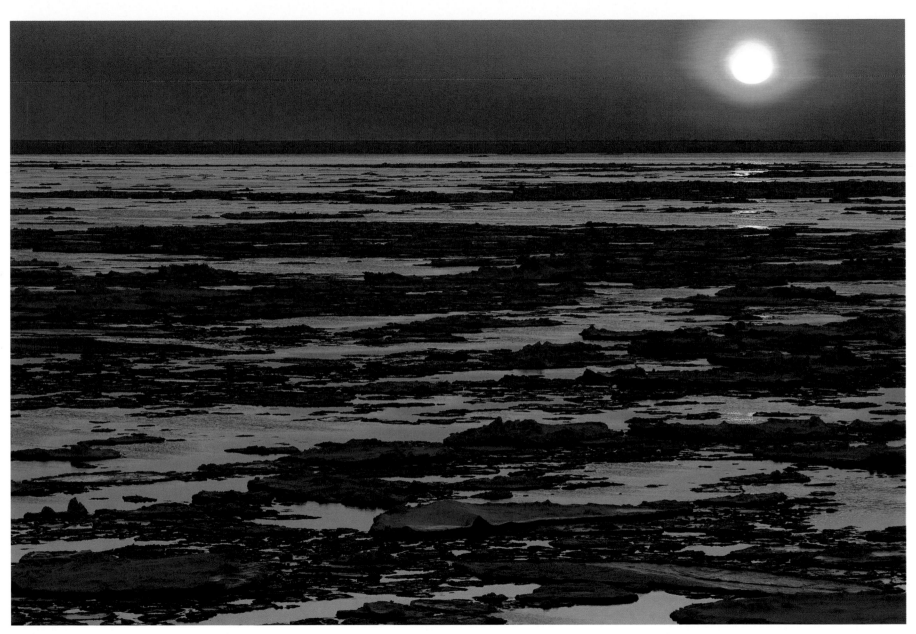

AT MIDNIGHT, THE SUN sinks low and paints the floes with pink light.

ship's broad bow, Megan Bernhardt and Gigi Engel hovered over an incubator. Bernhardt and Engel were on the krill team, a group of researchers headed up by Evelyn Lessard of the University of Washington and Rodger Harvey of the University of Maryland. Their mission: to understand the role of krill in the ecosystem. Bernhardt and Engel's mission at this particular moment: seal up the electrical parts of the incubator so they wouldn't get totally ruined by the seawater. Bernhardt joked about their "high-tech electrical boxes"—plastic leftover containers, sealed up with silicone sealant and duct tape. On one cruise, she said, they'd had a little problem with electrical shocks—as in, every time you touched something on the incubator, you'd get one—and she was really hoping to make this thing shockfree. "As long as you can make your electrical junctions as waterproof as possible, it's the way to go," she said. Bernhardt and Engel were in the process of reversing their sleeping schedule; krill are active at night, so the krill team had to be too, rolling out of bed in time for what everyone else would call dinner, eating lunch in the middle of the night, and having pancakes and sausage before bed in the morning.

At an orientation meeting, various Coast Guard officers filled scientists in on how to live on the ship. The ship had a new recycling program and was trying not to throw trash over the side anymore. Be sure to sign in when you do laundry so other people can page you when your laundry is done. Close the waterproof doors quietly, because people sleep around the clock. There was safety training. Everyone practiced what to do if there was an abandon-ship announcement—wear as much clothing as humanly possible (ok, this was only theoretical in the drill), grab blankets, and meet the other people assigned to your lifeboat on the helicopter landing pad. People who were going to sea for the first time also had to learn how to struggle into a "gumby suit"—a giant red suit that made you look, and possibly feel, like the bendy cartoon character. Arms and hands were not that useful. Zipping up your own suit was nearly

impossible. The whole thing had quite a comic effect. The chances of having to abandon ship, of course, were pretty small.

Finally, the ship left the harbor. "We are expecting some seas tonight so this'll be a rough indoctrination if you're new to this," said Doug Petrusa, the ship's engineer. As it turned out, the weather wasn't bad. The ship steamed out of the harbor, with the help of a tugboat to get around a tight turn. The crew members who'd stood on deck to cast off the lines pulled up in a small boat; a winch raised them to the ship. Boatswain's mate Jim Merten, who had been on the *Healy* for two years, was driving the boat. "My job's pretty cool," he said. "We get to drive small boats up by the Arctic Circle."

With everyone gathered on board, the ship headed out to sea and turned north. The mighty mountains rolled by. Scientists stood in clumps around the flight deck, watching. Then it was time to wave goodbye to the Aleutian Islands—the last sight of land for weeks.

The next morning, there was a banging sound. Only twelve hours after pulling out of Dutch Harbor, the ship was already in the ice; cold north winds had driven ice far to the south, where we met it. At first, the ship passed in and out of broad, white bands of broken pieces of ice. Thud thud thud rumble rumble grate grate! it growled belowdecks. Then calm again, as the ship moved back into a strip of open water.

The idea for this cruise was to follow long, invisible lines through the Bering Sea. Through the magic of modern satellite-based navigation systems, the ship could follow these transects, stopping at equally invisible points in the Bering Sea that had been sampled on past cruises and would be sampled again.

This cruise was part of a project, involving dozens of scientists over several years, to understand the entire ecosystem of the Bering Sea by studying one chunk at a time. The chunk being gnawed on by the forty-two members of the science party on this cruise covered everything from the smallest things in the

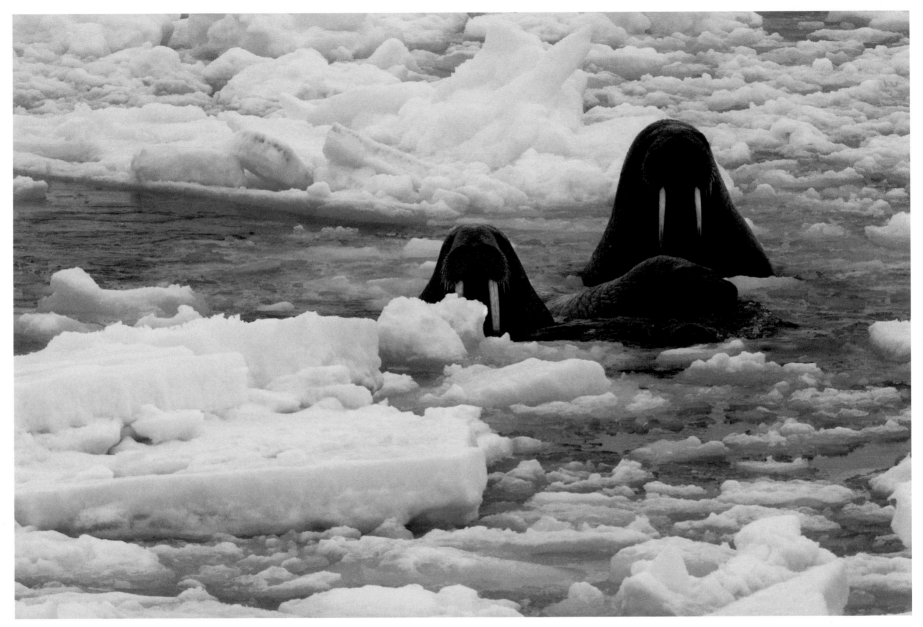

A QUARTET OF PACIFIC walruses investigates the icebreaker.

KATRIN IKEN, A SCIENTIST at the University of Alaska Fairbanks, shows how thick she thinks the ice is based on the broken chunks she can see sliding past the sides of the ship. She helps the Coast Guard decide which patch of ice is safe enough to hold a dozen or so people and their equipment.

water—single-celled protists, algae, and so on—up to krill. They're only an inch long, but on this cruise, they might as well be whales.

The ship would stop for two kinds of stations: short stations and process stations. At a short station, some basic measurements and samples would be taken. At a process station, scientists would be looking at the processes going on in the Bering Sea at that place and time. They'd run experiments on board: How much are the tiny crustaceans in the sea eating? How fast are algae multiplying? Together, all these measurements at all these places at all these times would start to add up into a portrait of the Bering Sea in the springtime, which is like Paris in the springtime, but colder and wetter and with cafeteria food.

By the fourth day of the cruise, the ship was going through ice most of the time. The sounds of ice brushing against the enormous metal hull were near constant underneath. Wildlife would occasionally drift by—a walrus here, a seal there. But then came an announcement over the shipboard intercom—a "pipe" in nautical parlance: "Walruses on the starboard side." To pipe something as ordinary as walruses was odd. The scientists in the aft science areas rushed outside to an amazing sight. Off the right side of the ship were walruses as far as the eye could see. It had been snowing, and a fog hung over the ice, so the eye couldn't really see that far. But the walruses went on and on and on as the ship passed through the ice. They lounged in groups on the ice a few hundred feet away. Every now and then, one would pop up through a hole in the ice close to the ship, eyeballing this enormous red-and-white metal interloper. In the middle distance, groups of walruses bobbed in the water like overweight, nearsighted vacationers in hot tubs.

Six people gathered around a big blue Coleman cooler, half-filled with seawater. It was the middle of the night and they were in the aft hangar, a room just off the ship's fantail. They crouched, staring at the water. "Yeah, there's krill in there," said oceanographer Evelyn Lessard from the University of Washington. "There's tons of 'em."

Lessard was one of the coleaders of the krill team, a group of six scientists, techs, and grad students who were working together to understand the role of krill in the ecosystem. Krill are crustaceans, kind of like tiny shrimp. There are eighty-six species of krill in the world; on this cruise, only five or six species would appear. Krill are food for fish and for fin whales and humpbacks. At this process station, the scientists were collecting krill to find out what they eat and how they fit into the ecosystem.

This midnight work was the reason why Megan Bernhardt, Gigi Engel, and the rest of the team had to adjust their schedule to sleep days and work nights. Krill vertically migrate; during the day, they hang out near the bottom of the sea, but at night they come up where nets can easily catch them. "They're aiming to get where the food is more likely to be, but not so high that they're visible to predators," said technician Tracy Shaw of Oregon State University. On nights with a full moon, they don't come up as high. Shaw got these krill on board with nets called bongo nets—they're called that because there's a pair of them, like drums. The nets went out of the boat on the A-frame at the very back of the ship, sank down, and came straight back up through the water, catching krill and whatever else was there and funneling them down into hard plastic tubes at the bottom of the net. These tubes were emptied into the cooler.

Then the krill had to be fished out of the cooler . . . with Chinese soup spoons. The deep-bowled spoons are the perfect tool for sneaking under a single clear krill and scooping it out of the seawater. Bernhardt and Engel knelt on the rough gray floor, soup spoons in hand. "One," said Engel. She held the spoon over the cooler, tilting it from side to side to dribble out extra water, then gently deposited the krill into a plastic leftover container. She turned back to the cooler. "Two."

RESEARCHERS GET TO THE ice by walking down this very steep ramp. It's not resting on the ice; it's hanging from a crane. So not only is it steep, it bounces at the bottom end. In the background are orange flags that mark the edge of the safe area of ice.

HELOISE CHENELOT, A TECHNICIAN from the University of Alaska
Fairbanks, takes ice cores with a corer that runs off an electric drill.

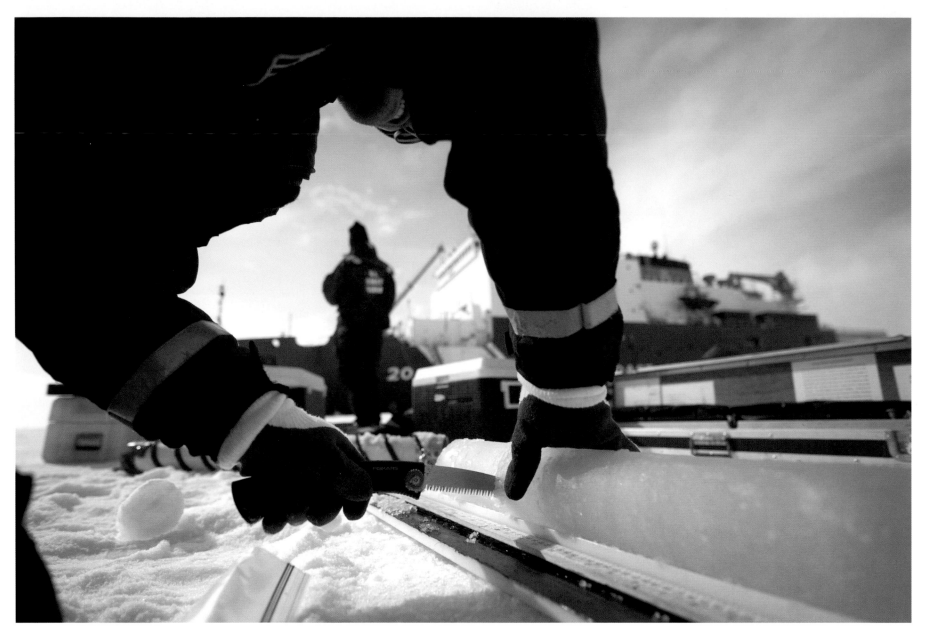

A MEMBER OF THE hydrography team slices an ice core into ten-centimeter lengths. His team studies the water and ice itself; most others on board are studying the things that live in the Bering Sea.

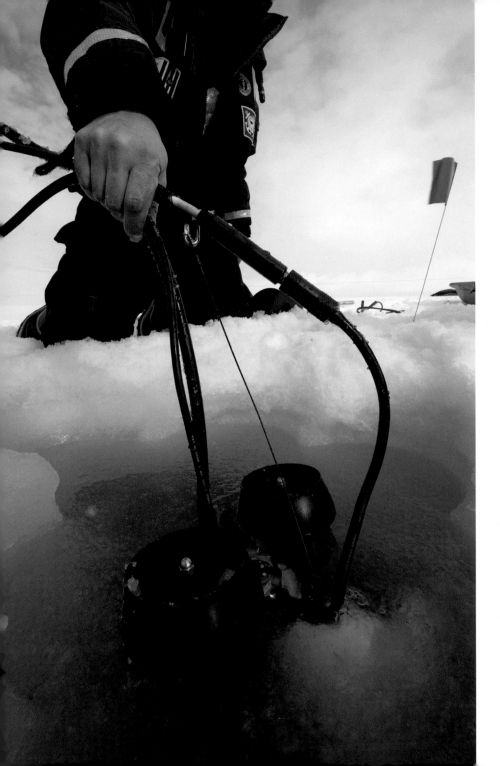

DAVID SHULL FROM WESTERN Washington University sends a remotely operated vehicle (ROV), like a tiny submarine, through a hole to peek at algae underneath the ice.

The next stop for the krill was one of three cold rooms in the science areas at the back of the ship. The cold room wasn't particularly cold that night—around 41 degrees Fahrenheit. It was noisy, with loud fans running, and dim lighting. The first step in the cold room was to fill nine two-and-a-half-liter plastic bottles with sea water; four people stood around, watching the bottles fill.

"We didn't say it would be exciting," said Shaw drily.

"It's not," said Bernhardt.

When the jars were full of water, a few krill were added to each bottle and the women got ready to go outside. They loaded the bottles into backpacks and, out in the lab, Shaw and Bernhardt pulled on rubber gloves with plastic extensions that went over their elbows. Then they passed through a waterproof door into the cold, cold night air and walked forward to the ship's bow, where their incubator waited. The *Healy* had started moving again after everyone was done sampling at the process station. The ship forged forward through snow-covered ice. Foot-thick chunks tumbled by, illuminated by yellow lights that shone down from the sides of the ship.

Up the stairs they clomped, and along the surface of a walkway roughened for a better grip. The krill team's clear plastic incubator—basically, a box full of seawater—sat at the closest corner of the ship's forecastle, the flat area at the front of the ship. Before the bottles could go in, Shaw and Bernhardt had to scoop out the slush that had formed on the water's surface. At 2:30 a.m., when most of the other people onboard were asleep, these scientists had their arms up to the elbows in slush. Each bottle was strapped into a rotating machine, like a Ferris wheel for krill. Lessard ran the motor, turning the rotator so that

SEARCHING FOR SPRING IN THE BERING SEA

Shaw and Bernhardt could use their gloved hands to pop the bottles in. The rotation would keep the animals from settling to the bottom.

The point of the experiment was to find out how fast the animals eat. Krill eat things that float in the water, like smaller animals and phytoplankton. For the next twenty-four hours, the krill would slowly rotate in the incubator, eating. The women knew how much food was in the water at the beginning of the experiment. At the end of twenty-four hours, they would collect the water and see what was left—which would tell them what the krill had eaten.

This process would be repeated over and over, night after night, throughout the cruise. But for now, these cold krill were ready to do science. "Good night, little krillies, all snug in your beds. Enjoy your last twenty-four hours!" said Evelyn Lessard, as the group turned to leave with empty backpacks.

Five weeks of this experiment wasn't going to create any earth-shattering news. There were no newsboys on corners that summer crying, "Krill Eat Algae! Read all about it!" But put together, through this cruise and other cruises in the same year and other cruises in other years, through all the seasons and all the places in the Bering Sea, and plugged into a computer with similar data on copepods and algae and fish, these few dozen krill, eating for twenty-four hours on a frigid night, would help explain the workings of an entire ecosystem. If the team was lucky enough to witness an algae bloom later in the cruise, for example, it would be interesting to compare these krill, eating on one of the first nights of the cruise, to those that were pulled out of water rich with multiplying algae.

Krill participated in other experiments on board, too. Rodger Harvey, the other leader of the krill team, is a biochemist at the University of Maryland. He and Lessard were collaborating on a project to study the lipids in krill's bodies to figure out what they were eating. Like humans, krill need cholesterol to function, but unlike us, they can't make it from scratch. They have to make cholesterol from lipids—molecules like fats and oils—in their food. So Harvey had worked out how to analyze their cholesterol and figure out what they were eating. Then that would be compared to the feeding experiments, which also show what krill were eating. "The idea is to get the same answer," said Evelyn Lessard.

Bright red- and black-suited scientists dotted the ice like oversized, waddling ladybugs. People were kneeling over holes in the ice, sawing cores, drilling holes. The ship was stopped for the day at an open expanse of ice.

Some of the scientists on board studied sea ice—its physical properties, like how salty it is, and also the algae that live on the underside of the ice. Of course, ice sits on top of water, and that water is very cold. Falling into the water can be deadly, so all sorts of precautions were taken to make sure the ship had stopped at a safe piece of ice that the people going out were unlikely to fall through.

Choosing that ice began early on the first Sunday in April, when the ship started driving around, looking for a good piece. The Coast Guard doesn't let anyone step off the *Healy* onto less than eighteen inches of solid ice. Scientist Katrin Iken of the University of Alaska Fairbanks stood on the bridge with Captain Frederick Sommer, looking out the window at the panorama of white. "You liking what you see?" asked Captain Sommer. "Ja . . . ," answered Katrin, hesitantly. She didn't love it, but the decision was made: this patch would do for the science party's first visit to the ice.

The visit to the ice started in the helicopter hangar. The ship's operations officer, Commander Jeff Stewart, led an ice briefing, reading his risk assessment off a clipboard. The water was at 28.9 degrees, the air at 34 degrees. At those temperatures, water and air were too warm for forming ice, making the ice slightly less safe for walking. The wind was at nineteen knots off the starboard quarter—unfortunately, the ship wouldn't be sheltering the patch of ice today.

And with a light swell moving through, it was possible that the ship could roll a little and crack the ice. If the ship's whistle sounded, he said, move fast up the ramp and onto the ship. The Coasties would check the ice first to make sure it was safe. Everyone was free to come and go from the ice as needed. "The only thing we ask is that you have a work-related reason to be on the ice," he said. Of course, six weeks is a long time to be on one ship. Scientists have been known to think up an experiment that has to be done on the ice just so that they can get off the boat and walk around a bit.

Teams piled their equipment in the hangar, some of it bundled onto sleds. Because of the danger of falling through the ice, everyone had to put on an MSD900 survival suit. These suits will keep you dry if you fall through, and they're good protection from the wind, but they aren't a lot of fun to put on.

To get into one, locate the waist. Step into the legs and get your feet all the way down into the bottom; that attached sock thing will go into your boots. Then take a deep breath, find the arm and neck openings, and dive into the top. With luck, your head will emerge, with most hair still attached, from the rubber-lined neck opening. The time between the dive and the emergence can induce a little claustrophobia, especially if you're trying to squeeze into a smaller suit than you should, so it's a good idea to have a friend nearby who will take pity and guide your head and hands out of the right holes. Then a mighty haul—again, a friend is useful—on the long waterproof zipper at the waist and it's time to walk out of the helicopter deck and along to the front of the ship to wait at the top of the brow, the mesh metal walkway that goes down to the ice.

On the day of this visit, Coast Guard crew went out to check the ice. They drilled holes in a few places with a hand drill to ensure that the ice was as thick as they thought, then stuck little plastic flags in the snow to mark a safe area. Scientists started going down the brow and lowering their equipment on sleds or ropes. As each person started down, a boatswain's mate on the deck radioed up to the bridge: "Bridge, Foc'sl, Helen to the ice." "Roger, Helen to the ice," came the answer through the radio. It was a scary, steep walk down; grippy tape on the handrails was much appreciated. Up on the bridge, someone wrote each name on a window with a marker, then erased it when the person returned. The idea was to have the same people come off the ice as went out at the beginning of the day.

Crunch, crunch, crunch went the boots on the dry snow. Members of the hydrography team pulled up cores of ice and sawed them into pieces. The first one was lying in the plastic holder, next to a yardstick, ready to be sawed. Calvin Mordy turned to Ned Cokelet. "Do we cut all this from the bottom up or the top down?" he asked. "I'm trying to remember how to do this. It's been a year." Someone remembered—slice the core into ten-centimeter-long sections starting at the top. Each chunk was slipped into a zippered plastic bag and put in a cooler. They'd be analyzed later to learn about the physical properties of the ice.

Cokelet picked up a hand auger and drilled four wells in the ice: 20 cm, 40 cm, 60 cm, and 80 cm deep. A little while later, he would look in the wells again to sample the brine that had trickled into them. As sea ice freezes, it excludes salt, making salty brine. That brine has a much lower freezing temperature than the fresh water in the ice; rather than freezing, it trickles in brine channels through the ice. Later, Cokelet would measure samples of water from the brine wells to see just how salty they were.

Elsewhere on the ice, technician Pat Kelly from the University of Rhode Island pulled again and again on the starter of an auger, which he and Katrin Iken needed to bore holes through the ice. Science can be a lot like yardwork. He finally got it started, and he and Iken each held one side, gripping the loud instrument's handles as it drilled through the tough ice. The blade broke through with a splash. Iken shook her hands to relieve the pain. "Yeah!

CONDITIONS CHANGE FAST ON THE ICE.
Blue skies can quickly turn to a whiteout.

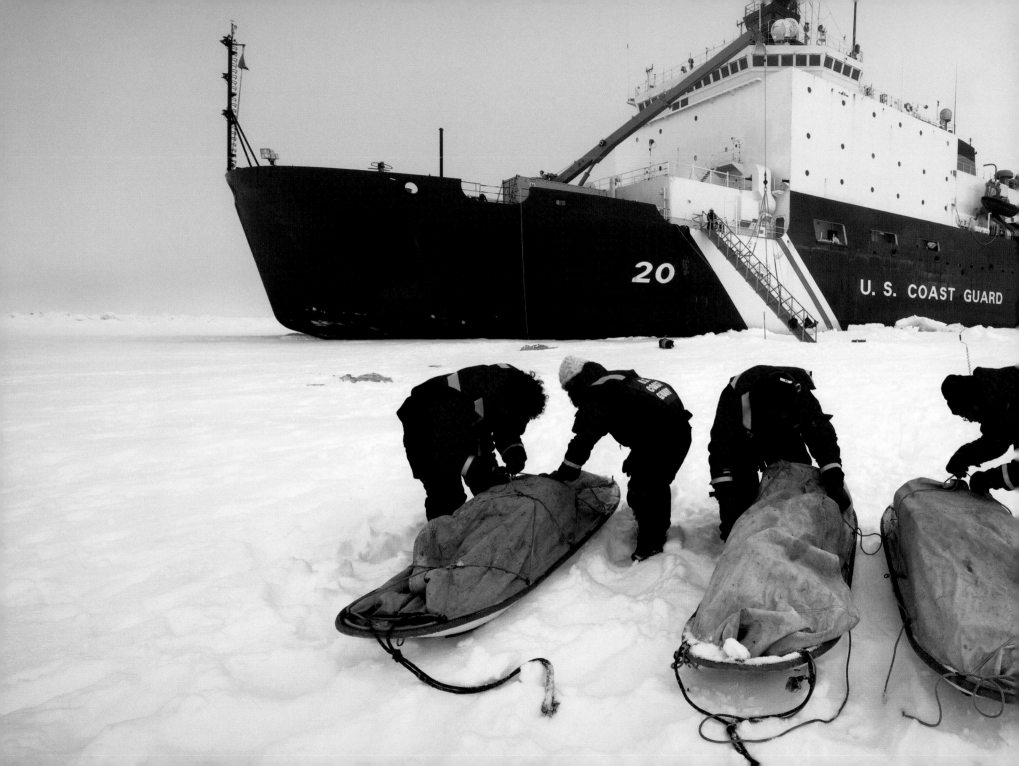

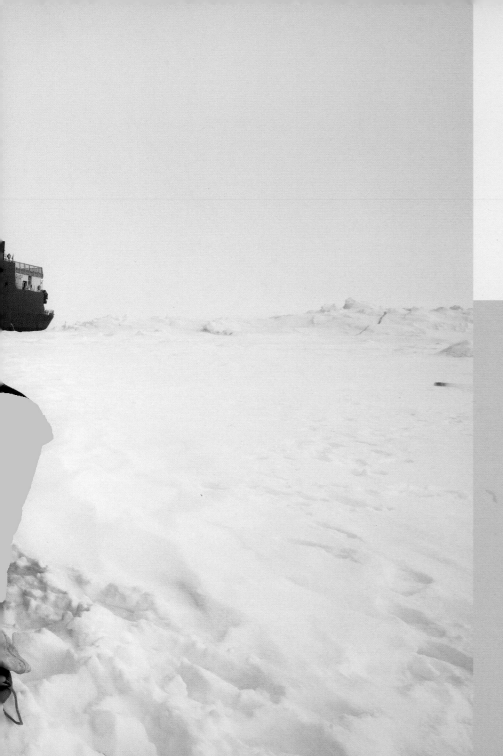

AT THE END OF A VISIT TO THE ICE, SCIENTISTS PACK THEIR EQUIPMENT ONTO sleds that can be dragged back up the steep ramp.

91

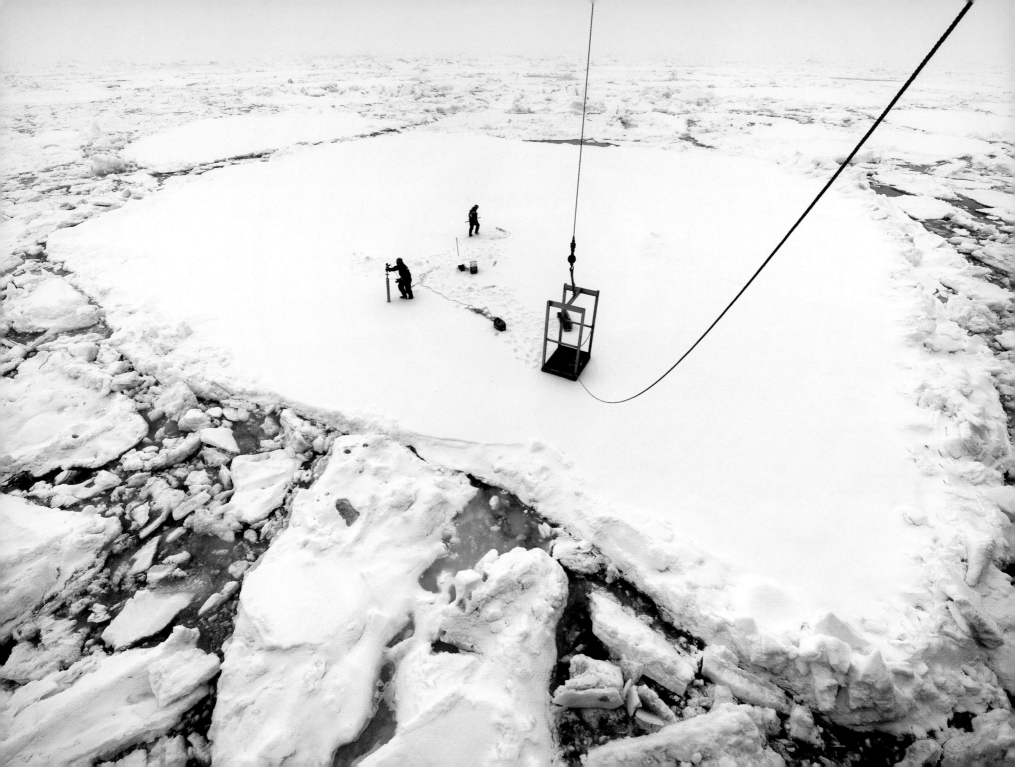

That felt good!" shouted Kelly. Later they would lower sediment traps through holes in the ice, to hang there and catch bits of sediment—dirt, dead algae, zooplankton poop—drifting toward the seafloor.

Farther out on the ice, boatswain's mate Trey Huneycutt was pacing back and forth, carrying a Remington 870, police edition. But he wasn't there to fight crime; he was there to fight polar bears. The chances that Huneycutt would actually ever fire that gun at a polar bear were slim. At this time of year, the polar bears are much farther north.

Huneycutt had qualified on the Coast Guard's shooting range back in Seattle, where the *Healy* is based, and he learned to hunt growing up in North Carolina. So what's different about shooting at a polar bear? "I wouldn't know, I've never shot a polar bear," he said. He'd only ever seen polar bears while the ship was going through the ice, never when he was on the ice himself. Never shooting at a polar bear is the idea—nobody wants to hurt one of the giant animals, and the paperwork would be horrendous. Anyway, people high up on the bridge can see much farther. What would really happen if a polar bear came by is that someone on the bridge would spot it, maybe a mile off. They would call down to the ice, everyone would climb on board, the crane would lift up the brow, and everyone would run for their cameras. Knowing the chances of seeing a bear this far south were close to zero, Huneycutt walked back and forth, wearing a path in the snow. As they finished, everyone packed up their equipment and dragged it back up the brow. The ship moved on.

Over and over this routine was repeated. Find ice, put on suit, walk down ramp, work. Whenever the ice was thick enough, and in big enough pieces, scientists went out on the ice to work. Katrin Iken needed more ice than most. A couple of times, when there wasn't a big enough piece of ice for everyone to work on, she was lowered down to a smaller piece of ice in a cage. But most of the 122 people on the ship never had the chance to get off of it—until the day of April 14.

That morning, scientists went out on the ice as usual. It was a beautiful, sunny day and the mood was light. They cut their holes, they cored, they made their measurements. Ned Cokelet used his bare hand to push a light sensor under the ice. Katrin Iken got her long, blond braid caught while sawing up an ice core. "It needs a trim anyway," she said. This day was a long ice station, which meant that Iken and Pat Kelly's sediment traps had to hang under the ice for several hours. So the ship wasn't going anywhere. Everyone wandered back on board as they finished their work, ready for lunch or naps.

Then an announcement came throughout the ship: "Nowww, all hands interested in going on the ice for recreational purposes, there will be a meeting on the hangar deck in ten minutes." Ice liberty! Anyone, whether Coast Guard crew or science party, could pull on a suit and go out. They didn't even have to put on the irksome MSD-900 suits that the science party usually wears on the ice; on this big, stable piece, everyone could get by in the regular floating coveralls they wear to work on deck.

People gathered around in the hangar. The ship's executive officer, Dale Bateman, led the briefing. "They will cordon off sort of the playpen out there that is well away from the science gear and where people have drilled holes," he said. "The swimmer and bear watch are in charge. That person is keeping you from being eaten by big scary white animals." They were also, as it turned out, in charge of chasing the playground ball. As soon as everyone was out on the ice, a game organized. No Coasties versus science party rivalry—two mixed

93

AT NIGHT, BRIGHT HEADLIGHTS help the crew pick a way through the ice. Normally the ship is driven from the bridge, behind the wide row of windows. But in heavy ice, the driver sits in the black box up above, called Aloft Conn, so he or she can see farther.

THE CTD, WHICH STANDS for "conductivity, temperature, depth," is the basic oceanographic instrument. Here, it's coming back on board after taking measurements and collecting water for experiments. Coast Guard marine science technician Marshal Chaidez's right hand is circling, signaling to the winch operator inside the ship to pull in more cable; with his outstretched left arm, he's telling the operator to tilt the large yellow A-frame back, which will swing the CTD onto the deck.

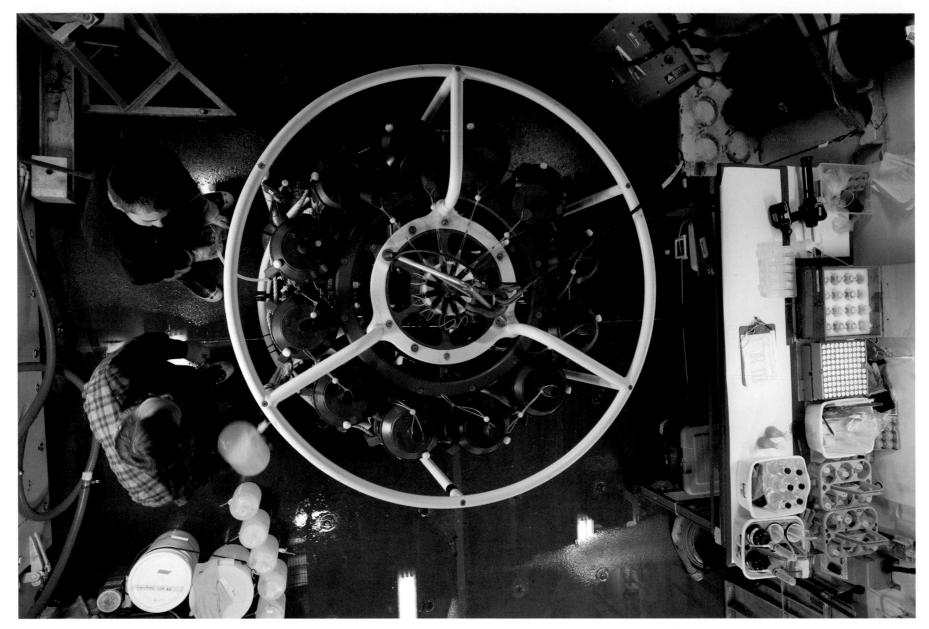

EACH BOTTLE ON THE CTD holds water from a different depth. When it comes back on board, it's wheeled into a garagelike room and scientists gather to take water for their experiments.

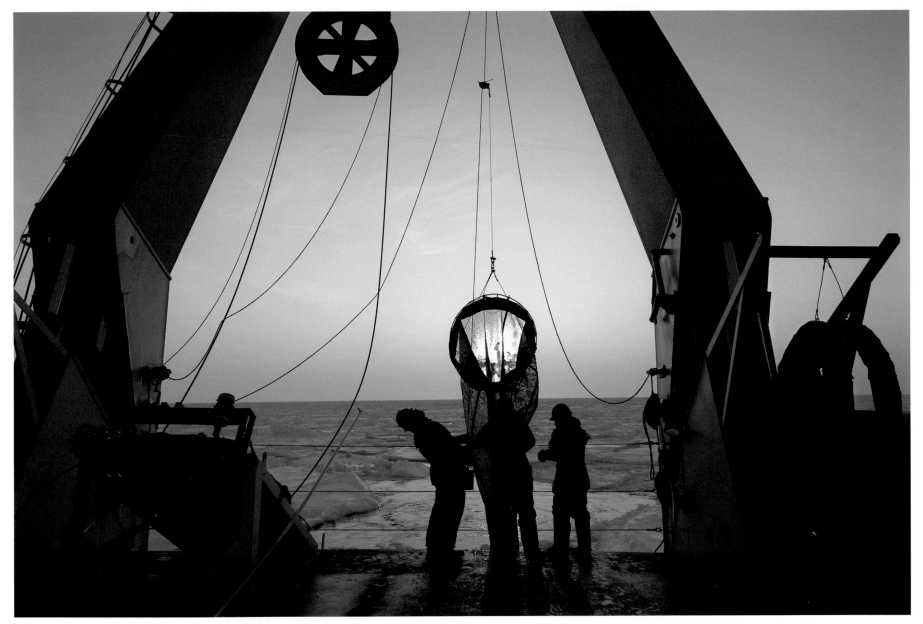

THE ZOOPLANKTON TEAM FISHES at sunrise. They're looking mainly for copepods, little crustaceans that are even smaller than krill—about the size of a pencil point.

teams formed, bases were marked, and the kickball game began. First it was a soccer ball, but that flew too well and kept going into the flagged science area where the swimmer had to chase it. So someone brought out the huge green balance ball from one of the ship's gyms. It bounced and flew across the ice to much laughter. Near first base, two technicians from the Scripps Institution of Oceanography worked on a snowman; the guy who runs the science computer network onboard smoked a cigar. Julie Arrington had her picture taken with a banner made by a grade school class she'd visited before the trip. It was 13 degrees out, with a windchill of 8, but with the sun and the base running, it felt much warmer. A yellow sweater was discarded next to the snowman.

Earlier that day, boatswain's mate Andy Yeckley had stood on the thick ice with a big gun, taking his turn as the polar bear watch. The year before, the ship stopped at a piece of ice that turned out to be full of cracks, covered by snow so you couldn't see them. "Five of us fell through the ice—four Coasties and Ned." The dry suits float so well, nobody even got wet. They'd mark the spot, move on, then someone else would fall in somewhere else. "But nobody got hurt. It happens." He looked around at the ice. "What we're doing right now, there's not many people in the world that have done this." Yeckley had been on the ship for two and a half years—he claimed to be so jaded by the Arctic that he wouldn't bother to get out of bed anymore if a polar bear was spotted. He was about to transfer to central California to rescue people who got into trouble in the surf.

A lot has been seen so far on this cruise, but one thing is missing from the water: life. Ok, there's life–a few scattered krill, copepods, and walruses. But there's almost no chlorophyll. Chlorophyll is a pigment used by plants and algae for photosynthesis. Chlorophyll means there's algae growing, and a lot of chlorophyll means an algae bloom—just what the scientists on board were hoping to capture on this cruise.

The *Healy* has systems that constantly pump salt water through the ship, so scientists can use it for experiments. They also monitor this water to see what's going on outside. A sensor near the ship's main lab measures the level of chlorophyll in that water constantly as the ship goes along and displays it on a screen. Looking at chlorophyll levels gives scientists an idea of how much photosynthesis is going on in the water. The level so far on this cruise: low. Most of the water was coming from under the snow-covered ice, where very little light gets through, which means little photosynthesis.

"It's always more exciting when there's more phytoplankton in the water," said biological oceanographer Mike Lomas from the Bermuda Institute of Ocean Sciences. Of course, he might be biased—he studies phytoplankton. They're like tiny plants that float in the water. He was on the ship to study in particular how fast phytoplankton turn carbon into new cells. His work was part of understanding the whole Bering Sea ecosystem—how energy moves through the food web.

Lomas isn't the only one who's excited about phytoplankton. A major goal for this cruise, for him and everyone else, was finding an algae bloom. In the Bering Sea, when the ice retreats, the water warms up, and the sun hits the water for the first time, the algae can bloom. Those algae become the fuel that feeds the rest of the ecosystem. But no one knew when the bloom was going to appear.

And no bloom was guaranteed. Many of the members of the science party were on a cruise on the same ship, at about the same time, visiting many of the same stations the year before. They also hoped to come across a bloom—but they never really did, said chief scientist Carin Ashjian, a biological oceanographer at Woods Hole Oceanographic Institution in Massachusetts. "We found

something, but it wasn't as dramatic as we wanted last year," she said. "Perhaps this year we will have better luck."

Every day, scientists studied satellite pictures to look for signs of photosynthesis. On April 24, three weeks into the cruise, something that looked like a bloom showed up on the satellite—but the weather was too bad to hang around. You can't hang heavy pieces of equipment off the side of the ship when the wind is blowing hard. And heavy weather, rolling in big waves, could destroy the incubators that sit out in the open on the ship's wide, flat forecastle. So the ship turned around and escaped into the ice. There it loitered, driving around in circles, waiting to see if the weather would break and allow the ship to turn south again.

The weather didn't cooperate, so the ship instead turned north to revisit a station where it had been a couple of weeks before. It was a long trip, on a Saturday. The TV in the science lounge was tuned to the NFL draft. Scientists worked on their laptops, caught up on samples that needed testing, knitted, and napped during the long trip north.

After the visit to the station, the ship turned back toward open water. As the ship approached the edge of the ice, a marine mammal bonanza sprang up. There were beautiful ribbon seals, including mothers with fat new pups. Spotted seals and ringed seals lay on the ice. A trio of killer whales showed their fins in an opening in the ice. At about 8 p.m., biological oceanographer Evelyn Lessard, from the University of Washington, saw the chlorophyll line start rising. She started taking samples from the flow-through system and running it through an imaging flow cytometer, an instrument that drips tiny droplets of water in front of a microscope, photographing every cell in the water sample as it goes by. And she was seeing a lot of cells.

At 10 p.m., she sent out an e-mail to all the scientists on board: "FYI—If you haven't happened to have seen either the underway traces or the green water outside, we have definitely entered an open water bloom."

"When we saw something interesting, we quickly picked up the water," said biogeochemist Didier Burdloff from Lamont-Doherty Earth Observatory in New York. He was on the ship to study photosynthetic organisms, so he was ready for this. He filtered four liters of water through a glass fiber filter. A few weeks earlier, it would have been difficult to even see the slightest tint on the white filter. Now the water left behind a greenish layer of algae.

A green layer on a filter may not sound like cause for celebration, but the people in the science party were excited. Finally, a bloom! Just what everyone had waited for. The next morning, the ship stopped to sample the bloom in depth. Lessard ran more water samples through her marvelous machine. Her krill team ran their overnight experiments, as did other groups. Finally, the krill would get a decent meal, not the weak water they'd had to work with early in the trip. "When we conduct our grazing experiments with these animals, we know in the water there's a tremendous potpourri of organisms," said biologist Phil Alatalo from Woods Hole Oceanographic Institution, a member of the team studying copepods, a kind of tiny crustacean. "We'll see if they choose these juicy little ciliates"—a kind of single-celled organism that was growing like crazy.

Alexei Pinchuk from the University of Alaska Fairbanks was on board to study zooplankton, tiny animals that float in the water. He used a fancy set of nets to collect the miniscule animals from water at multiple depths. The nets, known as a MOCNESS, are all on the same frame, set up so he can open and shut them at different times remotely. Late one night during the algae bloom, he bent over his laptop in a control room near the rear of the ship where technicians ran the winches that lowered instruments into the water. He watched the data coming back from his rig as it sank beneath the water. When it was a hundred meters below the surface, he told Marshal Chaidez, the Coast Guard marine science technician who was helping him that night, to start hauling it back in. "Ok, let's bring it up at eight," he said. A red dot on his screen showed

THE TEAM'S NETS BRING UP A POTPOURRI OF ZOOPLANKTON.
Tiny animals like these form an ecosystem in the sea.

101

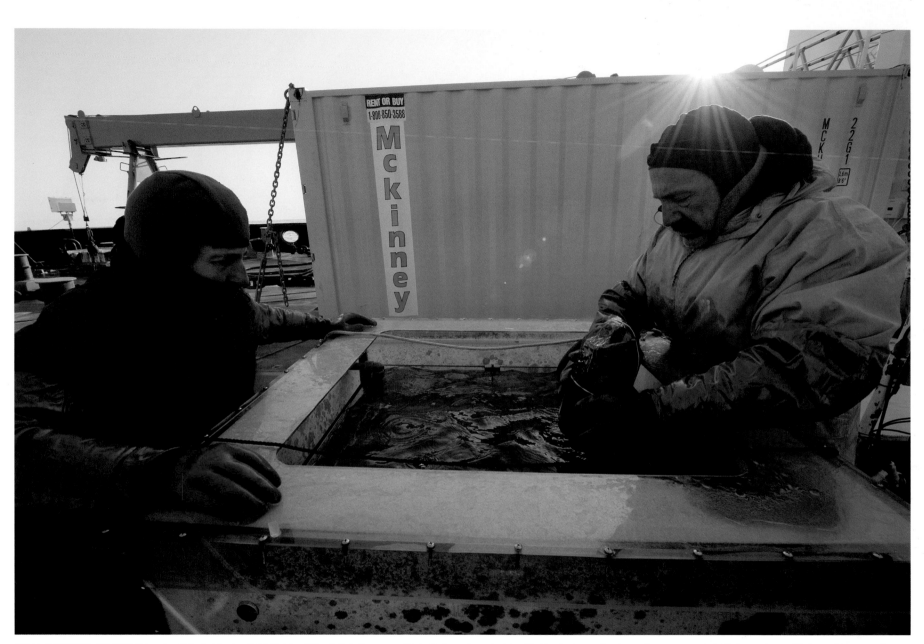

CELIA GELFMAN OF THE University of Rhode Island and Phil Alatalo of Woods Hole Oceanographic Institution set zooplankton-filled bottles into an incubator of seawater on deck. Their experiment will show what copepods eat in spring in the Bering Sea.

EVERY COPEPOD FROM THE EVERY COPEPOD FROM THE experiments has its picture taken under a microscope by Carin Ashjian or one of her colleagues, then is dried out so more measurements can be done back on land.

the nets moving up as the ship drove forward into the night. He wanted the nets to rise at a certain rate, to go through just the right amount of water before he closed each net. "Now is a little bit slower than I want," he said. A minute later he asked for a call to the bridge: "Hey, Marshal—can you tell them to speed up just a little, about 0.2 knots." The voice from the bridge sounded skeptical that such a small change in speed was possible. "He does not like it," said Alexei. "Oh, he can do that," said Brandi Murphy, a science party technician sitting nearby. When the net had risen twenty meters, Pinchuk sent a message from his laptop to the nets, to close one net and open the next. That way, each net brought back a sample of the critters swimming in a different layer of water.

A sweetish, nutty, earthy smell drifted from the nets as they came out of the water and Pinchuk, with marine science technician Tom Kruger, brought them back on board. "The smell is coming from the bloom, from the algae," Pinchuk said. "It's the quickest way to tell there is a bloom." He washed the nets down with a seawater hose, collected the water from the bottom of each net and sieved it to concentrate the animals until the contents looked like rich, dark, homemade applesauce. He poured the rest into a jar and quickly added a dose of preservative, killing the animals so he could count them later. He held up a jar, filled with a thick cloud of tiny crustaceans, mostly copepods. "Those are the guts," he said, pointing at one of the tiny animals. "They have green guts . . . they are all stuffed with diatoms." Those diatoms, a kind of algae that make their own glass shells, were growing like crazy in the bloom. Back in Seward, Alaska, Pinchuk would spend hours hunched over a microscope, counting the critters in

103

SEARCHING FOR SPRING IN THE BERING SEA

EVELYN LESSARD FROM THE University of Washington was one of the first people on board to see the algae bloom up close. She did that with the black machine next to her, an imaging flow cytometer—a microscope that takes pictures of every organism as a sample of water drips by. She saw lots of algae.

WHEN THE SHIP ENTERED the phytoplankton bloom, biogeochemist Didier Burdloff from Lamont-Doherty Earth Observatory ran four liters of water through a glass fiber filter. Here's what stuck to the filter: algae. The algae in the Bering Sea is yellow brown when it's fresh, but it dries green.

his samples and adding them to a giant spreadsheet. Like everyone else's data, this would be part of the entire picture being drawn of the Bering Sea ecosystem.

The ship zigzagged through the bloom for almost a week, stopping frequently to sample and study. A map tracking the ship's movement showed the chlorophyll levels that the ship had measured for the entire cruise, a long track winding through the sea. Red is high chlorophyll, blue is low. For that week, the ship left brilliant yellow and green rainbow lines crisscrossing the electronic map.

Before intercepting the bloom, the *Healy* was on a foray into open water. It was the Bering Sea in April—but not a speck of ice was in sight. Seventeen people, among them scientists, marine science technicians, and those who would be in charge of driving the boat, gathered on the bridge to plan an operation. They were figuring out how to use the *Healy* to pick up a set of sediment traps that had been deployed the day before. The traps were brine-filled tubes, open at the top, that were suspended in the ocean. They catch sediment in the water—anything that's falling through the water column to the bottom. This gives an idea of how energy flows from the part of the ecosystem that's suspended in the water—zooplankton, algae, and so on—to the things that live on the bottom, like brittle stars and clams. This material is called marine snow, and it fuels whole food chains on the bottom of the sea.

The traps were hanging on a 125-meter-long rope beneath a big orange buoy. Atop the buoy was a spar with a diamond-shaped metal top that showed up on radar so that other ships wouldn't run over it. Below that was the rope; traps

SEARCHING FOR SPRING IN THE BERING SEA

were attached to it at 25, 40, 50, 60, and 100 meters below the surface. At the end of the rope was a 135-pound weight to hold it vertical in the water.

The problem now was how to get the traps, with their precious cargo of marine snow, back on board. Normal procedure is to snag the buoy from one of the ship's small boats, drag it over to the back of the ship, and use a winch to lift the sediment traps out of the water. But a storm was coming in, and at twenty-five knots, the wind was too high and the swells were too big to launch the small boats. So the people on the bridge were trying to figure out how to use the whole 420-foot metal behemoth to sidle up to the buoy and snag it from the rolling deck.

Commander Jeff Stewart, the ship's operations officer, led the meeting next to a big pad of paper propped on the captain's chair. He drew a diagram with a marker. Much of the conversation revolved around a tool called a "happy hooker" that would be used to snag the spar, the tall metal pole that sticks up from the buoy. "The happy hooker, can it reach the water?" he asked. He drew ropes on his diagram. "We have one line made off to the cleat and the other one on the happy hooker." The ship would have to line up just right so that someone near the back could get a hook on the spar. "There is some risk to the personnel back aft," said Stewart. The spar was bobbing energetically in the waves, and the deck was moving too. Somebody "could get slapped by that spar."

Oceanographer Pat Kelly from the University of Rhode Island had been waiting the whole cruise for a chance to put his sediment traps in. They need open water with no ice around and twenty-four hours to soak. There'd been an attempt a week before, but this was the first time he'd actually managed to get them into open water to collect this data. There were no preservatives in the

HELEN FIELDS

JARS HOLD THE ZOOPLANKTON captured by Alexei Pinchuk of the University of Alaska Fairbanks. Nets at different depths caught different combinations of animals. The deepest sample, at left, is dominated by baby amphipods; in the jar collected nearest the surface, at right, that pinkish material is a mass of copepods.

METRIDIA COPEPODS SWIM AROUND on a sieve in a darkened room, leaving bright blue trails of light. "The thought is that they emit this blue light to scare off a predator," says copepod expert Carin Ashjian.

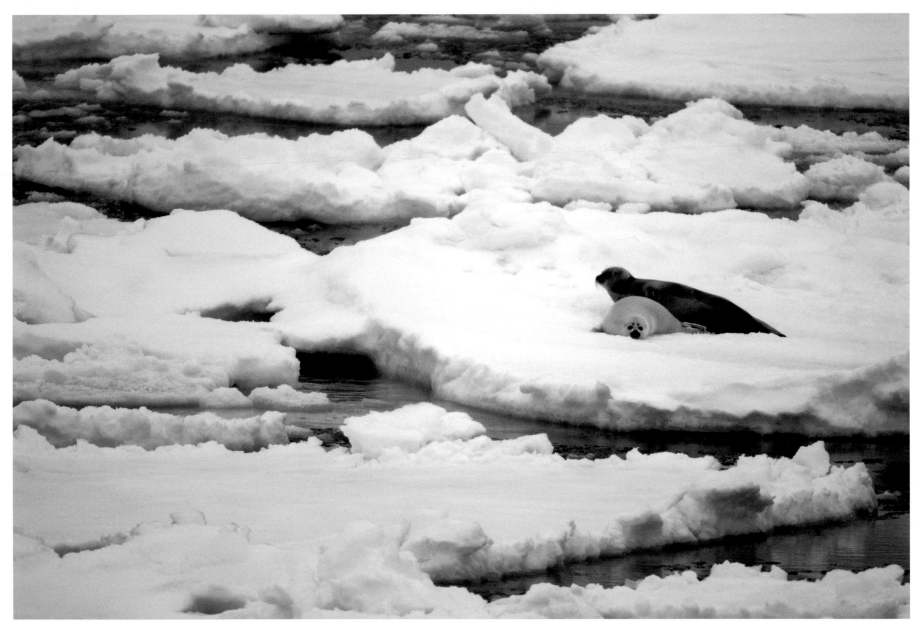

A RIBBON SEAL MOTHER and her white pup rest on an ice floe. Seals in the Bering Sea have their pups on sea ice; the pups float around on the ice until they're ready to swim themselves.

THOUSANDS OF THICK-BILLED MURRES FEED IN A LEAD, OR OPENING IN THE sea ice. As the icebreaker approaches, they skitter in every direction along the surface of the water and the thin ice. They may have bellies too full for flying, or maybe they just don't want to leave.

SCIENTISTS AND *HEALY* CREW members take one of the ship's small boats out to retrieve sediment traps, clear plastic tubes that have been hanging in the water overnight, catching dead material in the water as it drifts toward the bottom.

THIS SHRIMP COULD HAVE died and just happened to fall into the sediment trap, or it could have swum in, then died in the extrasalty water the trap is filled with.

tubes, and if they sat out there too long, shrimp or other animals could get in and eat everything up. If there was much of a delay, the sediment traps would become just plastic and ropes. The plan was complicated, and Kelly wanted to be sure he got those traps back. "There's really no harm in taking a practice pass, either. Just to see how things sit," he said.

As they talked, the buoy appeared on the horizon. They got closer. The ship slowed. The person driving the ship got close, then even closer. It was like a city bus trying to snuggle up to a ping-pong ball. Boatswain John Rose took over driving the ship from the rear control room. Crew members tracked the buoy's slow walk toward the back of the ship, calling in on radios. It was past the front of the ship, then past the point on the starboard side where sewage is discharged. It appeared in a window, bobbing up and down, as if it were peeking its head over the railing to say hi. Out on deck, boatswain's mate Trey Huneycutt reached out and captured the spar. The buoy was walked, with the sediment traps attached like fish on a leash, to the very back of the ship. And finally the sediment traps were attached from a winch. Kelly, with help from other scientists and crew, got the brine-filled plastic tubes back on board.

"That went ok," said Kelly. The sediment traps splashed a bit on their return from the rough sea. Kelly wasn't worried, though. The traps were meant to collect falling particles, so anything he was interested in had fallen to the bottom. The good news: there was stuff visible in the tubes. Kelly thought it was mostly zooplankton poop. "Now we let the samples settle a bit. Then I'll let you guess what we do," he said. The answer on this ship is almost always filtering. There's a lot of filtering in oceanography. After some basic measurements of the water, you learn a lot more from the stuff in the water—chlorophyll, zooplankton, whatever—than the water itself. Kelly filtered the water to capture the particles of marine snow. He folded the filters up in foil so they could be analyzed later. He would be looking for thorium 234, an element that occurs naturally in water and sticks to organic particles—it's a way to find particles that are too small to see.

Thorium 234 is a handy element. It's radioactive, but it's in such tiny quantities that it's not dangerous. It's produced when uranium 238, another radioactive element, decays. Thorium 234 happens to have an interesting characteristic: it likes to stick to dead organic matter. "Any dead material, it'll stick to," Kelly said. "If someone cut your arm off and threw it in the water, thorium 234 would stick to it." Now of course nobody was cutting off any arms and throwing them into the water, and thorium 234 doesn't do anything biologically. It's not dangerous. But it is relatively easy to detect, and it can be used to measure how much dead organic matter is in the water. And that's interesting because something that just looks like dead organic matter to us is delicious, life-sustaining food to tiny critters that live in the ocean.

Kelly slid five samples at a time into the beta counter, an instrument that measures the tiny particles that come off thorium as it decays and turns into another element, protactinium 234. That's radioactivity, but people are exposed to more radiation just walking around than they could get from the amount of thorium in a quart of seawater. "The lead shielding on the instruments actually protects the samples from outside radiation, not us from the samples," Kelly said.

Dave Shull, a benthic ecologist at Western Washington University, was also studying thorium. The "benthic" in "benthic ecologist" means he studies the bottom of the sea. Shull's main instrument on board the ship was the multicorer, a teepee-like contraption so heavy it has to be moved across the deck with a crane. The multicorer is lowered to the bottom, where it takes eight tube-shaped samples of the mud, sludge, and critters that live there. One day, a clam the size of a palm was just unlucky enough to get caught in the tube; most of the time, it captures smaller prey. Brittle stars and small clams are particularly common bottom dwellers in the Bering Sea.

WHEN ALGAE, ZOOPLANKTON, AND walruses die, they fall down and are recycled by organisms that live in the mud. This sample of mud from the bottom holds brittle stars, clams, worms, and, just to the right of center in this picture, a little pink sand dollar. "Mud dollar," joked one scientist.

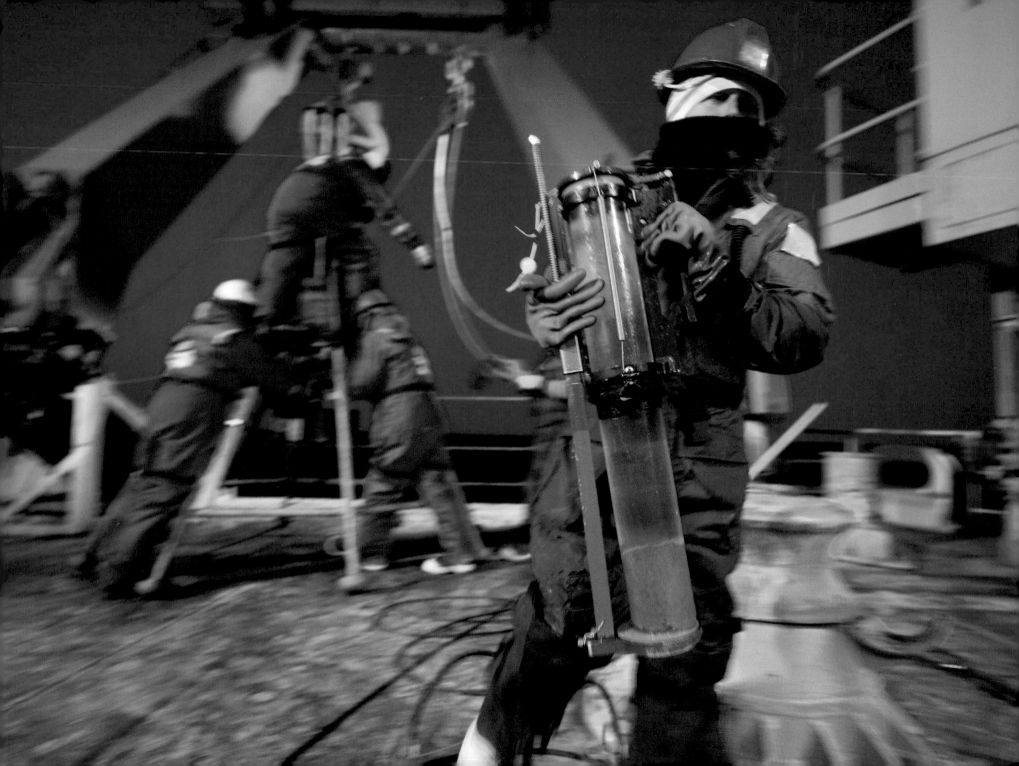

THE MULTICORER IS A thousand-pound instrument that looks like a teepee and goes down to the bottom to sample mud. When it touches the bottom, it settles on its legs, then its cylindrical tubes push straight down to take eight samples at once (opposite).

THIS MAY BE THE world's unluckiest clam. It's exactly the same diameter as one of the multicorer's sampling tubes and was in just the right place to get picked up. Usually the cores capture much smaller clams, worms, and tiny crustaceans.

Mud from the multicorer went to more projects than Shull could count. But some of that mud was dried, then ground to a fine powder by Maggie Esch, Shull's master's student, an avid swimmer who had come along on the cruise, then put into another machine that measures thorium.

A week after that sediment trap retrieval, the ship was in the middle of the algae bloom. People were pulling in nets teeming with smelly life. And Shull was pretty sure he'd identified the bloom on the bottom; there was way more thorium 234 in the dried mud than there had been a few weeks before. "We think we're seeing the bloom hitting the bottom!" he said. He pointed at a peak on a computer screen, delighted. "This little peak is thorium." It was the readout from his radiation detector, showing that the element was in the bottom sediments. "Thorium suggests that stuff in the water column is hitting the bottom with a vengeance," he said. He knew it wasn't old thorium 234 because there was no such thing as old thorium 234. It has a twenty-four-day half-life, so every twenty-four days, about half of it decays and turns into protactinium 234, until eventually the thorium 234 is all but gone. "Thorium is really of no biological use, but it's our natural stopwatch—it has just the right properties to allow us to look at processes of interest in the Bering Sea," Shull said. "Pretty slick, huh?"

After Shull and Kelly analyzed their data, they would have a few more links in the chain—another pixel in the image of the Bering Sea ecosystem being assembled aboard the *Healy*.

SEARCHING FOR SPRING IN THE BERING SEA

HEALY PUSHES THROUGH BROKEN PLATES OF ICE AT NIGHT.

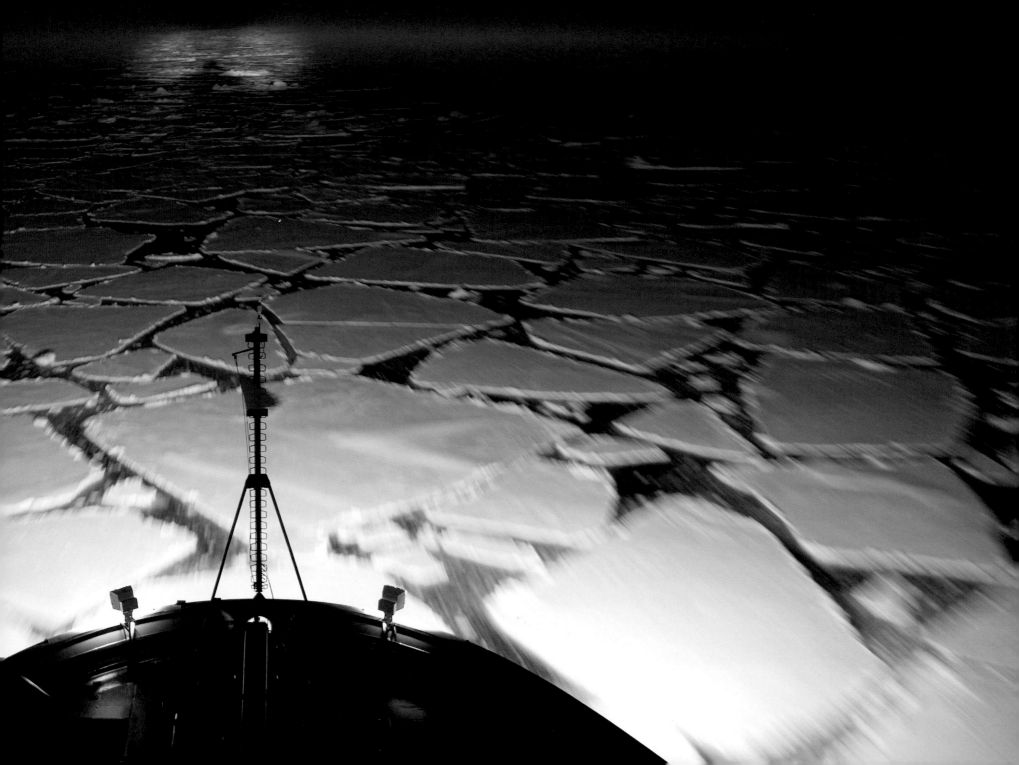

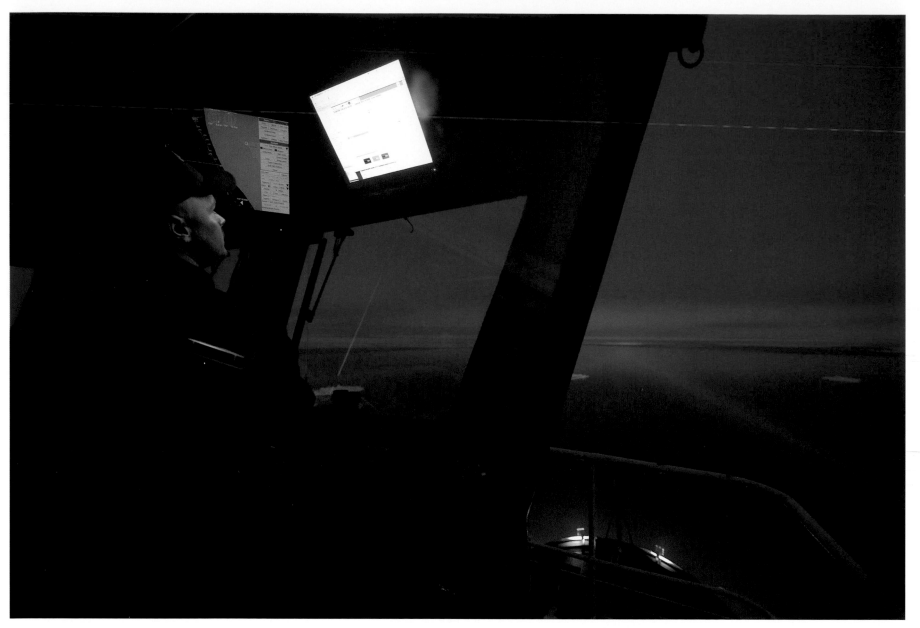

BOATSWAIN'S MATE BILLY GLENZER drives the ship from Aloft Conn. He's training to be an officer of the deck, someone who's qualified to drive the ship. This is a little slower paced than his last assignment, which involved a lot of small, fast boats.

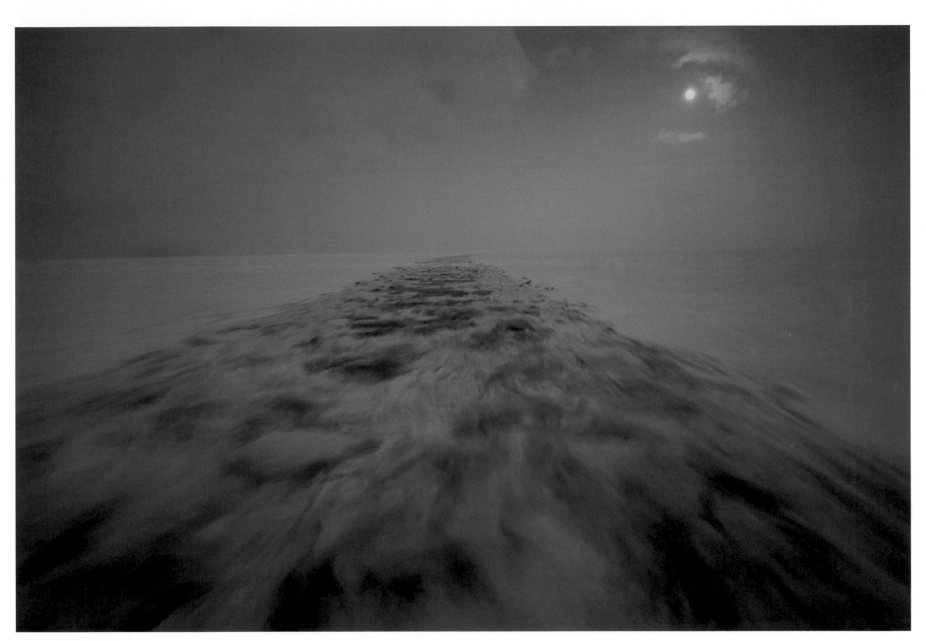

A FULL MOON RISES over the ship's wake.

This is how it normally works on a ship: if there's a bang, that means the ship just hit something, and that is bad. *Real* bad. Drop-everything-and-run-to-your-station-for-general-emergency bad.

Here's how it works on an icebreaker: if you hit something, it's Tuesday. Or Wednesday. Or any other day. One's very first trip into the ice takes some getting used to. Coast Guard people are normally deployed on the *Healy* for three years if they're enlisted, two years for officers. The ship had eighty crew members on board, from tentative-looking teenaged seamen and firemen, fresh from boot camp, to a few chiefs who were nearing retirement.

Down in the galley, the food service crew was in charge of keeping 122 people fueled for forty days. The ship was completely cut off for those six weeks—no helicopters came by with fresh strawberries—so the lettuce that was on board on April 3 was all the lettuce anyone was getting. There was a clear progression: spinach and mixed greens go bad first and were replaced by romaine within a week or two. In the last few weeks of the cruise, a progressively dingier parade of iceberg appeared on the salad bar.

On a Tuesday late in the cruise, the iceberg lettuce was looking bad. Two seamen were going through the remaining heads, pulling off the plastic wrappings and the brown outer layers to get at the barely usable leaves inside. "I wish there was no lettuce at all, because I'm not going to be able to get good enough lettuce that I'm going to want to eat myself," said Mark Hamilton, a food service worker who was supervising them. Hamilton and his colleagues kept the ship well supplied with fresh pies, cookies, and soft ice cream. The ship always carries enough food to be stuck in the ice over winter (a very unlikely event).

Down the hall from the galley is the Java Hut, a shop with a top-of-the-line espresso machine. "It's the Lamborghini of coffee makers," said Dan von Kauffmann, an information system technician who was also qualified to make lattes. Coffee drinks were $2.25—$2.00 if you supplied the mug. Also available: t-shirts, sweatshirts, hats, deodorant, loofahs, film, tweezers, frozen paninis, towels, Altoids, gum, and temporary tattoos of the ship.

Hair doesn't stop growing at sea. As a storekeeper, Bobby Griffin's main job was to keep track of parts and supplies on board. When you're a twelve-hour steam from the nearest port, you don't want to realize you're out of that one kind of bolt. Griffin had been a barber in civilian life, but he had to go to military barber school to be officially allowed to cut Coast Guard hair. "I just went to barber school in San Diego and just got back," he said. He'd gotten on the trip in Dutch Harbor, the same time as the science party. Anyone could sign up to get haircuts during his office hours. He can cut women's hair, but most of his clients on board were men who were keeping their hair at regulation lengths; women were more likely to keep hair in a ponytail or a bun.

Boatswain's mate chief Wayne Kidd had been on board the *Healy* for about five years—he retired from the Coast Guard soon after this cruise ended. He's got a lot of experience with icebreaking and could be seen at all hours instructing younger pilots on how to drive in ice. Actually, on an icebreaker, a lot of the goal is *not* breaking ice. "In general, it's not good practice to hit things with a ship," said Kidd. This ship is made for breaking ice; it's got a reinforced hull and a special coating of low-friction paint to help it glide until it falls through and the ice breaks under it. But breaking ice is an inefficient use of engine power. Plus it causes a lot of vibration that wears out equipment. So much of driving the ship in ice is figuring out how to avoid ice. A frozen sea is like a constant, rolling puzzle that goes on for miles. Ice pilots are always thinking, can I go around that piece of ice or do I have to drive through it? Radar helps a little, but mostly they're looking ahead trying to figure out a path.

The first rule of icebreaking, said Kidd: "Don't break the ship." If hitting ice is unavoidable, you must hit it at the right speed, at the right angle, and with

the right amount of engine power, so it breaks before you do. Also, don't hit seals. "We will back up and go around if need be," he said. "This is their house." But that's not normally necessary—Coasties who've been on the *Healy's* bridge for a while are experts at spotting seals far off. They can even tell the difference between a live seal and a dead one. (There's no paperwork required for hitting a dead seal. Once on this cruise the ship ran over a dead seal on a piece of ice, knocking it off and probably providing the disappointment of a lifetime to the seagull that had been eating it a moment before.)

In really thick ice, the pilot sometimes has to resort to the "back-and-ram" move. When the ship gets stuck, the pilot carefully lines up the rudders—so they don't get broken backing into ice behind the ship—baaaaacks up, fires up the engines, and moves forward to hit the ice again. Sometimes it takes an hour to go the length of a couple of football fields. Sometimes it's unavoidable, but you don't want to get stuck backing and ramming when you could have gone around, Kidd said. "There's nothing more mortifying than when you're stuck in the middle of a floe, open water on either side, backing and ramming because you were trying to cut corners, and your relief comes." You'll be the butt of jokes for days, he said. As the ship went along, cracks opened before it, sometimes in surprising directions. "I'm a pretty good ice pilot, and I still get surprised," said Kidd. "The ice will humble you."

Meanwhile, science went on. The teams collected data, measuring everything from the physical properties of the water—how cold, how salty, how dense—to the rate that krill and copepods ate. "We already had an idea of how the ecosystem works when we began," said chief scientist Carin Ashjian after the cruise. Ashjian is a biological oceanographer at Woods Hole Oceanographic Institution. As chief scientist, she coordinated all the competing needs of the scientists on board—things can get tense if someone feels their research needs are being ignored—and dealt with logistics, while also leading her own team's research on copepods.

Basically, this is how the ecosystem works: the sun hits the water, the phytoplankton photosynthesizes, and the copepods eat them. But understanding the world at the level of a third grader's food chain isn't enough to make predictions about what will happen to the Bering Sea as the climate changes. Ashjian said, "What we're trying to do here is rigorously quantify the exchanges between the different components of the ecosystem. So, for instance, how much phytoplankton do the copepods eat?" The answers will go into mathematical models of the Bering Sea; once good models have been set up, tweaking them will give an idea of how the ecosystem might respond if the climate warms.

It's not just a question of how many copepods there will be. This cruise was concerned with the small end of the ecosystem, but higher up on the food chain, the Bering Sea is one of the richest fisheries in the world. U.S. and Russian fishing fleets pull hundreds of millions of pounds of fish and crab from its waters each year. "And those fish that are being harvested, pollock especially, depend on these components of the ecosystem that we were studying on the cruise because that's what they eat," said Ashjian. Many people make their living off pollock and crab, and knowing how climate will affect the fish's food could be crucial to their livelihoods. "The idea is that if you can understand what's going to happen to the pollock, we may have a chance of regulating our fishery so that we can sustain it."

After six long weeks, the ship returned to Dutch Harbor. The sun shone as a tugboat helped the ship pull up at the dock. The cruise was finished, but the science goes on.

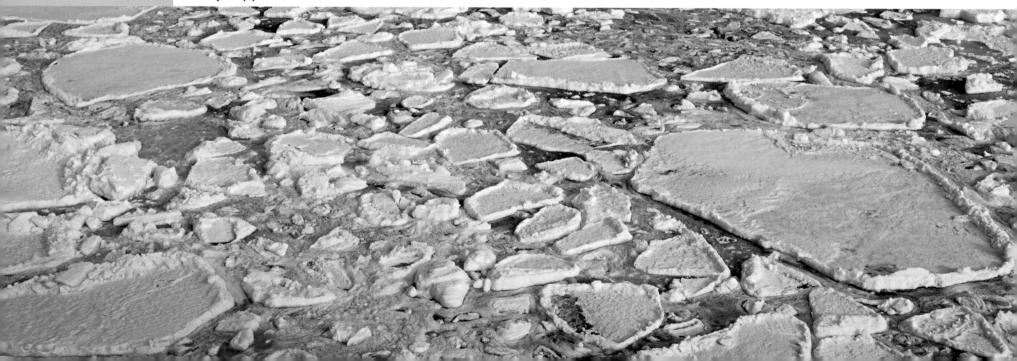

3 EXPLORING THE ARCTIC SEAFLOOR

Lonny Lippsett

THIS POLAR ODYSSEY BEGAN ON A MOON OF JUPITER AND IN A BATHTUB. The bathtub was on Earth, and in it was Cassidy Reves-Sohn, just a few months old and being scrubbed by her dad, Rob. The tub was full of soap bubbles and bobbing toys, including a Sesame Street submarine captained by Elmo, and the occasion, as bath times usually are, was full of fantasy.

We'll never know what Cassidy was fantasizing about. But her father, an earth scientist at Woods Hole Oceanographic Institution (WHOI), looked at the white bubbles atop the bathwater and conjured up images of the Arctic Ocean—in particular, the formidable barrier of sea ice that covers the ocean and that has ever blocked scientists from getting to the bottom of it. Wouldn't it be neat, Sohn mused, if we had vehicles that could safely explore beneath the ice and resurface again, as easily as Elmo's sub?

The year was 1997, and a few hundred million miles away, a spacecraft called *Galileo* was exploring a moon of Jupiter called Europa. It discovered that Europa's surface is sheathed in ice that probably covered an ocean—a scenario resembling the Arctic.

But maybe the story actually began twenty years earlier in 1977 with two unexpected and revolutionary discoveries by two completely different explor-atory vehicles. The first was the submersible *Alvin*, exploring inner space. Diving to the seafloor near the Galápagos Islands, scientists in *Alvin* found vents gushing shimmering, warm, chemical-rich fluids into the cold, dark depths. To their astonishment, they also found an abundance of crabs, mussels, giant clams, six-foot worms tipped with brilliant red plumes, and other extraordinary life forms congregated around these vents. Until then, the seafloor had been regarded as relatively barren terrain, where the only sources of nutrients were scant dregs that percolated down from the sunlit surface.

The discovery transformed our understanding of where and how life could exist. It revealed that something other than sunlight and photosynthesis could provide energy to sustain life. Ocean scientists soon found other vents along Earth's midocean ridges, the forty-thousand-mile undersea volcanic mountain chain that encircles the globe like the seams on a baseball.

Midocean ridges form the boundaries of Earth's tectonic plates. Magma erupting at the ridges creates new seafloor crust that spreads outward, adding to the plates on each side of the ridges. Seawater seeps through cracks in the seafloor and is heated by volcanic rocks below. The heated seawater chemically reacts with rocks and rises buoyantly like geysers, discharging fluids through

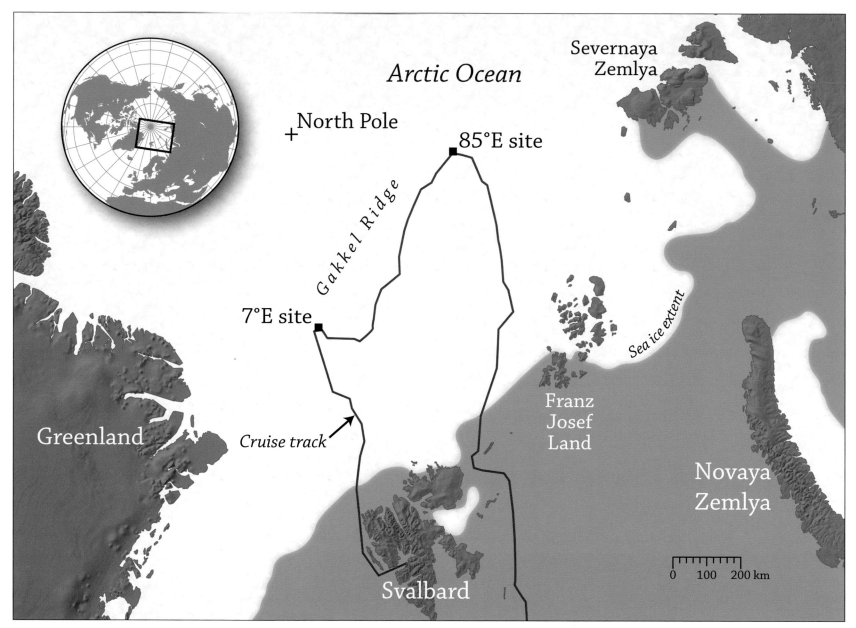

North Pole

Arctic Ocean

Severnaya Zemlya

85°E site

Gakkel Ridge

7°E site

Sea ice extent

Franz Josef Land

Greenland

Cruise track

Novaya Zemlya

Svalbard

0 100 200 km

JULY 2007 SEA ICE extent from satellite data courtesy National Snow and Ice Data Center.

hydrothermal vents (from the Greek words for "water" and "heat"). The fluids are full of chemicals that deep-sea life forms use to live and grow.

Shortly after that 1977 *Alvin* dive, the *Voyager I* spacecraft set off to explore outer space. Eighteen months later, as it flew past Io, the innermost moon of Jupiter, it photographed volcanic eruptions ejecting material hundreds of miles above the moon's surface. Quite unlike Earth's long-dead moon, Io turned out to have more than four hundred active volcanoes. The volcanism is driven by Jupiter's massive and varying gravitational pull on its tinier nearby moon, which generates friction and heat within Io's interior.

Two discoveries, worlds apart: first, there are probably more volcanoes in the solar system than we had ever dreamed; second, volcanism in the presence of liquid water can spawn life.

Two decades later, those two discoveries combined to make Europa a prime future target for space scientists to search for extraterrestrial life in our solar system. If Io had volcanoes, it is likely that Europa would, too, but its volcanoes would be beneath an ocean—just as on Earth. If life thrived at the bottom of Earth's oceans, why not on Europa?

Meanwhile, to earth scientists like Sohn, the bottom of the Arctic Ocean seemed almost as remote, inaccessible, and unexplored as Europa. In the mid-1990s, around the same time as Cassidy's fateful bath, the U.S. Navy for the first time offered nuclear submarines to the scientific community for unclassified Arctic research. On one mission, the *USS Hawksbill* was equipped with a sonar system specially built by an engineering team led by Dale Chayes at the Lamont-Doherty Earth Observatory. The sonar could record data to make high-resolution, three-dimensional seafloor maps.

Sailing in the eastern Arctic Ocean, the *Hawksbill* surveyed the Gakkel Ridge, a midocean ridge that stretches 1,100 miles from the north of Greenland to Siberia. It was named after Soviet explorer Yakov Yakovlevich Gakkel, who first predicted the ridge's existence and location before it was actually confirmed by Soviet expeditions around 1950.

Lying 1.8 to 3 miles beneath the icy ocean surface, the Gakkel Ridge is the deepest midocean ridge. It is also spreading apart far slower than other ridges, less than one inch a year. That seemed to indicate that little magma was produced on the ridge, which led almost everyone to expect that the Gakkel Ridge would not have a lot of volcanic activity or hydrothermal vents on it.

Then in 1999, the Gakkel Ridge began to stir. A swarm of seismic activity was detected on the ridge by the worldwide network of seismometers, which records the motion generated by earthquakes, volcanoes, and other ground-shaking events. There are no suitable land-based sites to install seismometers in or near the Arctic Ocean, but the events were large enough to be detected far away.

Over nine months, seismologists recorded 250 seismic events centered around 85° N on the Gakkel Ridge. Coincidentally, the *Hawksbill* was surveying the same region at the same time. Scientists aboard didn't feel anything, but with data from their hull-mounted sonar, they discovered two fresh volcanoes on the Gakkel Ridge at 85° N.

The exciting discoveries roused the scientific community to muster the first research cruise to collect rock samples from the ridge. Hedy Edmonds, a marine geochemist at the University of Texas, was invited to join that ten-week expedition aboard the U.S. Coast Guard's newest icebreaker, the *Healy*.

Edmonds's specialty was the chemistry of seawater, not rocks. In particular, her expertise was detecting plumes of hot fluids discharged from hydrothermal vents that rise into the oceans and then trail off horizontally, like smoke from smokestacks. Though the 2001 expedition leaders did not expect much volcanic

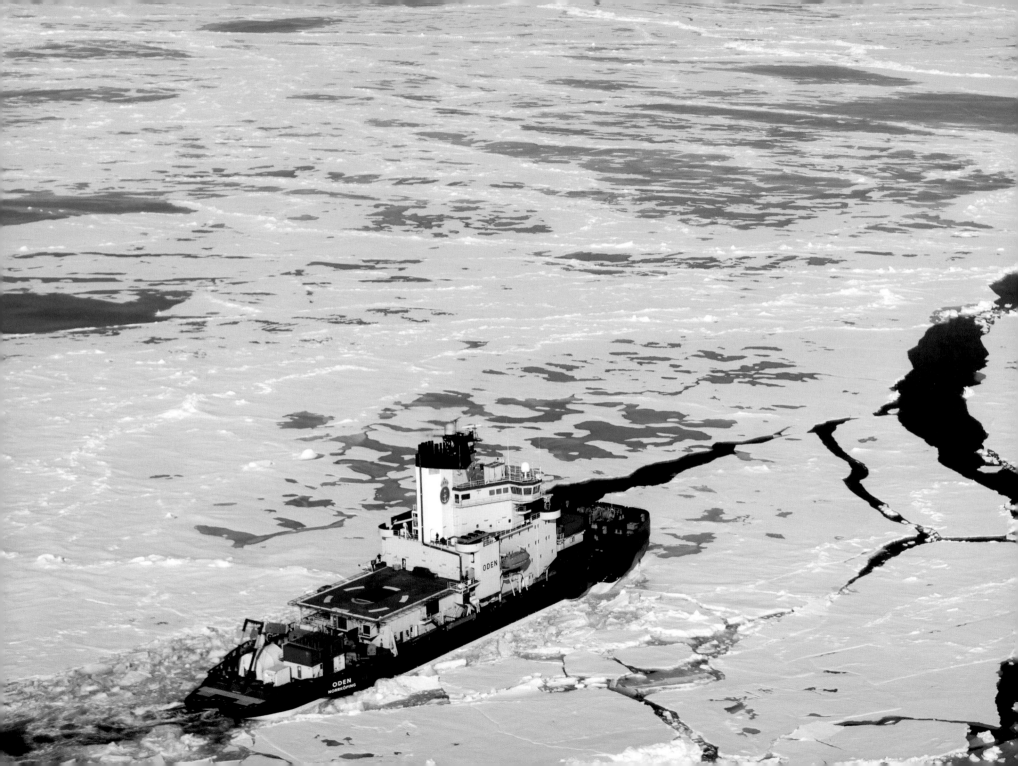

THE SWEDISH ICEBREAKER *ODEN* WAS ORIGINALLY BUILT TO BREAK ICE IN THE
Baltic Sea during winter and to keep the shipping routes open between Sweden, Finland,
and Russia. It still does that, but it has also adopted a second career during North American
summers as a research vessel, taking scientists to conduct research at both of Earth's poles.

129

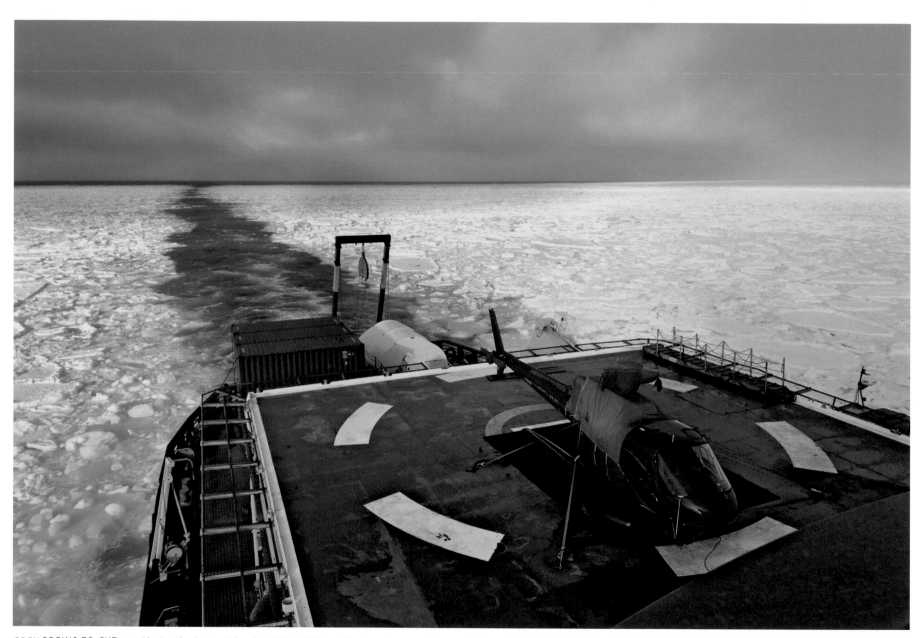

ODEN BEGINS TO CUT a corridor into the thin ice at the edge of the Arctic Ocean. The ice pack starts out in a remarkably straight line (background). Winds blowing from the south push thin ice, newly formed in the previous winter, against thick ice farther north that never melts and grows thicker and harder year by year. For comparison, imagine pushing checkerboard pieces against a wall with a ruler.

activity on the Gakkel Ridge, "they wanted somebody who had experience with hydrothermal vents and could react—on the off chance we found anything," Edmonds said.

"I thought the probability of finding vents was small," she said. "But after all, the Gakkel Ridge is a ridge. There would be seawater circulating through the ocean crust, and there could be hydrothermal vents. I may not see anything, I thought, but if I do, it'll be spectacular. If there were vents there, I wanted to discover them."

On the 2001 cruise, Edmonds attached an instrument onto the cable that lowered rock-sampling dredges to the seafloor. The device, called a Miniature Autonomous Plume Recorder, or MAPR, measures, among other things, how light is "scattered" through seawater. Hydrothermal vent plumes contain lots of dissolved particles; light reflects off these particles and back to the MAPR.

"I almost didn't believe it when the very first cast contained evidence of hydrothermal venting," Edmonds said. "Then I started to get big signals of plumes, and things got exciting. It became the exception to get a MAPR back and not see evidence for a plume."

During the 2001 expedition, the *Healy* worked in tandem with the German research icebreaker *Polarstern*. On board that ship was Vera Schlindwein, a seismologist from the Alfred Wegener Institute for Polar and Marine Research in Germany. She was experimenting with a new technique to try to detect the shaking caused by small seismic waves generated by volcanic and earthquake activity on the Gakkel Ridge. These occur every day, but the closest seismic-recording stations are too far away to pick up anything but the strongest shaking on the Gakkel Ridge. Typically, earth scientists could deploy seismometers on the seafloor to get closer to the action. But the Arctic's permanent sea ice makes it almost impossible to put down ocean-bottom seismometers and get them back.

So Schlindwein deployed portable seismometers on drifting ice floes. She flew out from the icebreaker in a helicopter to install them, left them for a time, and retrieved them before the ship departed the area. This unusual measuring method proved successful. The ice floe seismometers recorded sounds by the minute. The sounds were explosive, but they were still too small to be detected by seismometers farther away. The sounds originated from the seafloor in the newly found volcanic region at 85° N.

Meanwhile, scientists aboard the *Healy* dredged up rocks that appeared to have been formed by hydrothermal reactions between seawater and crustal rocks. The accumulating evidence all pointed to the tantalizing possibility that the Gakkel Ridge was not volcanically dead and that it could harbor hydrothermal vents with exotic life forms.

"A lot of scientists in a variety of fields wanted to go back to find out," Edmonds said. "But a lot of things had to align," including getting funding to mount another expedition, securing an icebreaker to use, and "putting together the right team of researchers and the right technology."

Which brings us back to Sohn and his dream of a sub that could explore beneath the Arctic Ocean's ice canopy. At the top of the world, the Arctic Ocean is cold, remote, and covered in darkness for half the year. It's hard enough to get onto the ice-covered ocean. It's even harder to get under it, down to its seafloor, and, most important, back to the surface.

The Arctic Ocean ice pack, up to thirteen feet thick, is a formidable, relentless, and unpredictable obstacle. Vehicles can easily become lost or trapped under the ice, or damaged by it. The ice posed too much of a risk to use *Alvin*, the United States' only human-occupied research sub, which did not have the capacities to break ice or remain submerged for a long time. Unmanned remotely operated vehicles were risky, too, because the cable that tethered

131

THE ICE WAS BEAUTIFUL, BUT IT WAS ALSO THE EXPEDITION'S CONSTANT
nemesis. Like the weather in other parts of the world, the ice governed where the
ship could go, how fast it could get there, and what scientists could do. At times,
the ice packed tightly together, causing ice floes to converge and combine to create
thick, impassable ice. Other times, sea ice spread outward, creating patches or slender
channels of open water, through which *Oden* could snake its way more easily.

132

them to surface ships could be severed by ice, leaving the vehicles at the bottom of the ocean.

A third possibility was unmanned, untethered deep-submergence vehicles that had just become operational a few years earlier. Sohn brought his idea to Hanumant Singh, a scientist and engineer at Woods Hole Oceanographic Institution with experience designing, building, and operating these so-called autonomous underwater vehicles, or AUVs. But even for these free-swimming vehicles, the ice posed challenges.

"In the open ocean, if something goes wrong, we can always make a vehicle buoyant, so it comes to the surface," Singh explained. "You can locate it using a radio beacon, and then you can drive your ship to it and pick it up. In the ice, that doesn't work, because if we were to shut the vehicle off and let it drift to the surface, it might come in under some ice, and we may not be able to recover it. And we have a saying in the underwater world: the number of recoveries should equal the number of deployments."

Now the threads of all these stories came together. Scientists at the National Aeronautics and Space Administration were intrigued by the prospects of searching for extraterrestrial life beneath the ice-covered ocean of Europa. Getting to Europa was right up their alley, and so was developing land-based exploratory rovers. But to develop underwater robots, they turned to scientists more accustomed to vehicles that operated in liquid environments. In 2002, NASA's Astrobiology Science and Technology for Exploring Planets program funded Singh to build experimental deep-sea vehicles for under-ice operations. Though remote, the Arctic Ocean was not as remote as Europa, and it offered a real-life analog to test drive (or in this case, test dive) the vehicles.

Meanwhile, the National Science Foundation funded a research cruise for earth scientists craving to return to the Gakkel Ridge. With Sohn as chief

scientist, the expedition would use Singh's new vehicles to try to find and explore hydrothermal vents, and possibly undiscovered life forms around them.

One scientist eager to go was Susan Humphris, a marine geochemist at Woods Hole Oceanographic Institution. A few years before hydrothermal vents were discovered in 1977, Humphris, then a graduate student, had analyzed rocks dredged from the ocean bottom and found telltale chemical clues that vents existed and were out there, waiting to be discovered. Rocks collected by the *Healy* expedition offered similar tantalizing evidence that hydrothermal activity also existed on the Gakkel Ridge, she said. But even more intriguing, some of the samples contained a type of rock not normally found on ridges, but rather in a deeper layer in the Earth called the mantle.

"Along some parts of the Gakkel Ridge, rocks from the mantle are exposed," Humphris said. "Rocks formed in the mantle, or ultramafic rocks, have a very different chemical composition than rocks in the overlying ocean crust. Hence, the chemical reactions that go on between seawater and ultramafic rocks are different." So they could produce different vent fluids and mineral deposits, which in turn could support life forms not found on other, more explored parts of the midocean ridge. Ultramafic rocks "also have a very similar chemistry to rocks that we believe existed on Earth billions of years ago when the planet was young," she said. "So the Gakkel Ridge is the closest situation we have to investigate the early volcanism that shaped our planet and perhaps the earliest forms of life on Earth."

Those prospects excited marine biologists such as Tim Shank at Woods Hole Oceanographic Institution, who has devoted his scientific career to elucidating how life has evolved in the deep sea. "Hydrothermal vents occur along midocean ridges, but not continuously along a ridge," he explained. "They occur here and there, in places separated by sixty or more miles from each other, with nothing

134

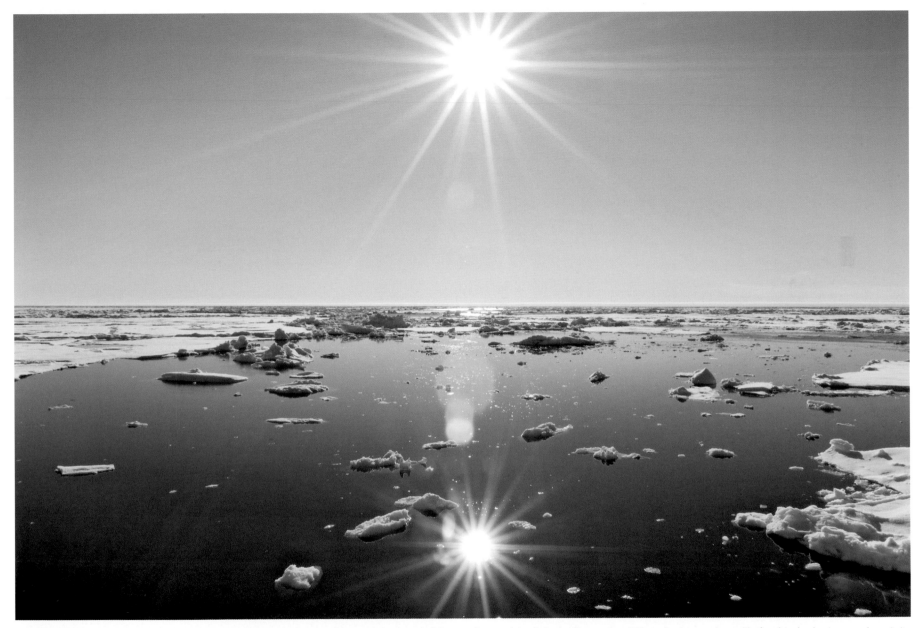

THE SUN NEVER SETS in the Arctic in midsummer, and scientists took advantage of the twenty-four-hour daylight to conduct round-the-clock scientific operations. With no visual cues and a wealth of work to do, sleeping was a low priority.

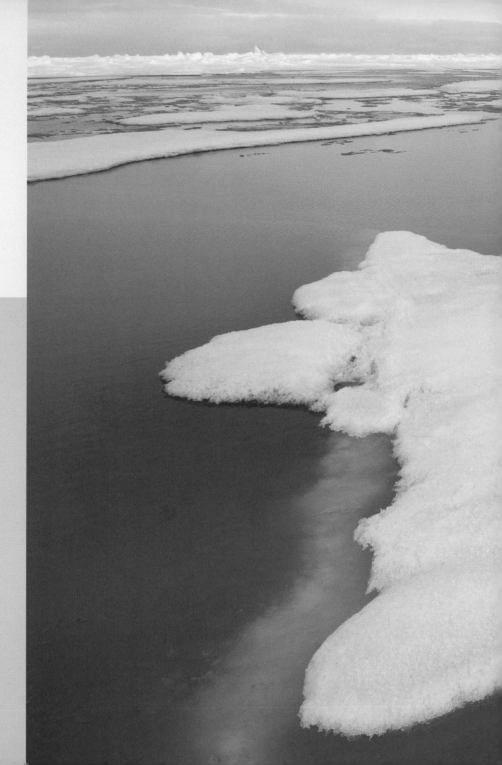

ATOP SOME FLOES, ICE MELTS INTO TURQUOISE POOLS OF WATER.
Maria Tausendfreund, a graduate student at the Alfred Wegener Institute for Polar
and Marine Research in Germany, sampled water in the pools, hoping to collect
specimens of possibly undiscovered species of microbes living in the Arctic.

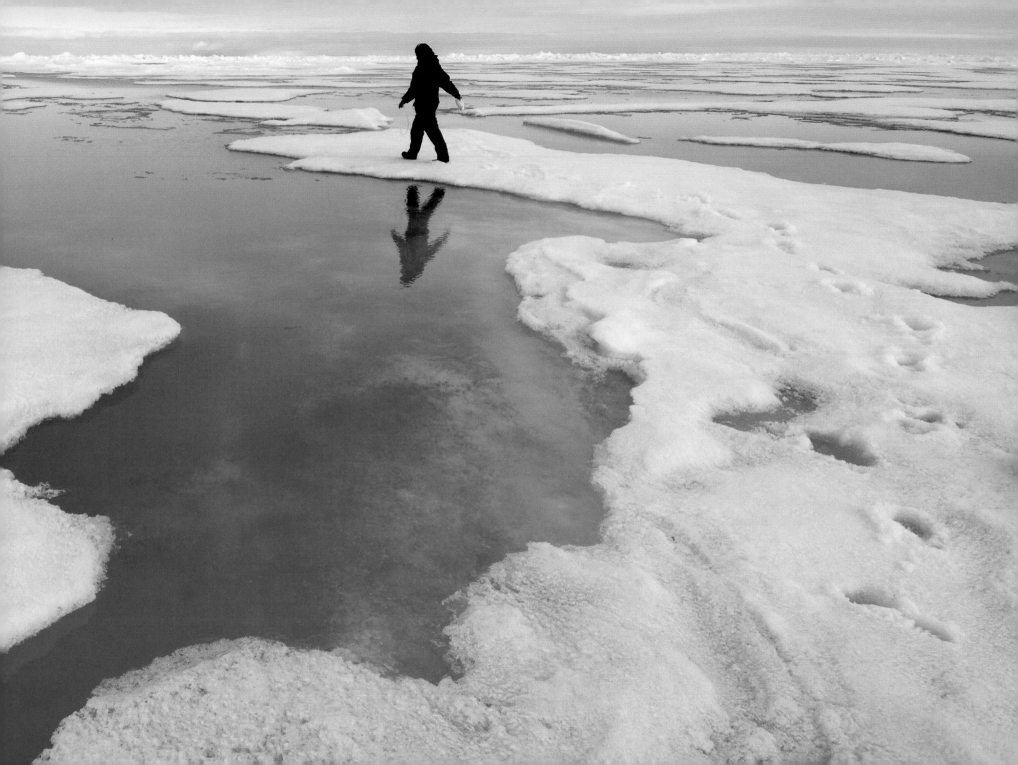

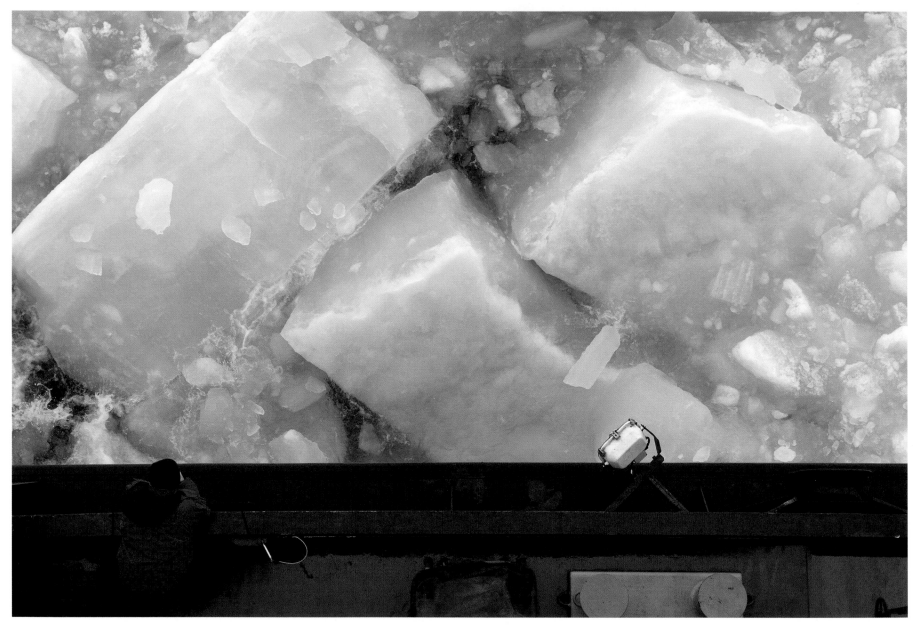

ARCTIC SEA ICE CAN range up to thirteen feet thick. *Oden* busted the solid ice cover into smaller but still massive blocks of ice—the smaller ones the size of SUVs, the larger ones as big as the sides of houses. As the icebreaker moved ahead, newly made chunks of ice bolted up and slid along the ship's sides, showing their ice-blue undersides.

ODEN CUT THROUGH THE white expanse, flipping over floes to expose brown underbellies full of ice algae. When the Arctic sun returns in summer, it penetrates through the sea ice, providing energy for marine algae to grow on the bottom surfaces of ice. The algae nourishes the entire food web, including Arctic cod and sea birds. Black-legged kittiwakes and northern fulmars flocked in *Oden*'s wake, taking advantage of an unexpected meal.

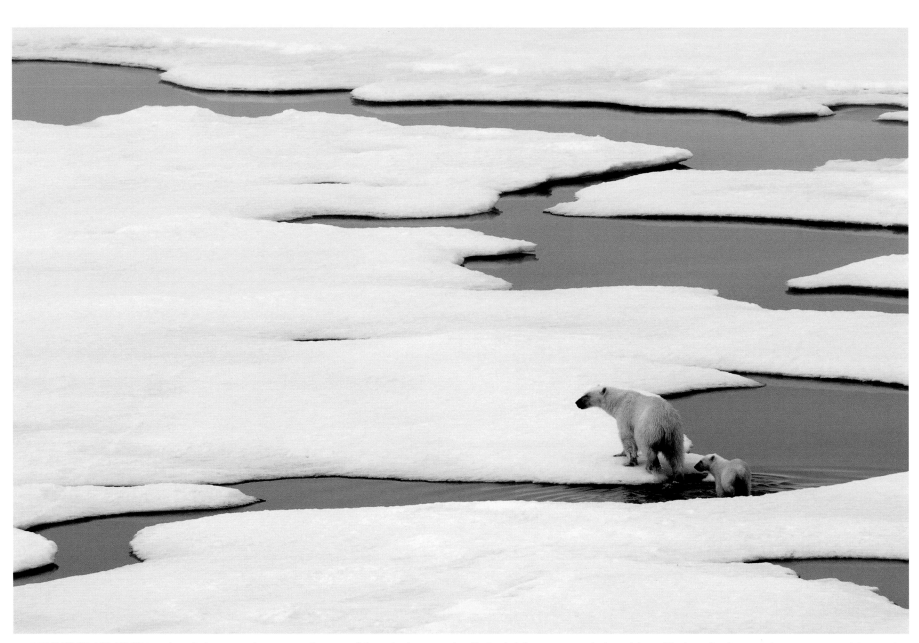

WHERE THERE'S ICE, THERE are also polar bears, or ice bears, as Scandinavians call them. They have streamlined bodies built for swimming and a five-inch layer of fat that makes them more buoyant in water and also provides insulation against the cold. The hairs of their fur are not white; they are actually hollow and translucent and act like miniature greenhouses, turning sunlight into heat. They also camouflage their skin, which is black. Black absorbs solar radiation more readily than white and keeps them warmer.

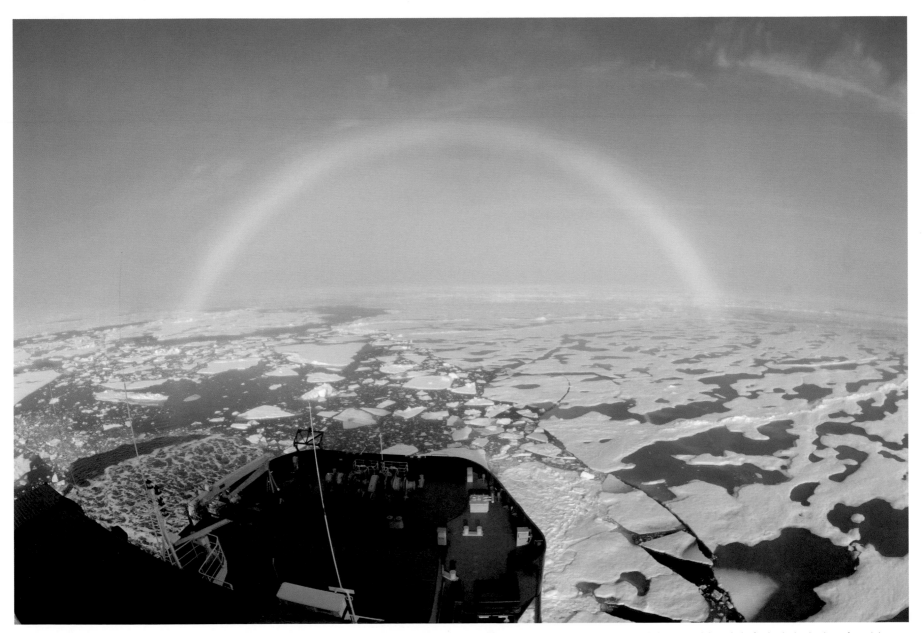

THE ICEBREAKER *ODEN* FOUND itself one day in a pocket of sunlight. Ahead of it in the distance was low fog bank filled with cold, tiny water droplets. As sunlight streamed through the fog bank, the droplets refracted the sunlight to create an Arctic phenomenon called a "fogbow" (also known as a "white rainbow"). *Oden* steered directly toward it, like a proud warrior marching home through a grand ceremonial arch.

life sustaining in between. You have a network of habitats, like they way you have Miami, Washington, D.C., and Boston along Interstate 95.

"Different types of species are found only in certain places. So along the East Pacific Rise (the midocean ridge in the eastern Pacific Ocean) and along the Galápagos Rift, we find areas dominated by tubeworms, large clams, and mussels. But up north, off the coasts of Oregon and Washington, the ridge has a *different* species of tubeworms than we see in the southern Pacific, and a notable lack of mussels.

"At Atlantic Ocean vent sites, it's completely different. We don't see any tubeworms. The Atlantic is dominated by huge swarms of shrimp. If we go to the western Pacific, those vent sites are dominated by different species of hairy gastropods—those are large snails.

"So one of the vexing questions we've had for a long time is what causes and maintains these so-called biogeographic provinces? How do populations on the seafloor get separated so that different species evolve?

"That's why the Arctic Ocean is one of the key places to explore," Shank said in early 2007. "The Arctic Ocean is a virtually enclosed basin. Water can flow in through the Bering Strait and out through the Fram Strait—but only at a shallow level.

"When seafloor spreading began in the Arctic some fifty-eight million years ago, the Arctic Ocean basin was almost completely isolated from any *deep-water* connection to the Atlantic or the Pacific. It has only been for the past nineteen million years that a small amount of deep water has flowed into the Arctic from the Atlantic. So whatever life has been evolving along the deep Gakkel Ridge has likely been doing so for tens of millions of years or so in isolation from other oceans.

"That leads us to ask, 'Well, what fauna is going to be in the Arctic?' We really don't know. It's sort of like thinking about how Australia became disconnected from Antarctica a hundred million years ago, and now we've got kangaroos and koalas there and all kinds of different animals that we don't see anywhere else.

"So what is the evolutionary history of the animals that live in the Arctic, on the Gakkel Ridge?" Shank asked. "If they're there, they may have novel adaptations. They may do things that we may not even know about yet. They may be living off nutrients that we haven't discovered yet."

Seeking answers to these mysteries, Shank, Humphris, Edmonds, Schlindwein, Singh, and Sohn all signed on to a forty-day expedition that was called AGAVE, an acronym for Arctic Gakkel Vents Expedition. Each brought expertise in a distinct scientific field to a mission to search for volcanic activity, hydrothermal vents, and new deep-sea life forms on the Gakkel Ridge. It was scheduled for the summer of 2007 aboard the *Healy*.

In 2006, however, the *Healy* temporarily suspended operations in the aftermath of a tragic accident in which two scuba divers died during a training dive beneath the ice. The scientists and the NSF scurried to find another ship. In the end, they secured the services of the Swedish icebreaker *Oden*.

The year 2007 officially marked the beginning of the International Polar Year, a dedicated effort by scientists around the world to advance knowledge of polar regions. In that collaborative spirit, *Oden* carried a team of scientists from the United States, Sweden, Germany, and Japan. On July 1, 2007, it sailed from the port of Longyearbyen on Spitsbergen, an island above the Arctic Circle, headed into the ice pack toward the Gakkel Ridge.

Peter Winsor had been asleep for only a few hours when a telltale crunching awakened him just before 4 a.m. on July 2. He rushed up to the icebreaker's bridge, seven flights of stairs from the main deck. He wasn't panicked, but rather excited.

Winsor, a physical oceanographer at Woods Hole Oceanographic Institu-

THE HELICOPTER ABOARD *ODEN* and its pilots, Sven Stenvall and Geir Akse, were indispensable. The helicopter scouted ahead of the ship to search for the best routes through the ice pack. It transported scientists and equipment to conduct experiments on the ice. And it proved invaluable for finding and rescuing underwater vehicles surfacing within or beneath thick ice floes.

THE FASTEST ROUTES BETWEEN two points in the Arctic Ocean were never straight lines. They were generally along thin channels of open water between ice floes called leads. On good days, the ship's crew could make connections from one lead to the next to chart an easier course through the ice pack.

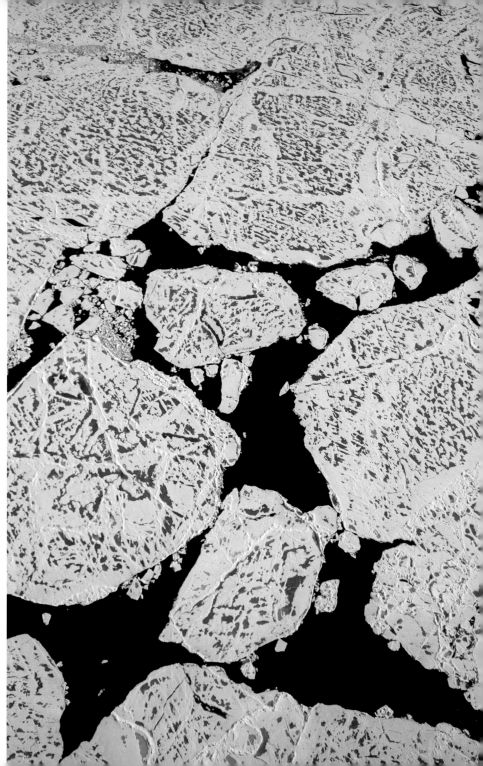

tion and a native of Sweden, had been to the Arctic Ocean aboard *Oden* three times before. So he knew what the crunching sound meant: after twelve hours of sailing in the open ocean, *Oden* had reached the edge of the Arctic pack ice at 80°43.78' N, 10°28.47' E.

And what a remarkably straight edge it was—a line that just seemed to appear suddenly in the ocean, almost like a mirror image of the long, straight horizon farther ahead. On the near side of the line was open ocean; beyond it, white ice as far as you could see.

Winsor joined a group of people looking down from the heights of the ship's bridge, surrounded by large windows on three sides, mesmerized and marveling at the sight. The ice at the edge had formed during the previous winter and was only about three feet thick. It broke easily into smaller floes that spun and jostled against each other, so that their pointy edges were rubbed round until they look like pancakes. That's what this type of ice is called: "pancake ice." All around, it looked like the world's biggest (and coldest) griddle.

Winds blowing from the south pushed the thin pancakes against ice farther north that never melts and grows thicker and harder year by year. The pancake ice assembled into a line, like checkerboard pieces pushed against a wall with a ruler.

The pancake ice was still thin enough to be affected by the ocean, and swells made them undulate gracefully. Atop some floes, ice had melted into turquoise pools of water. And where there's ice, there are also polar bears, or ice bears, as

LONNY LIPPSETT

144

ICE AND WEATHER CONDITIONS continually shifted and scientists and crew convened several times a day to decide which areas they wanted to investigate and what instruments or vehicles they wanted to use. Then the ship's meteorologist and crew calculated how to negotiate the ice to get the ship in the right place at the right time. From left are Hedy Edmonds, University of Texas geochemist; Ulf Hedman, expedition leader from the Swedish Polar Research Secretariat; *Oden*'s captain, Mattias Peterson; WHOI geophysicist Rob Sohn; WHOI engineer Hanumant Singh; WHOI geochemist Susan Humphris; and WHOI biologist Tim Shank.

THERE ARE FEW SUITABLE locations for placing permanent seismometers near the mountains of the Gakkel Ridge to record earthquakes or volcanoes. So Vera Schlindwein and graduate student Julia Linder, pictured, from the Alfred Wegener Institute for Polar and Marine Research in Germany brought their instruments to the mountains. They temporarily installed portable seismometers on ice floes to record seismic waves that travel up through the ocean from the seafloor to the ice floe.

THE FIRST TOOL IN the scientists' toolbox to search for seafloor hydrothermal vents is called a CTD, which stands for "conductivity, temperature, depth." It is lowered and raised by a cable through the ocean, dangling sort of like a fishing line, to collect measurements of seawater temperature and conductivity (a measure of salinity) at various depths. It is also equipped with sensors to detect chemicals and particles that are found in plumes of fluids emanating from vents.

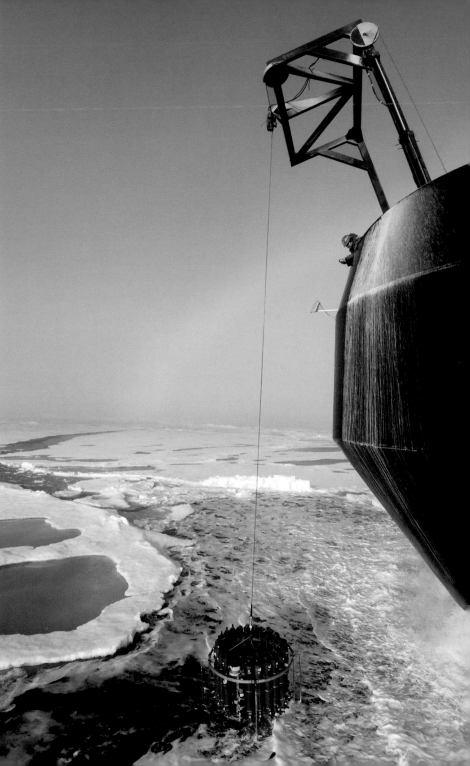

THE CTD AND WOODS Hole physical oceanographer Peter Winsor—even the big A-frame supporting the cable for the CTD—all look tiny compared to *Oden*'s massive, broad bow. Water jets on the bow pushed ice away to maintain a pool of open water through which to dangle the CTD into the depths. A fogbow arched right behind Winsor's head and into a melt pond on an ice floe. The pot of gold for scientists was 2.5 miles below—active hydrothermal vents on the seafloor.

Scandinavians call them. Soon a mother and cub appeared, and later, another mother with *two* cubs.

"*Oden* was not intended to be a research vessel," Winsor said. "It was actually built in Sweden to break ice in the Baltic Sea during winter, to keep the shipping routes open between Sweden, Finland, and Russia. But it turns out that we got more interested in the Arctic, and *Oden* was not used in summer, which is the best time researchers can go to the Arctic." So *Oden* took on a second career.

Heading toward the Gakkel Ridge, *Oden* cut a thin black line in the ice. Moving forward at three to four knots, it created spidery cracks that propagated ahead through the floes and broke them apart. Some floes flipped over to reveal a brown underbelly—full of ice algae that grow on the bottom of sea ice. Arctic birds congregated in the icebreaker's wake as it churned the ocean, probably exposing Arctic cod that feed on ice algae.

"It's like watching a campfire," Winsor said. "You never get tired of looking at it."

The ice was beautiful, but it was also the expedition's constant nemesis. Like the weather in other parts of the world, the ice governed where people could go, how fast they could get there, and what they could do. The ice *was* the weather.

Yet, ice conditions were ultimately influenced by atmospheric conditions, so meteorologist Bertil Larsson, a veteran of eight polar cruises, was aboard to help figure out the best way to navigate through the ice pack. The Swedish

LONNY LIPPSETT

148

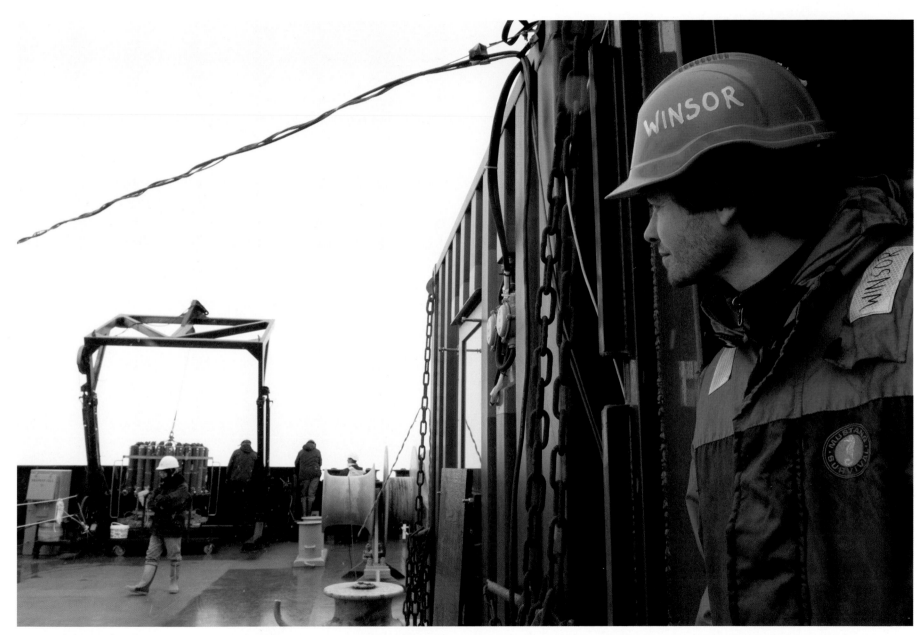

THE CTD ALLOWS SCIENTISTS to map a vertical section of the ocean, physical oceanographer Peter Winsor explained. "We lower the CTD from the surface all the way to the bottom and up again. As it travels down, we make many kinds of measurements. On the way up, we can stop and capture water samples from different depths in the ocean, bring them up onboard, and analyze them in the lab." The scientists moved from spot to spot, using the CTD to detect evidence for hydrothermal plumes.

HELICOPTER PILOT GEIR AKSE REPOSITIONS A SOUND BEACON ON AN ICE FLOE.
The beacons sent signals back to the ship indicating where the ice floe was. By tracking the signals,
Oden's crew could monitor the direction and speed of the ice pack, so they could maneuver the
ship most efficiently. As *Oden* and the ice pack drifted, the pilots continually had to go out, pick
up ice buoy stations drifting out of the range of the ship, and reposition them closer to *Oden*.

150

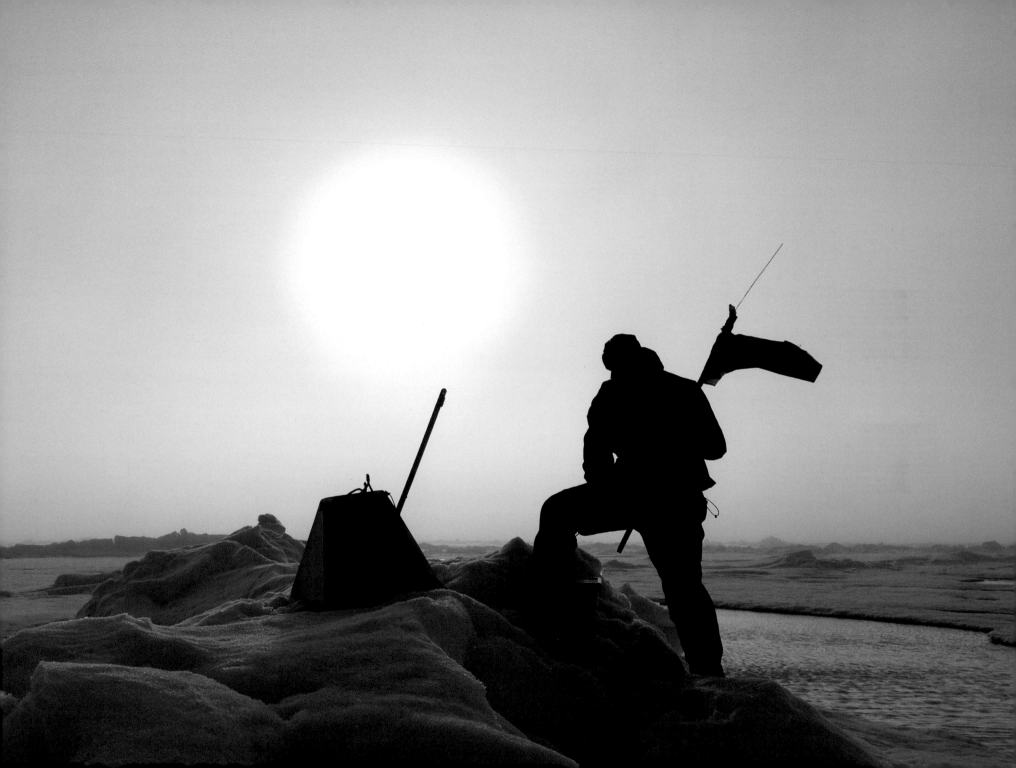

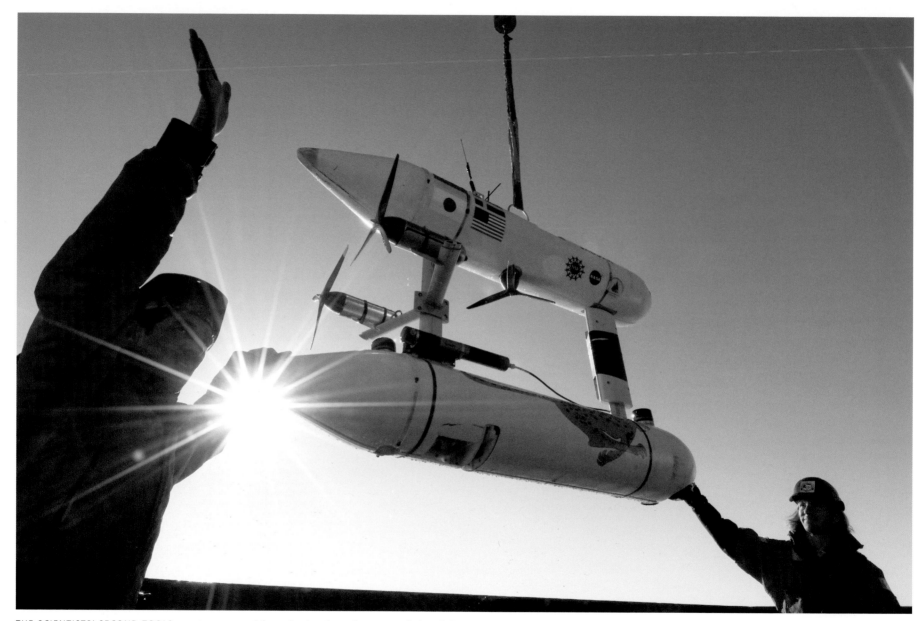

THE SCIENTISTS' SECOND TOOLS were two unmanned, free-swimming, deep-submergence vehicles called *Puma* and *Jaguar*, developed by an engineering team led by Woods Hole scientist Hanumant Singh, left. *Puma* was programmed to swim above the seafloor, surveying wide areas. It was equipped with sonar to make seafloor maps and sensors to detect telltale signals in hydrothermal plumes and help guide scientists to their sources: vents. *Jaguar* was designed to hover just above the vents while its camera and lighting systems collected images of the vents and any animals living around them.

ONE MISSION OF THE AGAVE expedition was to field test experimental underwater vehicles for operations in ice-covered oceans—something that had not been tried before. "You can plan and plan and plan, but you don't know what will happen until you actually do it," said Sohn, biting his nails. "We knew the vehicles had a very real chance of failing, and even being lost under the ice." In a control van, graduate student Clay Kunz (center) and John Kemp, head of deck operations, monitor *Puma*'s ascent from the depths.

Meteorological and Hydrological Institute sent him Arctic weather maps that showed the locations of high and low air-pressure systems.

High-pressure systems make winds spin clockwise, causing the sea ice to converge. "That is not good," Larsson said, because it packs the ice more tightly together. When ice floes converge, one floe can slide atop another and then combine to create multiyear ice that can reach many feet thick. Low-pressure systems, on the other hand, allow sea ice to spread outward, increasing the chances of creating isolated patches of open water or slender, zigzagging cracks in the ice, called leads, through which *Oden* could snake its way with less effort, time, and fuel consumption.

So the trick was to find and follow the leads. In the old days, polar mariners scanned ahead, looking for clouds floating low on the horizon. White ice often reflected brightly off the bottoms of low-lying clouds, a phenomenon known as "iceblink." In contrast, patches of dark open ocean cast dark reflections on cloud bottoms, a phenomenon known as "water sky."

Oden's crew, however, relied heavily on its helicopter. Several times a day, it took off like a metallic dragonfly and disappeared into a white-on-white ice and sky or into murky gray mists. Throughout the day, even if those aboard *Oden* couldn't see the fire-engine-red helicopter in the gray mists, they could still hear its higher-pitched hum above *Oden*'s deep rumble.

The helicopter was owned and operated by Sven Stenvall, part of a fleet of ten helicopters owned by his family business. Stenvall, who has been flying since 1979, has had all sorts of clients. He has flown hunters, fishermen, hikers, tourists, and heli-skiers into the backwoods of northern Sweden. He has transported equipment for the Swedish space agency and used helicopters to herd reindeer during dark Swedish winters.

Stenvall and fellow pilot Geir Akse would go aloft with one of *Oden*'s officers—Thomas Strömsnäs, Mikhael Hagre, or Niklas Hammarqvist—scouting up to twenty-five miles ahead for leads and trying to connect them with other leads to chart an easier course for the ship to follow. The pilot and officer might recommend taking a lead around the northern edge of an ice floe, rather than the southern lead, for example, or guide the ship to steer clear of impregnable floes with diameters measured in miles.

When they settled on the best route, the pilot flew along it from its end back to the ship. Sound beacons on the helicopter logged the route directly into the ship's navigation system. On a monitor in *Oden*'s control room on the bridge, scientists and crew could watch throughout the day as the icebreaker moved along the helicopter's track—at first. But over time, the two tracks diverged as the ice pack continuously shifted. Ice floes surged and spun. Cracks opened and closed. The path that existed four hours ago no longer did, and the helicopter went aloft again to scout current conditions.

Despite the heroic helicopter reconnaissance, *Oden* inevitably had to break ice and did so in its own way. *Oden* did not resemble conventional icebreakers with traditional wedge-shaped bows that try to crack the ice by ramming it. Instead, *Oden* had a square bow equipped with twelve nozzles, or thrusters, that sprayed high-powered jets of water onto ice floes. The water lubricated the ice so that *Oden*, with its relatively flat bottom, could ride up and on top of the ice more easily.

"Most people would think of snow as slippery," said Strömsnäs, *Oden*'s second officer. "But with thirteen thousand [metric] tons of pressure on it [from the ship], you do get friction." The water from the jets reduced the friction, and the pressure from the ship's thirteen-thousand-ton weight cracked the ice floes into smaller pieces. Networks of cracks appeared and spread through large ice floes—just the way (on a much smaller scale) cracks spread across the surface of a frozen puddle when you step on it.

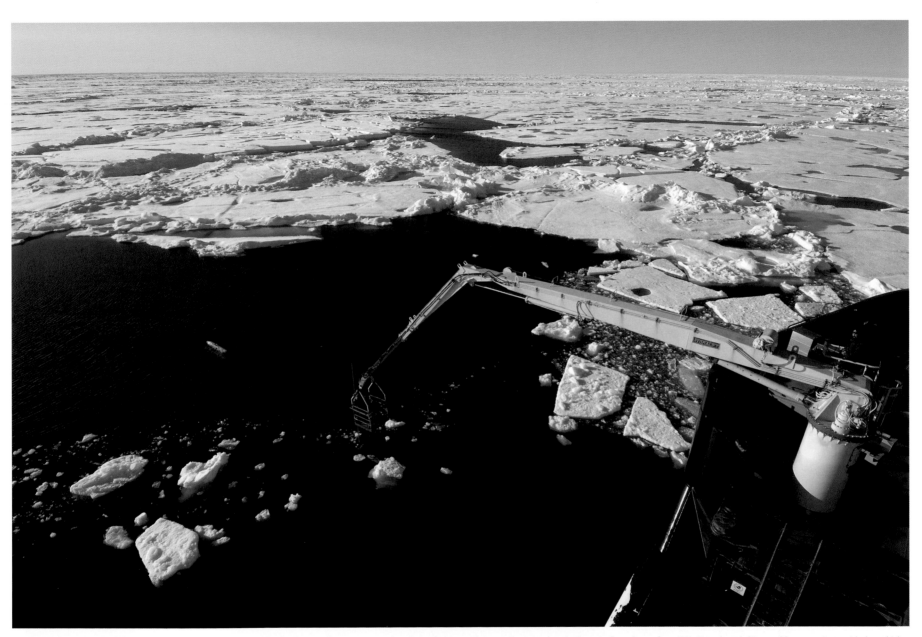

155

UNDER GOOD CONDITIONS, THE operational scenario called for *Puma* and *Jaguar* to complete their missions and rise to about two hundred meters from the surface. Scientists aboard ship would communicate with the vehicles by transmitting and receiving acoustic signals and guide them toward a hole in the ice. On a good day, there was a big hole. Able seaman Stefan Börstad extends *Oden*'s crane to get John Kemp, in a metal basket at the tip, close to the water line to retrieve *Puma*.

ON SOME DAYS, ICE CONDITIONS FORCED *ODEN*'S CREW TO WORK HARD TO make holes to retrieve underwater vehicles. *Oden* busted ice floes into smaller but still massive blocks of ice. The icebreaker rode over the icy rubble field, mashing it into even smaller pieces. Then it veered into a tight circle, with a diameter of perhaps two ships' lengths. It herded the ice rubble into the center of the circle. Then it tried to push it to the side to create a hole. But the ice swarmed back, clutching at the ship's hull.

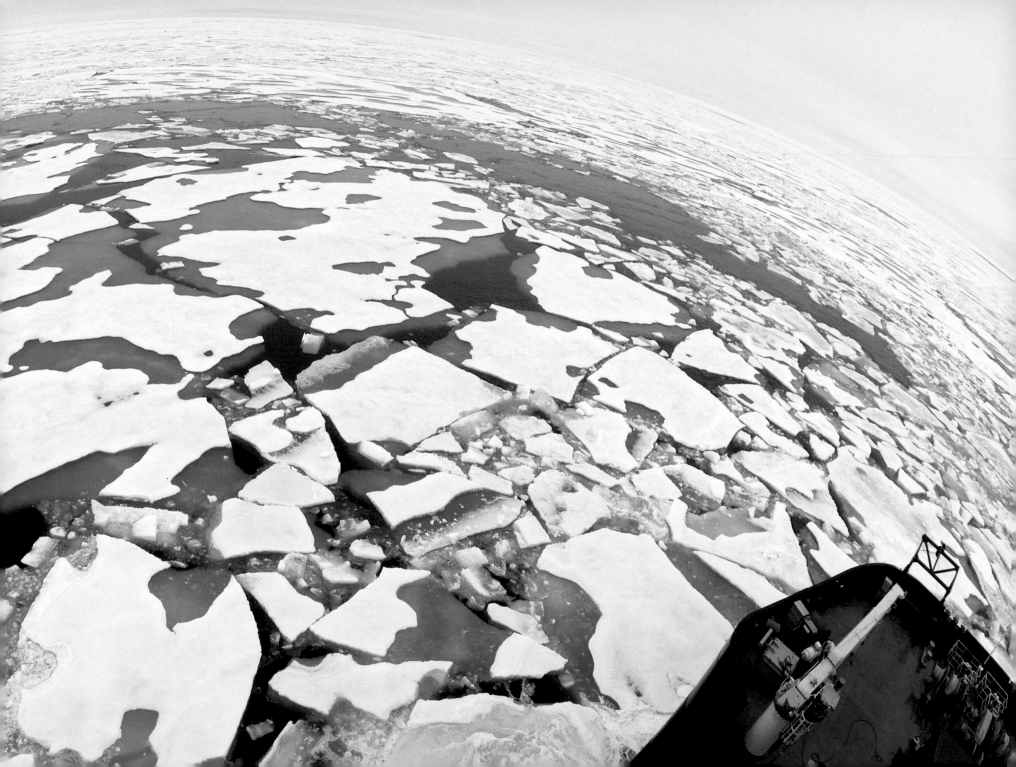

JOHN KEMP AND ULF HEDMAN, WITH A SHOTGUN SLUNG ON HIS BACK in case of polar bears, were lowered to search for *Jaguar*, which lay somewhere under the ice. They carried rope and a receiver that could locate a sound beacon on *Puma* similar to one used to find people trapped under snow in avalanches. The receiver would beep more loudly if it were near *Puma*'s beacon and more faintly if it were farther away.

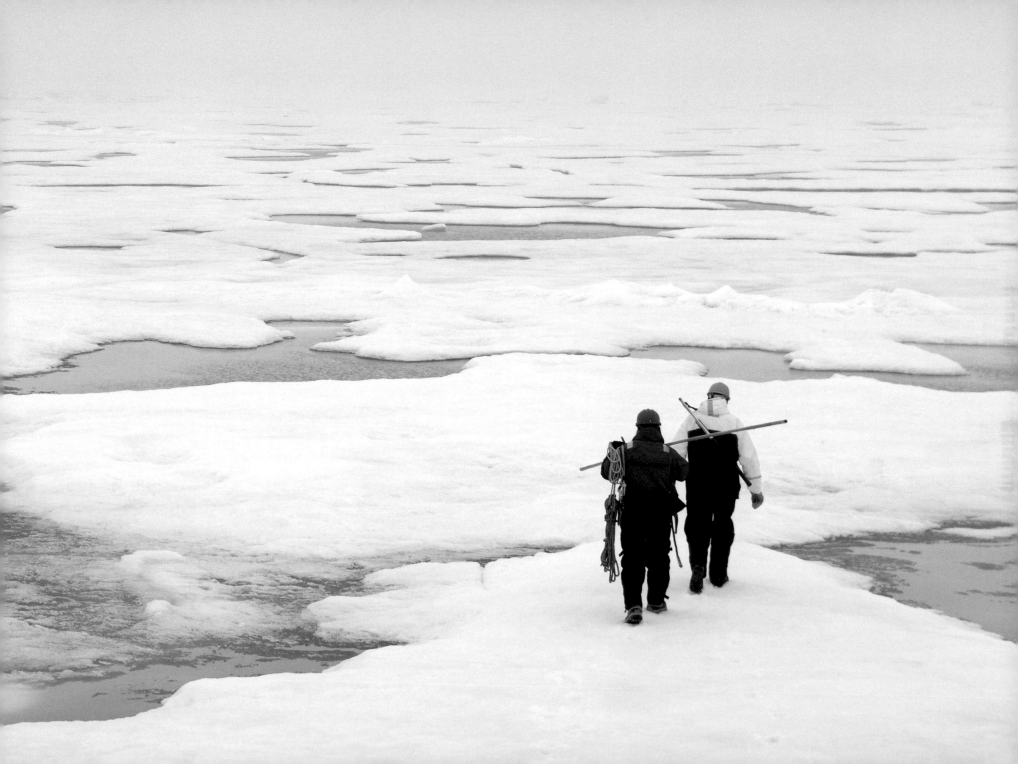

Once a sheet of ice was broken into a jumble of smaller (though still massive) ice chunks, *Oden* had to clear those ice chunks out of the way. Typically, the crew would steer *Oden* to one side of a lead, breaking ice on one side of the ship and pushing broken ice into open water on the other. But when high-pressure conditions pressed the rest of the ice pack hard against the ship from all directions, it was hard to find space to shove the ice.

"When the ice gets tough, the best weapon we have is the ship's heeling tanks," Strömsnäs said. These are two pairs of tanks on the port and starboard sides that each can be filled with four hundred tons of water.

"You have the full weight of the ship and the added weight of the water on the ice," he said. The water can be shifted from one side of the ship to the other through a pipe as tall and wide as a person—in about fifteen seconds. That causes *Oden* to list back and forth, from one side to the other, which helps break ice. The ship could be programmed to do this automatically, something the crew called the "duck walk."

"Level ice is normally not a problem," Strömsnäs said. "The problem is the ridges, and we really don't want to go into those." Ridges form when the sides of ice floes smash against each other or are squeezed together and can pile up thirty to forty feet high. "Sometimes there just isn't room, and we end up smack-boom in the middle of a ridge," Strömsnäs said. "So we back up and get lined up better and ram."

Occasionally, *Oden*'s bow butts heads with an ice floe and loses, and the ship must back up and seek a path of less resistance. "The worst thing is to go (into a lead) between two big floes," he said. "It looks very tempting. But the floes can exert tremendous pressure on each side of the icebreaker and wedge it in.

"Sometimes, we just get stuck," Strömsnäs said. "We wiggle from side to side or back and forth, just to move a few decimeters. Sooner or later, you will get loose. Or you wait for the tide and the weather to change and loosen the ice. I think the record (for being stuck) is about twenty-four hours."

The AGAVE expedition returned to a site where six years earlier Schlindwein had found evidence of volcanic activity and Edmonds found evidence of hydrothermal plumes. The scientists came back with robotic vehicles designed to follow the plumes back to their vent sources. But first the scientists had to find plumes again. "A major fear is that there isn't a vent field there any more," Sohn said. "A second fear is that's it's there, and we can't find it."

Picture this: You are searching for a group of people huddled around a small campfire. It is in a vast and unforgiving desert, so you can't just walk in. Your only hope is to fly a helicopter above the desert to see if you can spot the smoke from the campfire. But an endless sandstorm swirls above the desert. You have to fly over it, and you can't see through it. So you put a thermometer and a smoke detector on a long wire that you lower down through the storm in a place where you think there might be campfire smoke, and then you hope your tiny instruments run into it.

For oceanographers, the ocean is the sandstorm; the thermometer and smoke detector on a wire is an instrument called a CTD, which stands for "conductivity, temperature, depth." As it is lowered and pulled up again, it sends temperature and salinity readings to scientists aboard ship. Hydrothermal vents emit fluids that often reach 662 degrees Fahrenheit, or 350 degrees Celsius. They are quickly diluted by cold ocean water, but vent fluids in the plumes still retain a telltale bit of their outgoing heat. If the CTD detects water temperature sharply rising by 0.01 degrees to 0.02 degrees Celsius, it has hit a plume. Hydrothermal vent fluids are also filled with mineral particles. The CTD has a device called a transmissometer that shines a beam of light through the

seawater. If the beam becomes clouded by particles, it is another sign that the CTD may have hit a plume.

Finally, the CTD carried a device called an E_h sensor, brought along by Ko-ichi Nakamura from the National Institute of Advanced Industrial Science and Technology in Japan. It is an electrochemical device that sensitively measures ions in fluids. It was originally developed for monitoring atomic energy plants, but Nakamura adapted it to detect tiny telltale chemical changes that signal the presence of hydrothermal fluids in seawater. On most other vessels, CTDs are deployed over the side, but that would be difficult on *Oden*, whose sides were usually hugged by ice. So on *Oden*, the large winch that spools the instrument wire up and down was located on its bow.

George Tupper, an engineer at Woods Hole Oceanographic Institution, had deployed CTDs for decades in all the world's oceans, but never before in an ice-covered one. There were advantages to it, he said. For once, he didn't have to wrestle a 1,500-pound instrument hanging on a wire on a rolling vessel. *Oden*'s jets pushed the icebreaker solidly against an ice floe to deaden any rolling.

But at same time, never before had Tupper dealt with making a hole in ice to put the CTD through and keeping that hole open for several hours as the CTD went down and up. *Oden*'s jets took care of that, too, pushing ice chunks away from the hull to create a watery hole and bubbling water in the hole to keep it open.

The CTD team also included Winsor and Bengt Liljebladh, a colleague from Winsor's alma mater, the University of Gothenburg in Sweden. The team literally tested the waters, casting the instrument into the ocean, lowering it to the bottom, and pulling it up again in search of a plume. Then the scientists would direct *Oden* to another spot, perhaps a quarter mile in one direction or another, to try again.

"It's hit or miss," Edmonds said. Or something like the old scavenger hunt game in which the seekers are told they are "getting warmer" or "getting colder" as they move closer to or farther from the object they are looking for.

Each CTD cast would normally take a few hours in an open ocean, but it took longer in the Arctic. In each spot selected by scientists, *Oden* had to break ice and use its water jets to create a clearing in the ice pack through which to lower and raise the CTD.

If the ship were in open water, it would simply steam to a newly selected spot. But in an ice-covered ocean, the helicopter often had to scout ahead to see if the ship could actually get to the site. Once, an impassable ice floe—five nautical miles wide by about four nautical miles long—sat squarely atop a site scientists wanted to investigate.

"It's a very different deal working up here," Edmonds said. In an ice-free ocean, scientists could tow the CTD along a line, rather than lower and raise it at just one point. In the Arctic, scientists plotted a line they wanted to measure and then huddled with *Oden*'s officers to calculate how fast and in what direction the ice pack was being shoved by winds. Together they decided where to put in the CTD so that the ship and the CTD would flow downstream with the ice in the direction they desired.

Meanwhile, Schlindwein and her graduate student, Julia Linder, worked on another front. They packed their gear into Stenvall's helicopter and flew to ice floes to set up an array of seismometers. The seismologists scraped snow off the floe to make a solid, level foundation for their devices, which would remain on the floes for several days, recording whatever seismic events occurred. Essentially, the scientists wanted the seismometers to record seismic waves that travel up through the ocean from the seafloor to the ice floe. They would ignore horizontal motions, which are largely caused by "ice quakes" generated by the creaks and rattles that occur when ice floes bump against one another.

They covered the seismometers with plastic buckets and shoveled a little

161

igloo of snow on top to minimize vibrations from winds. Then they planted a red flag on the ice floe to help helicopter pilots find and retrieve the instruments. "We don't know if and when we're going to be back here again," Sohn said. "We really feel like we've been given an opportunity and a mandate to get as much information as we can, across all disciplines."

While physical oceanographers and geochemists continued to probe the ocean's watery depths in search of plumes, Singh and his engineering team began to test their robotic vehicles. Painted canary yellow and shaped like double-decker torpedoes, they were called *Puma* and *Jaguar*.

Once the CTD team provided a rough idea of where a plume was, Puma was programmed to swim hundreds of feet above the seafloor, surveying areas of perhaps 1.25 miles. It was equipped with sonar to make seafloor maps and sensors to act like a bloodhound and "sniff out" telltale temperature, chemical, or particle signals in the plumes and help guide scientists to their sources: vents. Then *Puma*'s look-alike sibling *Jaguar* was designed to take over—to home in on the vents and hover just above them like a hummingbird while its camera and lighting systems collected images of the vents and any animals living around them.

Originally, *Jaguar* was also supposed to have a robotic manipulator arm to collect samples, designed in collaboration with scientists at the University of Maryland's Space Systems Laboratory. But NASA budget cuts forced it to scale back or eliminate many science projects, including that one.

The Woods Hole scientists had a plan B. A team led by engineer John Bailey quickly constructed a third new under-ice vehicle, which it nicknamed *Camper* (short for "camera/sampler"). It was a steel-framed, open-sided box—five feet wide, seven feet long, five and a half feet tall, and weighing 6,200 pounds—with all its electronic guts and plumbing crammed inside and exposed to view. Dr.

Frankenstein would have appreciated it. Describing the three vehicles, Singh referenced the old Clint Eastwood movie: "I can't tell which one of the vehicles will be good or bad, but I do know which one is ugly."

Camper was equipped with camera and lighting systems, thrusters to maneuver and hover the vehicle briefly over vent sites, and hydraulically operated systems to collect samples. It was lowered to the seafloor and towed behind the icebreaker on a reinforced fiber-optic cable that relayed commands down from operators aboard *Oden* and data up to the ship.

Since scientists did not know what they would find at Arctic Ocean vents, *Camper* had two types of sampling devices: a mechanism like a steam shovel to sample rocks and immobile creatures such as clams, and a suction device, like a vacuum cleaner, designed to slurp up swimming organisms such as shrimp.

Nobody had any experience using vehicles like these under the ice. "You can plan and plan and plan, but you don't know what will happen until you actually do it." Sohn said. "We knew the vehicles had a very real chance of failing, and even being lost under the ice."

"Given the risks and the potential returns, we felt that this [was] worth pursuing," Singh said. "If we didn't take risks, we would not make huge leaps."

Under the operational scenario, *Puma* and *Jaguar* would complete their missions and rise to about two hundred meters from the surface. Scientists aboard ship would communicate with the vehicles by transmitting and receiving acoustic signals and guide them toward a hole in the ice for retrieval.

On a good day, scientists guided *Jaguar* up and toward the pool where it popped out, like a wet kitten coming out from under a porch, and headed directly toward *Oden*. The ship's crane, which could extend 105 feet over the side, seemed to stretch toward it like a long arm with a bowl of milk to coax the kitten home. In a metal cage at the crane's tip, John Kemp, a Woods Hole engineer and head of deck operations, reeled *Jaguar* in.

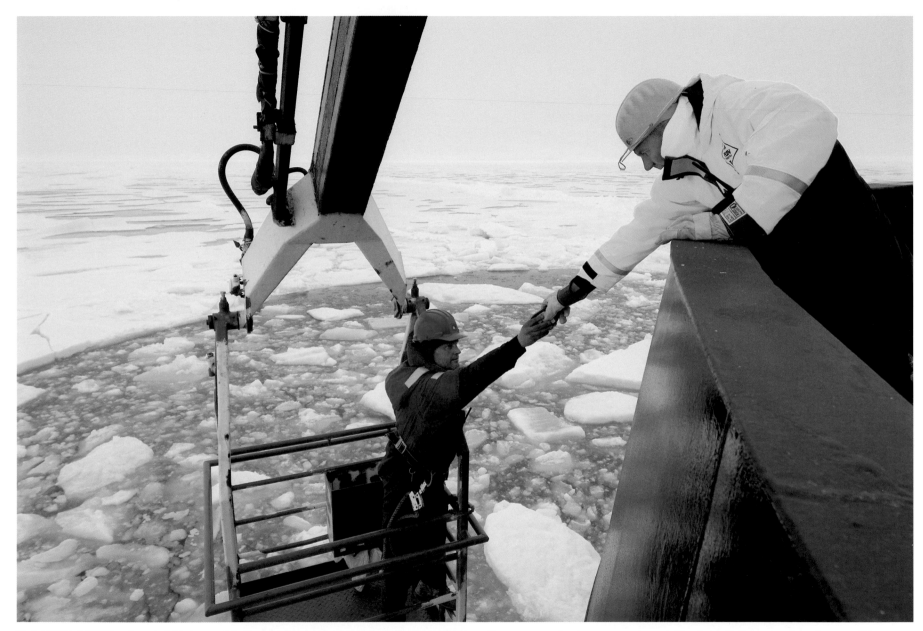

IN A METAL BASKET at the end of *Oden*'s crane, John Kemp reaches up to hand an avalanche beacon to Ulf Hedman. There was no nearby place to get a replacement if he dropped it. Kemp was trying to locate a vehicle somewhere under the slurry of ice in a pool that *Oden*'s water jets were trying to keep open.

ODEN'S CHIEF OFFICER, OLA ANDERSSON, LOWERED A METAL CRANE-BASKET toward the ice, reaching slightly underneath the ship and along its hull. *Puma*'s yellow nose peeked out from under an ice floe. With a long metal pole, John Kemp pushed aside ice floes to create a small opening for the rest of *Puma* to pop into, and he steered away other potentially damaging floes. He reached to fasten a clip to a hook on top of *Puma*, and Andersson hoisted Kemp and *Puma* aboard.

165

But then there were other days.

With the sun shining shortly after midnight on July 20, halfway through the voyage, *Puma* entered the ocean, perhaps showing a hint of reluctance. The mechanism releasing it from its line didn't work. Kemp grabbed some tape and attached his knife to a metal pole. He cut the line manually to send *Puma* on its way to the seafloor.

Sometime after 7 a.m., after completing 75 percent of its planned mission, *Puma*'s vertical thruster stopped working. It could no longer propel its way upward. The vehicle could rise only by using its own buoyancy to float to the surface. And it had to rise in an open pool of water near the ship, not under the ice. "We just have to make sure the AUV's lift and the ice's drift coincide perfectly," Bailey said sarcastically. "It should be a piece of cake."

Puma had no steering wheel or joystick to control it, Bailey explained. Its drivers got a reading of its location every few minutes and could give it basic commands, such as "stop," or "go forward to this location," or "go upward to this depth"—though that last command was worthless on this day because of the malfunctioning vertical thruster.

The AUV team calculated how long it would take for *Puma* to rise from its depth of 2.3 miles. Larsson calculated where the ice drift would take the ship by that time. *Oden*'s helicopter flew out to find an area in the dense ice pack where *Oden* could make a hole in which *Puma* could surface. The AUV team calculated a route for *Puma* to rendezvous with *Oden* at the surface.

Oden busted ice floes into smaller but still massive blocks of ice—the smaller ones the size of SUVs, the larger ones as big as the sides of houses. Along the ship's sides, the newly made chunks—suddenly separated and freed from the ice pack—bolted up along fresh cracks and somersaulted, showing their thick, ice-blue undersides. Tall, tilted slabs of ice lurched out of the ocean like arms thrust out of graves in a horror movie. Flat bricks rose up buoyantly with a whoosh, as waves of water sheeted off their surfaces and fell in waterfalls over the edges. This hodgepodge of hunks mixed with a slurry of slush, like the wreckage of a sunken ship.

High above on *Oden*'s glass-windowed bridge, *Oden*'s master, Mattias Peterson, directed operations, and Second Officer Strömsnäs worked the ship's controls. They looked down on the unforgiving ice pack, continually assessing the situation.

Oden rode over the icy rubble field, mashing it into even smaller pieces. The icebreaker veered into a tight circle with a diameter of roughly 650 feet, perhaps two ships' lengths. It herded the ice rubble into the center of the circle, then it tried to push it to the side to create a hole. But the ice swarmed back, clutching at the ship's hull.

Transponders, or sound beacons, were put over the side to listen for "chirps" from *Puma* as it neared the ship. Woods Hole engineer Cliff Pontbriand and graduate students Claire Willis and Mike Jakuba—looking like picadors at a bullfight—used long metal poles to keep away ice floes that would squash the transponders like grapes. They stood ice duty for hours in the cold, hoping the AUV team could steer *Puma* back to a small pond filled with broken ice off *Oden*'s bow.

"We had to come up [with *Puma*] as soon as we could and as close to the ship as we could," said Singh. But several circumstances made the situation dicey.

The scientists directing *Puma* couldn't prevent it from rising. But they could slow its ascent slightly by moving it forward and pushing its nose down a little. Whenever they used that maneuver, however, they used *Puma*'s diminishing battery power, and when the batteries died, the vehicle would lose its ability to move at all. The drivers also lost track of *Puma*'s location as it neared the ship's sides, where the transponders could no longer pick it up well.

Woods Hole scientists Humphris and Shank donned exposure suits and

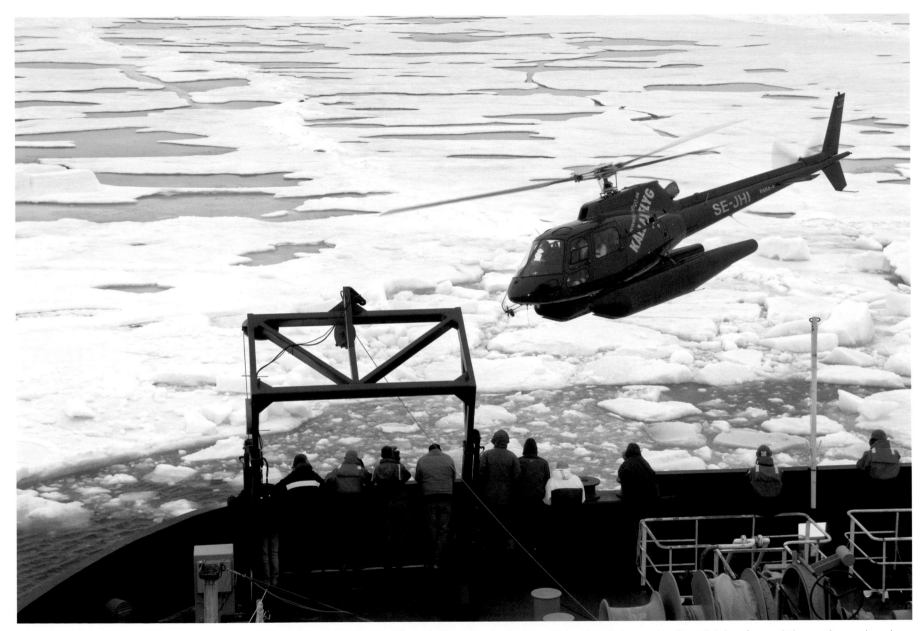

DURING DIFFICULT RETRIEVAL OPERATIONS, helicopter pilots flew around the ship, with the avalanche receiver dangling by a cable just above the ice, searching for a telltale beep from a vehicle somewhere nearby under the ice. Flying directly in front of *Oden*'s bow, the helicopter's rotors blasted frigid gusts on a line of people looking over the bow and searching for a glimpse of *Puma* amid the ice slurry.

DURING ONE RESCUE, PILOT STENVALL LANDED THE HELICOPTER
on a small floe. Pilot Geir Akse and Ulf Hedman rushed to the edge of the floe and
hooked a line on *Jaguar*. They attached one of *Oden*'s round lifesavers to prevent the
heavy line—if it broke—from dragging *Jaguar* down under again. The helicopter took
off, and the robot designed to swim through the ocean flew through the air.

168

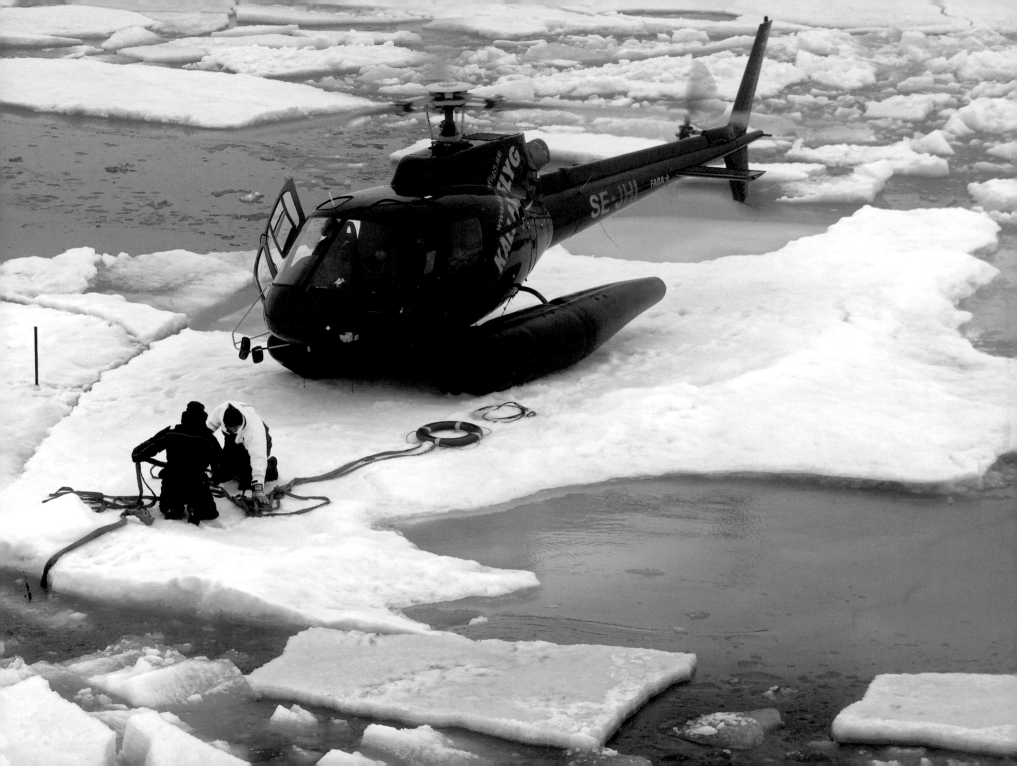

boarded *Oden*'s helicopter with pilots Stenvall and Akse. They carried a receiver that could locate a sound beacon on *Puma* similar to one used to find people trapped under snow in avalanches.

Stenvall flew the helicopter around the ship, with the avalanche receiver dangling by a cable just above the ice. The receiver would beep more loudly if it were near *Puma*'s beacon and more faintly if it were farther away. Stenvall hovered in one spot, then another, sometimes leaning the helicopter and sometimes inching it backward over the floes, searching for a telltale beep and trying to find and follow a sound trail.

At one point, the helicopter flew directly in front of *Oden*'s bow. Its rotors blasted frigid gusts on a line of people looking over the bow and searching for a glimpse of *Puma* amid the ice slurry.

Then Shank spotted *Puma*'s blinking strobe light between jumbled pieces of ice on *Oden*'s port side, right next to its hull, and then a bit of *Puma*'s yellow skin. Kemp was already strapped into the metal basket on the ship's crane. *Oden*'s chief officer, Ola Andersson, lowered the basket toward the ice, reaching slightly underneath the ship and along its hull. For several tense minutes, neither Kemp nor anyone else saw *Puma*. Had it gone under the ship? Then Nakamura shouted, "There it is!"

Puma's nose peeked out from under an ice floe. Andersson maneuvered Kemp toward it. With a long metal pole, Kemp pushed aside ice floes to create a small opening for the rest of *Puma* to pop into, and he steered away other potentially damaging floes. He reached to fasten a clip to a hook on top of *Puma*, and Andersson hoisted Kemp and *Puma* aboard.

Before *Jaguar*'s first-ever deep-sea mission, Sohn was eager, and he projected his emotions onto the robot: "*Jaguar* was saying, 'Let me out of my cage. Show me the bottom.'"

But *Jaguar* never saw the bottom. At 1 a.m. on July 22, *Jaguar* lost contact with the sound beacons on the seafloor that told the engineering team where the vehicle was located in the depths. The team did not want to risk going down blind and sent a command to stop the mission.

At first, *Jaguar* did not respond and continued to dive to the seafloor. Finally, it did respond, and soon engineers figured out why it had taken so long. A software glitch caused commands to the vehicle to stack up and have to wait in line. Like a computer processing too much data at once, *Jaguar* backed up and began to run torturously slowly. It took *Jaguar* forty minutes to respond to a command, rather than the usual three minutes.

At 10:30 a.m., scientists and crew prepared to recover the vehicle. Woods Hole graduate students Chris Murphy and Clay Kunz sent transducers over the side in four locations on *Oden* to measure how long it took sound signals from *Jaguar* to reach the transducers. On the bow, for example, it took 0.3543 seconds. That, multiplied by the speed of sound traveling through Arctic seawater (about 1,500 meters per second), equaled *Jaguar*'s distance from the ship—roughly 530 meters (1,738 feet). But they could not tell for sure which direction it was in, and in all directions, there was ice.

Humphris, Shank, Stenvall, and Akse boarded the helicopter again with the avalanche beacon to try to locate *Jaguar* under the ice. The receiver's range was twenty to thirty meters (sixty-five to a hundred feet). Akse lowered the avalanche receiver out the helicopter's window by a cable. It dangled over the ice, sometimes only inches above it, as the helicopter slowly circled an area roughly 530 meters away from the ship—a little red helicopter searching for an even littler yellow robot in a vast field of white. They spent an hour in the air, but they heard no signal from *Jaguar*. Time to try another strategy.

The helicopter flew back to *Oden*, and Kunz and Murphy got in with a transducer to receive signals from *Jaguar*. Akse dangled it on a cable and dipped it

into leads in the ice—first on *Oden*'s starboard side, then moving counterclockwise to just in front of *Oden*'s bow. Kunz and Murphy relayed information to the bridge, where Jakuba used a little quick trigonometry to determine the exact point where *Jaguar* was located.

"It's pretty much dead ahead, slightly off starboard," said Singh, pointing to the bow—565 meters (1,853 feet) from *Oden*'s Global Positioning System antenna.

"That puts it 86 meters (282 feet) into that floe," said Captain Peterson, pointing ahead and looking out the big bay windows on the icebreaker's bridge.

Stenvall and Akse took off toward the spot with the avalanche beacon. This time they got a signal from *Jaguar* beneath the ice. Stenvall dropped a red-painted piece of wood on the ice to show him where the ice surface was. He landed the helicopter, picked up the wood, scraped it into the ice to mark *Jaguar*'s location, and flew off.

Now a decision had to be made. One option was to use the helicopter to put people on the floe with a small camera-equipped robot with a 250-meter (820-foot) line that could swim under the ice and locate *Jaguar*. It was also rigged to try to hook a line on *Jaguar* and pull it out from under the ice.

Or the crew could try to move *Oden* close enough to the marker without accidentally running over *Jaguar*, pushing ice floes into the vehicle and damaging it, or stirring up the ice too much and losing the vehicle again. Kemp recommended "gingerly sneaking the ship" closer to *Jaguar*.

It's not often that you can use a word like "sneaking" in reference to a 9,438-gross-ton, 107.7-meter (353-foot) icebreaker, but that's essentially how Captain Peterson maneuvered *Oden*. He inched the vessel along a lead toward the marker, nudging at the ice, shaving pieces off the edges, steering them away, or flushing them aside with *Oden*'s water-jetting bow thrusters going at their mildest level.

Another challenge lay ahead. Between the lead and the marker was a pressure ridge—a raised line of ice in the floe where two floes had collided before freezing together. As high and thick as they rise, the ridges usually descend even deeper into the water, often creating jagged undersides that could easily snag a *Jaguar*, Kemp said. Captain Peterson nibbled at the ridge to crack it without damaging *Jaguar*, which was somewhere nearby.

At last, the starboard side of *Oden*'s bridge nearly hung over the red marker, and Captain Peterson stopped the vessel. He walked to the other side of the bridge to assess the situation on the port side, then walked back. With a smile and a little twinkle in his eye, he whispered something that means the same in both Swedish and English: "Phew."

Scientists and crew, bundled against the cold, raw weather, stood on several of *Oden*'s decks looking for a glimpse of *Jaguar*'s yellow skin. People high on the bridge saw it first. A few minutes later, people on the first deck saw it too, and their whoops and cheers rose up to the bridge. Not far off *Oden*'s port side, up popped *Jaguar*. It was alongside and parallel to a chunk of ice that was slightly longer and wider than it. They snuggled against each other like mother and baby animals.

Jaguar and the ice chunk floated against a larger ice floe with a big bluish square block atop it. Between the two, *Jaguar* now seemed nuzzled by two parents. *Oden*'s small boat, *Hugin*, was lowered into the water, and *Jaguar* would be back on board by 4 p.m.

But *Hugin* didn't start. Its battery was dead.

Kemp and Ulf Hedman, the expedition's leader from the Swedish Polar Research Secretariat, strapped themselves in the crane-operated metal basket and were lowered over the side. But in anticipation of putting *Hugin* into the water, *Oden*'s engines had been turned off, and they couldn't be turned on again for thirty minutes. By that time, *Jaguar* and its ice-floe escorts had moved almost

THOUGH OCEANOGRAPHIC VEHICLES AND components are thoroughly tested and work fine in the lab, engineers count on the fact that they may not work perfectly, and will certainly undergo wear and tear, when they are actually used in the harsh conditions of the ocean, especially those in the Arctic. Then they count on engineers such as John Bailey, who have long experience solving problems and fixing and improving instruments at sea.

a ship's length off the bow and were now hemmed in by a rubble of ice that had converged around them.

Second Officer Strömsnäs took the controls with Captain Peterson directing, and they maneuvered the icebreaker gingerly and expertly toward *Jaguar*. Then suddenly—nobody saw how it happened—*Jaguar* disappeared. Had it gone between and beneath smaller ice floes? Or was it swept under the edge of the large ice floe just to the right?

At last, the ship reached close enough to lower the basket bearing Kemp and Hedman, a shotgun for polar bear slung on his back, onto the ice. Kemp searched for a signal from *Jaguar* with a handheld avalanche beacon. He reached the floe near where *Jaguar* had disappeared and leaned against it. With Hedman holding a rope strapped to Kemp, the Woods Hole engineer jumped to another ice floe to check farther out for a signal from *Jaguar*. He got none. The two men returned to the basket and the ship, but not before Kemp retrieved Stenvall's red stick. "The vehicle could be far under the ice by now," Strömsnäs said. "We may have to start all over again."

"It kills me that the vehicle was just sitting there, as pleased as punch," said Sohn on the bridge. Throughout the day, he had kneaded, tossed, and fisted a seed-filled blue ball that his nine-year-old daughter Sintra had made for him as a going-away present. "She said to use this on stressful days," he said.

The helicopter pilots took off again to try once more with the dangling avalanche beacon. This time, the helicopter appeared to home in on and hover above a spot just off the ship's starboard bow. Stenvall landed on a floe, stuck his red piece of wood into it, and flew off. Minutes later, *Oden* started a crack that bolted straight across the ice floe about twenty inches from Stenvall's marker. The crack spread open, and in the dark water below the ice, right by the marker, was a flash of yellow.

"It's in the crack," someone on the bridge shouted. There was *Jaguar*.

But then, just as quickly as it opened, the crack closed and shut tight. Once again *Jaguar* had disappeared. *Oden* backed up to relieve the pressure on the floe so that the crack might reopen, but it didn't. So the ship broke the big floes into three smaller ones, and at the edge of one of those, *Jaguar* reappeared.

Stenvall landed the helicopter on the floe, which wasn't much larger than the helicopter. Akse rushed out across the floe to the edge and hooked a line on *Jaguar*. Then he and Hedman rigged a strong green line for the helicopter to lift the vehicle. They attached one of *Oden*'s round lifesavers to prevent the heavy line—if it broke—from dragging *Jaguar* down under again.

The helicopter took off, the line straightened, and *Jaguar* was lifted out of the water. The robot designed to swim through the ocean flew through the air—before it had ever seen the bottom. The helicopter flew *Jaguar* high above the ocean around *Oden*'s stern and laid it gently back into a pool of open water on the ship's starboard side. Stenvall dipped the helicopter toward the ship so that a crew member could grab the green line. Then Stenvall veered the helicopter away and backward, its job done.

Even then, said Woods Hole photographer Chris Linder, "it was touch-and-go until the last minute." Ice was closing in on the pool. "Floes were smashing against the hull," said Linder, who grabbed a long metal pole to try to deflect the floes. "It bent like a pole vaulter's pole."

It was after 8 p.m. when Jakuba guided *Jaguar* back on board. When it was safely on its wooden cradle, he reached over with his hand in a fluorescent orange extreme-weather glove and patted *Jaguar* twice on its nose.

It was a heroic recovery. The number of recoveries still equaled the number of deployments. But scientists were no closer to their goal of finding hydrothermal vents.

173

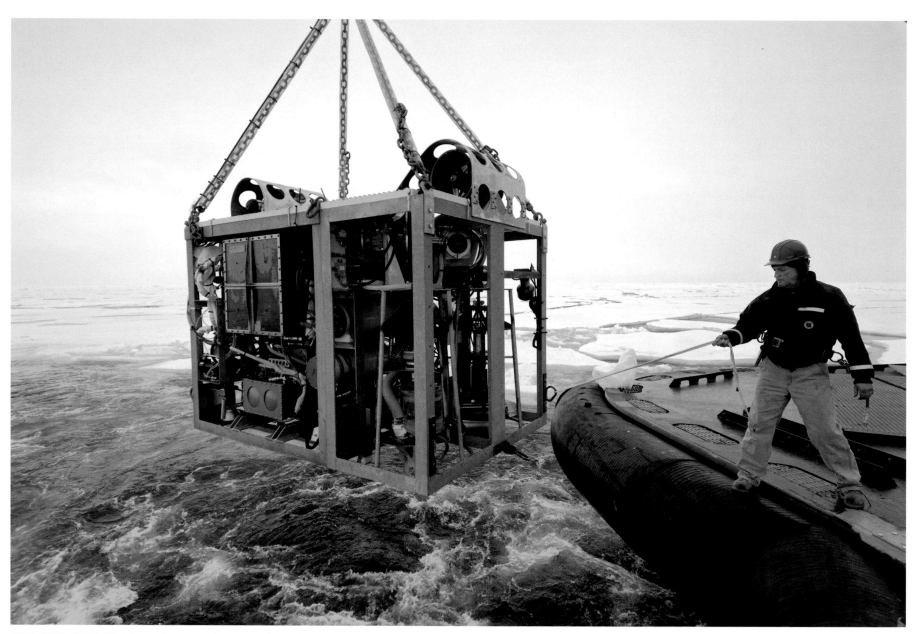

JOHN KEMP, HEAD OF deck operations, lowers the scientists' third tool into the ocean—an under-ice vehicle nicknamed *Camper* (short for "camera/sampler"). The 6,200-pound, steel-framed, open-sided box was lowered to the seafloor and towed behind the icebreaker on a reinforced fiber-optic cable that relayed commands down from operators aboard *Oden* and data up to the ship. It was equipped with camera and lighting systems, thrusters to maneuver and hover the vehicle briefly over seafloor sites, and two hydraulically operated sampling systems to collect samples.

With the ice pack becoming too dense and tight to risk launching and recovering *Puma* again, and only about a week remaining, it was up to *Camper*. When the vehicle was lowered into the ocean, the *Camper* team—Bailey, Humphris, Shank, and Woods Hole engineer Phil Forte—burrowed into a cramped, stuffy, equipment-filled shipping container near the fantail.

Black plastic trash bags taped over the windows shut out all light—the better to see the computers and camera monitors inside. Eyes glued to those monitors—side by side by side by side—Forte, Bailey, Shank, and Humphris all watched video streaming up from *Camper*'s cameras 2.5 miles below. The seafloor rolled by at six inches per second for hours and hours.

The team had no control of the vehicle's speed or direction. Suspended by a cable behind *Oden*, *Camper* hovered a few meters above the seafloor, drifting along with the ship, which drifted with the ice pack. "Our path is up to the flow of the floes," Bailey said.

Still, a great deal of calculation went into trying to put the ship in the right place at the right time. The scientists pointed to an area they wanted to survey. Larsson and Hedman forecasted the ice pack's drift, and the crew steered upstream of the scientists' target, so that the drift would take *Camper* over the area they desired to investigate.

While team members were "camping," as they put it, images of the seafloor were also broadcast live on screens aboard *Oden*. For the many people who had never gone to sea before, and for *Oden*'s crew, who had plied the sea for years but had never seen the bottom of it, watching the video was fascinating—at least for a little while. *Camper* had five cameras in all, one pointing up, two down, and two forward. But the scenery didn't change much: brown rocks, mud, and boulders went on and on. For the *Camper* team, focused on finding vents, it must have been like looking for oases in the Sahara Desert. "There's hours of boring stuff, interspersed with minutes of excitement," Bailey said.

The excitement came when team members thought they saw something interesting emerging tantalizingly out of the darkness and into their narrow field of lights, or when they went to sample something with one of its two sampling devices.

Shank had a joystick to control the pan and tilt of the forward-looking cameras. Right over his shoulder, Humphris watched the unfolding scene, logging data. To Shank's left, shoulder to shoulder with him, was Bailey, who had joysticks to control the samplers.

"It's like four people doing a concert," Shank said. On Bailey's left, Forte sat higher up on a tall stool. (If this were a jazz quartet, Forte would have been the stand-up bass player.) He had a toggle that controlled the winch that raised and lowered *Camper*'s height above the seafloor, as well as manipulators controlling thrusters that could pivot the vehicle around.

As the arc of *Camper*'s front lights moved onto a rock or a curious orange patch on the seafloor, Humphris might assess that it was interesting and ask to sample it. Forte moved the vehicle as best he could to put it into a good position for Bailey. Shank adjusted the camera angle as *Camper* kept moving to maintain the best view of the target. Bailey timed his strike to release the appropriate sampling device.

"We have to decide and act quickly," Bailey said. "When the target comes into sight, we have ten to fifteen seconds."

"There's a lot of communication," Forte said. "We're talking back and forth. You have to do this as a team."

"If we want the orange thing, and we miss it, we wait for the next orange thing to come along," Bailey said. "There's no yelling, but there is laughing. Susan will say. 'It's coming up, there's the rock I want. No, that one!' And I'll say, 'Are we shopping for diamonds?'"

"It takes a village to get a sample," Shank joked. "We got a sample last night,

175

WHILE *CAMPER* WAS BELOW, scientists and engineers crowded into *Camper*'s control van, intently watching video from *Camper*'s cameras and working in coordination to operate the vehicle. Engineer Phil Forte (foreground) operated the winch and cable to control *Camper*'s height off the seafloor. John Bailey (center) used two joysticks: one to control small thrusters on *Camper* that maneuver it; the other to control two different sampling devices, a grabber for rocks and stationary animals such as clams, and a "slurp gun" to suction in moving animals such as shrimp. Biologist Tim Shank (background) manipulated *Camper*'s camera systems, and geochemist Susan Humphris maintained the log of all operations.

CLAY KUNZ (LEFT) AND Chris Murphy, two graduate students in the Massachusetts Institute of Technology/Woods Hole Oceanographic Institution Joint Program, use themselves as props to test cameras that would be installed on *Camper* to collect video from the deep.

IT'S ALL HANDS ON deck on scientific expeditions. Woods Hole biologist Tim Shank goes under the hood, so to speak, to help adjust components on the *Camper* vehicle he used to explore the Arctic seafloor.

and everybody high-fived each other. We keep trying to find ways to describe it. We were coming up with things like . . . flying in a hot-air balloon in the dark, duct-taping a penlight on a vacuum hose hanging below, and trying to suction up a marble in a field of rocks."

Once a visitor sidled into the *Camper* van, saw something on the screen and said, "What was that? Go back!" But the video—like the ice pack, *Oden*, and *Camper*—just kept drifting along.

"*Camper* can't go back," Shank explained, "it can only go forward."

"Just like time," noted Singh. And time was running out.

In the last forty-eight hours before *Oden* had to return to port, the *Camper* team rarely slept and hardly left the stuffy van as *Camper* made five more dives. In the end, the scientists did not find active vents or vent animals. But they did discover and sample fluffy, yellowy-orange material wisping out of the crevices and coating seafloor rocks. It resembled mats seen at other vent sites, composed of microbes nourished by chemicals in vent fluids. Shank froze the specimens for subsequent genetic analyses that would reveal whether these microbes are new species, perhaps with novel adaptations.

The scientists also found evidence of recent volcanic activity. They saw jagged, glassy, black shards of lava (called pyroclastic deposits) and bits of basalt blanketing the seafloor and spread out in all directions from three volcanic craters they discovered, which they named Loké, Oden, and Thor. The rock debris lay atop relatively new lavas, indicating that it had not been swept there by flowing lava, but rather had fallen down or precipitated out of the water.

LONNY LIPPSETT

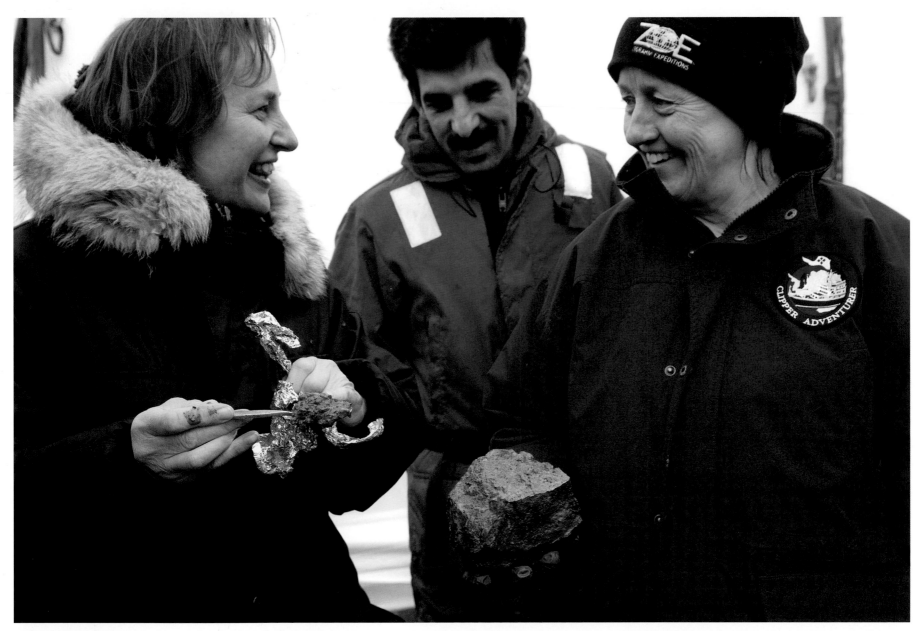

LIKE KIDS IN A candy store, scientists flocked to *Camper* when it surfaced from a mission to see what samples it collected from the seafloor: mud, rocks, or orange microbial material. Gathering to eye newly retrieved scientific goodies were Elisabeth Helmke, a biologist from the Alfred Wegener Institute, and engineer Hanumant Singh and geochemist Susuan Humphris from Woods Hole Oceanographic Institution.

CAMPER BROUGHT BACK SAMPLES of orange material that lodged in the crevices between seafloor rocks or coated their surfaces. It resembled mats of material seen at other vent sites, composed of microbes nourished by chemicals in vent fluids. The specimens were frozen for subsequent genetic analyses that would reveal whether these microbes are new species, perhaps with novel adaptations (opposite).

CAMPER ALSO COLLECTED IMAGES and samples of glassy, black shards of lava blanketing the seafloor near three newly discovered volcanic craters on the Gakkel Ridge. Subsequent analyses of the shards determined that they were formed when liquid lava was violently shattered by expanding gas bubbles during an explosive eruption. The evidence suggests the explosions emitted tremendous blasts of carbon dioxide—something scientists had thought was impossible under the pressure almost 2.5 miles below the ocean surface.

SCIENTISTS COMPILED THIS PHOTOMOSAIC by joining overlapping images collected on the seafloor on the Gakkel Ridge. It shows yellow-orange mats composed of microbes and material produced by microbes, probably living on chemical-rich fluids seeping from the seafloor. On some other ridges, microbes like these form the base of the food chain for bustling ecosystems of larger deep-sea animals. But on the Gakkel Ridge, the microbial mats were largely undisturbed, suggesting that the northern Arctic Ocean may represent a kind of oceanic desert, with few large animals.

Seafloor eruptions are more likely to resemble those of Kilauea in Hawaii, which oozes lobes and sheets of flowing lava, rather than Mount St. Helens in Washington, which ejected explosive plumes of gas, steam, and rock. That's because the intense pressure of overlying water keeps gases in solution and hinders the formation of steam and carbon dioxide gas required to explode a mass of rock upward.

Closer analysis of the shards collected by *Camper* showed that they were angular bits of quenched glass known to volcanologists as limu o Pele, or Pele's seaweed. These fragments are formed when lava is stretched thin around expanding gas bubbles during an explosion.

All in all, the evidence suggests that the Gakkel Ridge volcanoes erupted violently, emitting tremendous blasts of gas—something scientists did not think was possible almost 2.5 miles below the ocean surface.

In light of these findings, Schlindwein is carefully studying the sounds she recorded with her ice-floe seismometers in 2001 and 2007. She hopes to glean clues to some of the geological processes that could generate such high gas pressures beneath the seafloor and such explosive submarine volcanoes. With the other scientists, she is adding her pieces to the puzzle that is the Gakkel Ridge.

As *Oden* headed south in August 2007, a bleary-eyed Shank, who hardly slept during the marathon last-gasp excursions with *Camper*, plopped himself onto a chair in the galley and—exhausted but exhilarated—didn't even notice the pun when he said, "We've just broken the ice up here."

But the Gakkel expedition did break the ice when it came to under-ice operations using AUVs. More confident of their ability to use AUVs and get them back, scientists are dreaming about other vehicles and expeditions, in the Arctic and beyond.

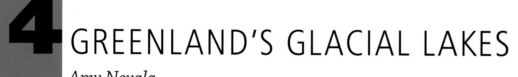

4 GREENLAND'S GLACIAL LAKES

Amy Nevala

I T WAS JULY 2008, AND I LAY IN MY TENT SHIVERING, CURSING MYSELF FOR packing a sleeping bag designed for a person twice my size. Instead of hugging my body, the bag swished around and gaped open, allowing my heat to escape—an unpleasant fate for someone camped on a sheet of ice four times the size of California and twenty-five miles from the coast of Greenland.

Below two thin sleeping pads and the canvas tent floor was more than a half mile of ice, extending all the way to bedrock. Though the Arctic summer sun blazed nearly twenty-four hours a day, nighttime temperatures dipped below freezing. After hours of restless thrashing, I finally found relief from the cold by stuffing the gaps with extra socks, a rain jacket, thermal pants, and a thick reference book about Greenland. These filled the void my body heat could not.

If my fellow campers suffered that night, they never discussed it. Scientists Sarah Das, Mark Behn, and Ian Joughin had camped previously in the Arctic and Antarctica to investigate how melting ice sheets could raise global sea levels. Joughin's graduate student, Kristin Poinar, and photographer Chris Linder were making their first trip to the ice sheet, but they had camped in remote regions throughout their childhoods.

The next morning I found the team as I would every day: sitting sleepily on plastic food storage bins in the ten-by-ten-foot cook tent, waiting for water to boil for making coffee and instant oatmeal. As the caffeine and food roused them, they discussed the day's plan.

Every hour on the ice mattered. We had twelve days out on the ice in the final year of a three-year study to continue chipping away at questions looming over the ice sheet in a warming world: Would Greenland's massive ice sheet recede or disappear? And if so, how fast could it happen?

It's a puzzle for scientists and a concern to people worldwide. Greenland—one of the world's largest islands—is home to one of Earth's largest ice sheets, second in size only to Antarctica. Roughly 80 percent of Greenland is covered in ice, made of layers of compressed snow from more than one hundred thousand winters. In places, the ice is more than two miles thick.

It is so vast that it seems impervious to melting. Indeed, even if global temperature were to continue on its current upward path, some studies estimate that losing enough ice to change sea level drastically would take at least seven thousand years.

But recent observations show that the climate around Greenland is warm-

GREENLAND'S LAKES FORM ATOP THE ICE SHEET EACH SPRING AND
summer as returning sunlight melts ice and snow. As lakes fill, large cracks can open
suddenly in the lakes' basins, allowing water to drain in a dramatic waterfall more than
a half mile down to the bedrock beneath the ice sheet. The water lubricates the base of
the ice sheet, like grease on a railroad track, allowing the ice to flow faster. As the global
temperature rises, more lakes and cracks may form, accelerating the flow of ice to the sea.

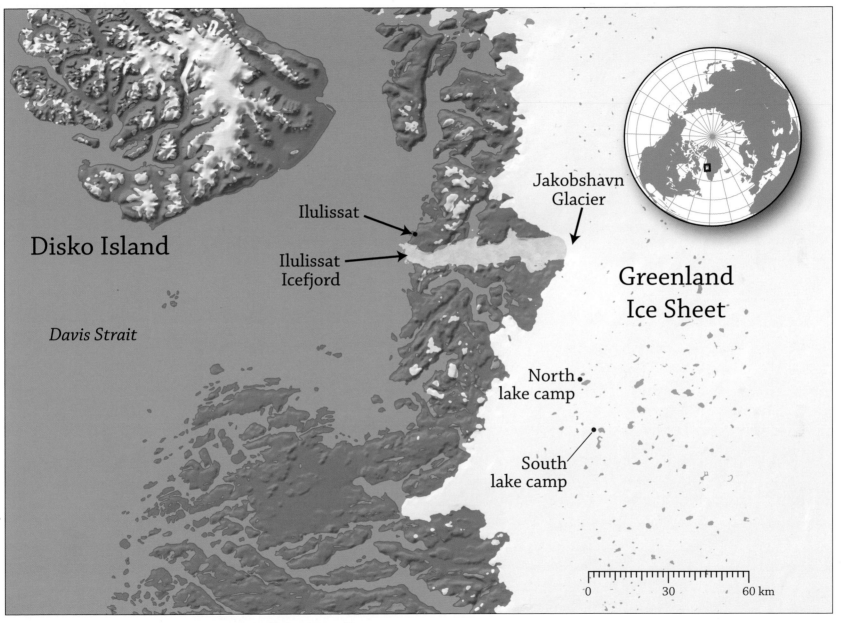

Disko Island

Davis Strait

Ilulissat

Ilulissat
Icefjord

Jakobshavn
Glacier

Greenland
Ice Sheet

North
lake camp

South
lake camp

187

0 30 60 km

SUMMER 2006 LAKE POSITIONS are based on a composite of NASA MODIS satellite images.

GREENLAND'S ICE SHEET IS never still. In fact, it makes a continuous march to the ocean. In places the ice noses past a rocky coast before dumping into the sea. As Earth warms, scientists worry that this flow of ice will get faster. Adding more fresh water to the oceans could also potentially change ocean circulation patterns, which could in turn affect worldwide rainfall and temperature patterns.

ing at a fast pace and the ice is melting, and sliding into the sea, more rapidly than expected. Warmer temperatures are increasing the number of summer days when portions of the ice sheet's surface melt. Along the margins of the ice sheet, up to twenty additional days of melting occurred in 2005, compared to the average since 1988.

Air temperatures over the Greenland Ice Sheet have increased by about 4 degrees Fahrenheit since 1991, spurred by a buildup of industrial greenhouse gases such as carbon dioxide in Earth's atmosphere. Since the mid-1990s, the Jakobshavn Isbrae glacier on the west coast and the Kangerdlugssuaq glacier on the east coast—which together carry about 10 percent of Greenland's ice from the top of the ice sheet to the ocean—have flowed two to three times faster than they had in the past.

A world without Greenland's ice would look very different. All that water—unfrozen and released from land back into the ocean—could ultimately raise the global sea level by twenty-three feet, drowning populated coastal cities from Boston to Bombay and low-lying regions from Florida and Louisiana to Bangladesh. It would also add enormous quantities of fresh water to the ocean with the potential to change ocean circulation patterns that could in turn affect worldwide fisheries and weather patterns.

The term "ice sheet" conjures up images of a hockey rink, something large and still. But Greenland's ice sheet is far from sedentary. In fact, it is con-

stantly on the move. During long dark Arctic winters, snow accumulates on the ice, especially at higher interior elevations. Gravity forces the snow and ice to flow constantly downhill, like a frozen river, over bedrock toward the coast.

The ice sheet creeps along, advancing at a rate of about 150 to 350 feet each winter and 500 feet each summer. In other areas, near the coast, these frozen rivers flow into two hundred or more outlet glaciers. Here the ice bulldozes along at six miles a year, grinding through valleys and around rocky coastlines before the glacier calves icebergs that fall into the sea.

As sunlight returns to Greenland in the spring, burning nearly twenty-four hours a day, ice and snow on the surface of the ice sheet melts and pools into depressions to form lakes. But by early fall, the majority of lakes are gone.

A theory arose to explain their disappearance: the weight of the water they accumulate eventually causes large cracks to open suddenly in the lakes' bases, draining the lakes' water in a dramatic waterfall all the way to the bedrock below.

Evidence had been mounting that this drained water may help speed the ice sheet's run toward the coast. Scientists theorized that the water lubricated the base of the ice sheet, like grease on a railroad track, causing the moving ice to flow even faster to the ocean.

But no one had been around on the ice sheet to witness a lake draining, and there was no way to get beneath the ice sheet to see what was happening underneath. Das and Joughin, who met in 2003 while working in Antarctica, shared a goal of finding out what was going on atop Greenland.

Water, frozen or liquid, had been a passion for Das since childhood, when she spent summers swimming and sailing on Cape Cod with her grandparents. In college she considered an oceanography career until a summer field course in Alaska changed her mind. She traveled there with a backpack to traverse the Juneau Ice Field, stopping at huts along the way, doing science,

ILULISSAT, THE THIRD-LARGEST TOWN IN GREENLAND, IS A TOP TOURIST DRAW
in summer when visitors come to gawk at twenty million tons of ice disgorged each year from
the ice sheet into Ilulissat's ice fjord. Ilulissat is the Greenlandic word for "icebergs, " appropriate
for a town with views of bobbing blocks of ice, some many times larger than a fishing boat.

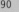
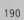

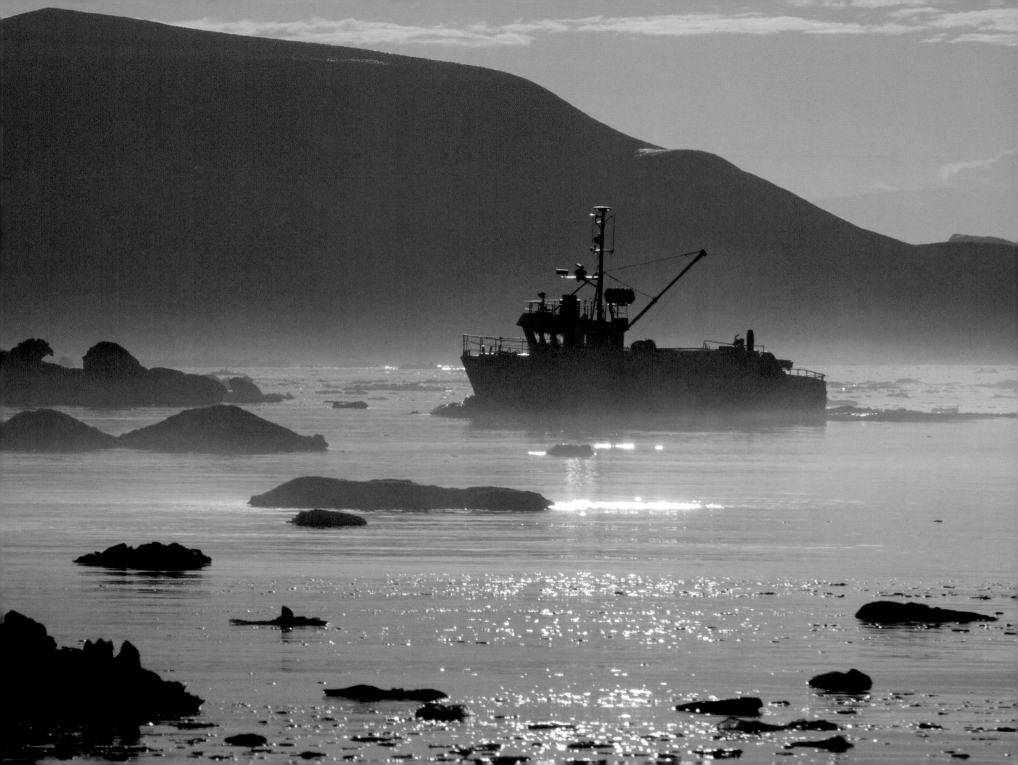

HUGE AMOUNTS OF MELTED ice could mean a fresher ocean—and potential disaster for halibut and halibut fisherman. If Greenland's 2.17 million square miles of ice ever melts completely, estimates show that this could raise global sea level by as much as twenty-three feet, altering fisheries and drowning populated coastal cities from Boston to Bombay, as well as low-lying regions from Florida and Louisiana to Bangladesh.

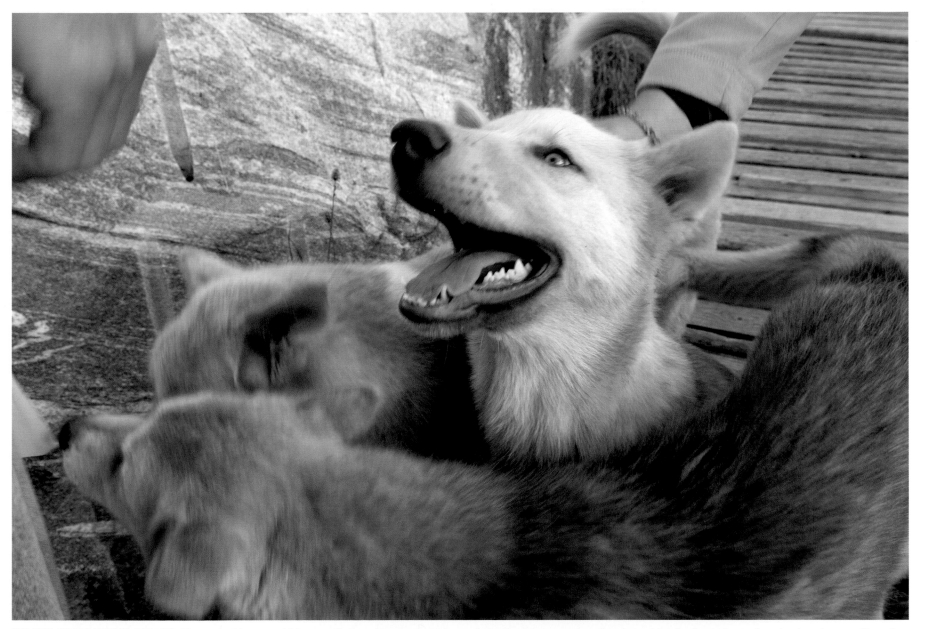

THOUGH SNOWMOBILES ABOUND IN Greenland, hunters and fishermen still rely on dog teams to travel across the ice, like their ancestors have done for more than five thousand years. But as ice along the coasts thins earlier each season, sled dogs are less employable. In 2002, Ilulissat's 4,700 dogs outnumbered the town's people. But in 2008, the sled dog census listed a thousand fewer dogs.

ONE LOCAL FAMILY MAY be worried about getting around in a warmer world, which would require them to swap their dog-powered sled for a gas-powered vehicle.

A HELICOPTER FERRIED OUR team and 2,300 pounds of gear to our first ice camp, situated twenty-five miles from the coast. We also used the helicopter for aerial studies of the ice sheet, noting the position of rivers, channels of melted water, and lakes.

TO SAVE TIME AND helicopter fuel, we performed a "hot unload." The pilot kept the rotors turning as we moved science equipment and camping gear out, running under the spinning blades.

climbing mountains, telemark skiing, and practicing how to rescue herself and others from crevasses.

Her first job after college was working as a field technician with a research group from the California Institute of Technology. For three months she lived out of a tent in Antarctica, learning how to drill boreholes to collect samples and study conditions beneath the ice. Beyond the adventure, Das said she became amazed and impressed by how important ice sheets are to the climate system and to sea level. It motivated her to pursue graduate work in glaciology.

In 2003, doctoral degree in hand, she joined Woods Hole Oceanographic Institution as a glaciologist and focused on studying ice sheets in west Antarctica and Greenland. Working with Joughin, a glaciologist at the Applied Physics Laboratory at the University of Washington, proved a good complement. Joughin came into polar research as an engineer. His graduate work at the University of Washington focused on finding ways to measure how fast ice sheets travel, using radar satellites to track movements.

Once he had developed the tools, he became interested in using them to understand how ice sheets respond to climate change. Like Das, he wondered if water drained from the lakes created a fluid layer between the ice and the bedrock that made it easier for Greenland's ice to slip away.

In July 2006, Das and Joughin's team flew to Greenland for the first part of their three-year study. They set up and left behind instruments near two large lakes on the ice sheet to record what happened. They used Global Positioning System receivers and motion-detecting instruments called seismometers to measure ice movement, water pressure loggers to detect changes in lake levels, and meteorological sensors to precisely measure surface temperatures.

One year later, in July 2007, they returned to collect data from their instruments and piece together what happened in their absence. About ten days after the team left Greenland in 2006, instruments recorded the drainage of a lake that once covered 2.2 square miles of the surface and held 11.6 billion gallons of water.

Like a draining bathtub, the entire lake emptied from the bottom in twenty-four hours, with the majority of the water flowing out in a ninety-minute span. They estimated that at the peak of the drainage event, volume of water flowing down matched the rush of water over Niagara Falls. As small cracks and crevasses filled with water, the greater weight and density of the water forced the ice to open further. When the water drained, it spread out, pushing up the ice from below and ultimately raising it by more than three feet. The seismic signature of the fractures, the rapid drainage, and the uplift and movement of the ice all showed that water had flowed all the way down to the bed.

These observations, published in the journal *Science* on May 9, 2008, confirmed the long-speculated plumbing system for ice sheets. The scientists proved that water filling large lakes can build up enough pressure to crack through the ice at the lakes' bottom, creating conduits that can penetrate the ice sheet and release torrents of water. Their first-of-a-kind observations went further to show that melting during the summer months indeed contributes to the speed of ice loss.

Two months after the journal articles appeared, we began the two-day trek by airplane and helicopter back to the ice for another field season. We planned to divide our time between camp sites at South Lake and North Lake, situated about twelve miles apart and about twenty-five miles from the coast. Though

197

thousands of lakes dot the ice sheet, South Lake and North Lake, named by Das and Joughin, were chosen because they met specific research criteria.

First, the scientists needed lakes that could easily be reached by helicopter from the coastal town Ilulissat. They also wanted lakes that Das called "well behaved"—that is, lakes from which the water drained reliably, year after year, during the summer months. By looking at satellite images of the western edge of Greenland over the period of a decade, they could see that South Lake and North Lake had a solid track record for draining each year in midsummer, when they planned to be there with instruments to capture information about the draining.

For more than four thousand years, people have lived on Greenland, along the coasts. The original inhabitants crossed from Siberia and migrated east across North America. Our journey there, though long, was mild by comparison. Still, it required months of planning and packing. There would be no returns to town for forgotten ice axes or extra rubber boots.

Everything needed meticulous accounting and organizing. Das called on her previous polar camping experiences as she developed and tracked long lists on her laptop computer. Spreadsheets helped her organize necessary clothing, medical supplies, and science equipment, and tick off needed arrangements, such as helicopters. A half dozen large plastic bins stocked with food and powdered drinks were sent ahead to Greenland.

Das also took careful steps to secure permits from Greenland's government to conduct research on the ice sheet. All told, there were 2,300 pounds of clothing, camping gear, science equipment, and food, and nine pounds of a harmless red dye that Das brought along for an experiment.

After a night in Greenland's coastal town Kangerlussuaq, the site of a former United States military base, we flew the final leg to Ilulissat, a popular

AMY NEVALA

KRISTIN POINAR, A GRADUATE student from the University of Washington, positioned her sleeping tent on a relatively flat spot on the ice sheet. Another tent was set up with computers powered by solar panels and generators. There was no shower. We skipped bathing during our time on the ice.

destination for tourists who come to watch icebergs calve from a glacier and bob in the town's ice fjord. Jaw-dropping Arctic views punctuated the forty-five minute flight: to the west, an iceberg-studded sea, and to the east, the ice sheet stretched to the horizon.

In Ilulissat we spent most of the day inside a hangar at the airport, sorting camping gear and swatting fat mosquitoes, common along boggy coastal Greenland. By day's end, we had every ice auger, tent, sleeping pad, generator, radio, and packet of hot chocolate inventoried, weighed, and divided into three tidy piles, each weighing about 770 pounds. Weight was critical when planning helicopter flights. Exceeding a helicopter's weight limit meant paying for another flight, which costs thousands of dollars.

We split into three groups as the helicopter shuttled people to South Lake, where we would spend the first six days. The twenty-minute flight crossed south over the twenty-five-mile-long Ilulissat ice fjord, where a slurry of ice chunks floated after breaking free at the edge of the glacier. Then the helicopter moved up the ice sheet, past crevassed terrain to a flatter plain.

Within minutes the lakes appeared, huge blue dots on the white ice, some connecting into long, meandering rivers or angular channels. Some lakes were full of water. Others were nearly empty, or at some stage in between. South Lake, extending more than a mile, was still full of water. We were there at just the right season to see it drain.

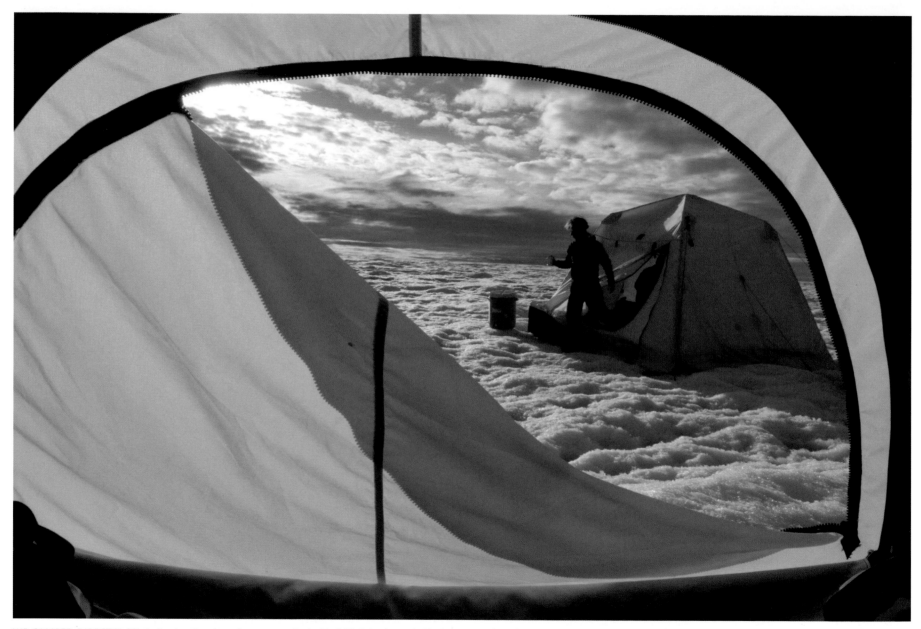

WE CAMPED DIRECTLY ON the ice sheet in unheated canvas tents lined with air-filled sleeping pads. The team prepared meals in a separate ten-by-ten cooking and dining tent, where we sat on large plastic bins that contained our food. Oatmeal with dried fruit, grilled cheese sandwiches, and pasta proved popular.

SARAH DAS (IN RED cap), a glaciologist at Woods Hole Oceanographic Institution, celebrated her thirty-fifth birthday with a cherry-topped cheesecake prepared with powdered milk that was mixed with water scooped from the ice sheet. After four trips to Greenland and six trips to Antarctica for her climate-change research, this was her first ice-sheet birthday cake.

HOLES CALLED CRYCONITES FORM ON THE ICE SHEET WHEN DUST BLOWS IN
from land. The dark dust settles on the ice, where it absorbs heat from the sun. The heat melts the ice underneath the dust and creates holes the diameter and depth of pockets on a pool table that fill with icy water. Several researchers prone to stepping in the cryoconites began to call them booby traps.

203

DESPITE ITS SPRINGLIKE NAME, ICE DOMINATES GREENLAND. ROUGHLY 80 percent of Greenland is covered in ice, some of it surprisingly delicate.

To save time and helicopter fuel after landing, we began a "hot unload." The pilot kept the rotors turning as we moved everything out, running and ducking under the spinning blades. I expected to slip on the ice sheet; I thought it would be flat and slick. Pleasantly, it was a much more varied terrain, full of long cracks and hidden holes and pockets of water. In places it crumbled and crunched beneath our boots.

We waved farewell to the helicopter pilot then turned to set up camp, where we would stay for the first six days. We positioned the camp two hundred feet north of South Lake, close enough to walk to instruments positioned around the lake. Within the hour, yellow tents dotted the ice. Roomier tents were for cooking, eating, and working on laptop computers.

With tents in place, the research began. We set off to check instruments that had been recording data for the past year at four locations around the lake. Their scattered arrangement around the ice was deliberate. Sensitive seismometers buried beneath the ice were there to detect and record even the tiniest quiver, as well as mark the times of these movements.

Scientists typically use seismometers on land and at the bottom of the ocean to study earthquakes and other ground-shaking movements. When Mark Behn, a geophysicist at Woods Hole Oceanographic Institution, met Das in 2004, he was using seismometers to study ground-shaking events off the coasts of Costa Rica and Hawaii. Das and Joughin realized that Behn's seismic studies could advance their own work in studying the ice sheet's movements, called ice quakes.

On land, scientists use a network of seismometers to identify the source of an earthquake. Behn wanted to do the same thing on the ice to locate the fractures as they formed and moved. As the ice shifts and cracks, and as water rushes through the ice sheet, this sends out seismic waves that travel through surrounding ice. The seismometers record these vibrations, or energy waves, that move out from their source. By analyzing these motions, Behn can infer a great deal about the characteristics of the ice that the waves are traveling through. He can tease out the structure and composition of the ice, which helps reveal hidden processes that create drainage cracks. Even though he can't see cracks in the interior and at the base of the ice, he can use the data collected from the seismometers to help him envision the cracks' locations, sizes, and shapes.

It would be gratifying if Behn could simply remove the instruments from their burrows, look at the data, and instantly arrive at answers about the underside of the ice sheet. Instead, his job in the years ahead will be to process and interpret the data, teasing out nuances and looking for trends. Then he will compare it to data collected from other instruments to begin forming a comprehensive picture about the cracks' formation and movement.

But while on the ice, he was able to make several conclusions—the seismometers were working, and the quality of their collected data looked promising. He could see dramatic spikes in the seismograph records that indicated large cracking and draining events.

Despite the labor required to analyze the data they record, seismometers can yield dramatic results. One seismometer that recorded the lake drain in 2007 showed normal movements of the ice during the instrument's first 209 days in the field. But on the 210th day, the seismometer recorded rapid movement in the ice, and a quiet line on the instrument's recording readout began to jerk wildly over a two-hour period, similar to a readout from an echocardiogram showing a person's heart rate increasing as he transitions from walking to a full sprint. Then the line leveled again, a sign that the water was gone and the ice was stable again. From this, the scientists were able to determine exactly when the lake drained and how long it took.

At South Lake, next to each seismometer stood a tower built from skinny metal poles and plywood platforms. They looked a bit rudimentary, but the

MELTED WATER ON THE ice sheet forms channels and rivers that feed into, and out of, lakes. Thousands of lakes dot the margin of the ice sheet. Some of the lakes have a diameter of more than two miles.

scientists had thought carefully about their construction to make them durable; for example, their tripod design kept them stable in the wind. They had sunk the poles deep into the ice using an ice drill, providing them a secure base against whipping winds.

Weather stations secured to the towers recorded air temperature, wind speed and direction, and levels of solar radiation. The weather stations helped answer questions such as, when do the strongest winds blow? When is the air temperature the coldest? This information helps scientists understand how the gradual warming in spring affects the melting ice surface.

Another instrument, a Global Positioning System receiver, sat next to the tower directly on the ice in a waterproof box. The most important part of the GPS is the antenna, which sits high on the tower, and sends down data to computers in the box. This instrument talks to a network of satellites that enables a GPS receiver to determine and record its latitude, longitude, and altitude—its precise location in space and time. GPS is commonly used by airplane pilots, automobile drivers, and hikers to record their location, direction, and speed of movement. Similarly, in Greenland the GPS functioned as a recorder of the ice's speed as it traveled during the warm and colder seasons toward the coast.

The GPS also recorded when the ice moved up and down. When the lake drained in 2007, the information recorded on the GPS amazed scientists. During the drain, the GPS captured the ice sheet rising by three feet as the water in the lake moved downward then pushed the ice up from below. Then, as the

GREENLAND'S GLACIAL LAKES

SUNLIGHT AND MELTED WATER pair up to create unique carved knobs, peaks, and valleys on the ice sheet (opposite).

WATER WAS ALL AROUND, some of the purest we could hope to find anywhere on the planet. We simply scooped and drank from the nearest pool or channel. We didn't even carry water bottles on our hikes, just a cup.

water spread out over the bedrock, the ice sheet settled down into its previous position. They also saw an increase in relative speed of movement across Greenland; in summer the researchers found that the slow-moving ice sheet increased in speed at rates ranging from 50 to 100 percent.

Four hours into our hike on the ice for our initial check on the instruments, we paused to examine a channel of water leading away from the surface of South Lake. The channel linked the lake to a hole in the ice that Das knew had previously drained the lake. Unlike other lakes on the ice that drained through cracks in their basins, this lake overflowed through the channel and disappeared through the hole on the ice's surface. We saw that the channel, like the lake, was now brimming with water. Das expected that South Lake would again drain this way at some point in the near future.

But waiting for a lake to drain is a little like waiting for a baby to be born. People know from previous experience approximately when it is going to happen—in this case, sometime in midsummer, yet without a specific date or time. Scientists have figured out that volcanoes may rumble or smoke days before they erupt, but they don't fully understand what signals that an ice sheet lake is ready to go.

That explained why the scientists were caught by surprise when, a day after the hike at South Lake, we began to hear distant booms from somewhere in the direction of the lake. But they couldn't see anything; that morning, a heavy

CRACKS AND HOLES COVER the ice-sheet surface, providing pathways for rivers of melt water to quickly reach the base of the ice sheet throughout the summer.

blowing mist had cut visibility to about a hundred feet. Fog shrouded the lake and the two closest instrument towers were barely discernible silhouettes.

When the fog lifted briefly at lunch, Joughin looked at South Lake and thought that the water looked lower. To find out, he placed a bamboo pole at the lake's edge and noted the time and GPS coordinates. Fog promptly hid the lake again.

Several hours later, Joughin went to check the lake. He returned to camp grinning. Water levels had indeed lowered around the pole. Joughin placed more poles throughout the day. Each time he checked he saw that the lake's level was dropping a few inches per hour.

With visibility still poor, Joughin and Behn decided to finish repairing an instrument. As they worked, they thought they could hear a rushing sound, like a giant waterfall. Then the thunderlike booms began again and the gushing sound intensified.

The scientists ran to each other, and stood, stunned, not far from the shore of South Lake. Beneath their boots they could feel the ice quivering. Shots like rifle cracks began alternating with thundering booms. Frightened and thrilled, everyone jumped when they head the noises and nervously noted the cracks, about a fraction of an inch wide, occasionally opening in the ice around their feet.

After about half an hour, the sounds changed to more muffled snaps, crack-les, and pops. Joughin swore he could feel the ice rise. Das speculated that the great volume of water that had been in the lake had finally made it all the way to the bottom of the ice and was shoving the ice upward. She surmised that the gunshot noises and booms were caused by hundreds of tons of cracking and shifting ice.

When the sounds diminished, they explored. To prevent slipping, they put on hard plastic boots and crampons, metal spikes worn like an additional slipper. With GPS systems in hand to mark the location of cracks and holes, they carefully walked onto ice that only hours before had been at the bottom of a lake. Slick ice teeth about two feet high lined the edges of the drained lake, making walking especially tricky. Waterfalls of melted surface ice gushed into new cracks. Ice blocks as big as school buses lay scattered.

After a few hours of traversing the lake bed, Das and the team found the prime culprit that had drained the lake: a massive crack extending all the way through the center of the lake bed. For Das, it was a revelation. She knew that South Lake had drained previously by overflowing through a drain hole on the surface of the ice. But now she saw that the same lake had drained in a completely different way—through a crack in its basin. No longer was it an either-or question about whether a lake drained by overflowing or through a crack in the base. She saw that it could do both.

The next day, she was able to get yet another perspective of the ice—this time by air. The team planned to use helicopter and airplane surveys, coupled with existing satellite imagery, to monitor the lakes and continue tracking the progress of ice moving toward the coast. The aerial views, along with perspectives obtained during our hikes, provided the locations of surrounding lakes and their features—how big they were, and if they had drained. If they were gone, the team would look closely at how they drained—through a series of deep cracks.

DAS RELIED ON A VARIETY OF TOOLS TO STUDY THE ICE SHEET, FROM
helicopters for aerial surveys to weather-recording instruments that captured seasonal
temperature changes. But hiking was one of her most valuable tools, allowing her to
note subtle changes in large cracks and surface drainage systems (opposite).

IAN JOUGHIN, A GLACIOLOGIST FROM THE UNIVERSITY OF WASHINGTON,
measured how much ice has melted since the previous field season. Using Global
Positioning System measurements, Ian learned that the area he studies on the western
flanks of Greenland slides a hundred yards closer to the coast each year.

213

MARK BEHN, A GEOPHYSICIST from Woods Hole Oceanographic Institution, used instrument towers, built from skinny metal poles and plywood platforms, as bases to position instruments for recording air temperature, wind speed and direction, and levels of solar radiation. These weather stations helped answer questions such as, when do the strongest winds blow? When is the air temperature the coldest? This information helps researchers understand how seasonal warming and cooling affects the ice surface.

A SEISMOMETER BURIED IN a hole drilled on the ice detected and recorded small vibrations, and large, local shifts in the ice sheet caused by cracks in the ice. Using data collected from seismometers, researchers could identify exactly when the cracks opened, giving them a clearer picture of what is happening on, and below, the ice. By analyzing these motions, researchers can infer a great deal about the characteristics of the ice that the waves are traveling through. They can tease out the structure and composition of the ice, which helps reveal hidden processes that create lake drainage cracks.

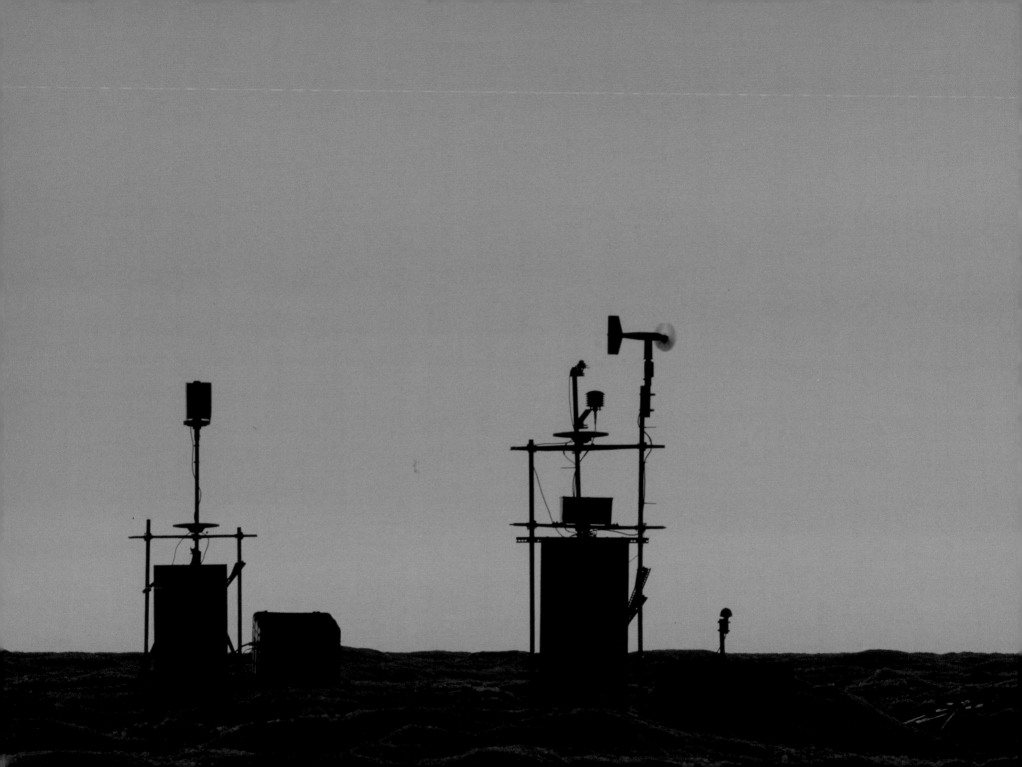

INSTRUMENT TOWERS LOOKED A BIT RUDIMENTARY, BUT THE SCIENTISTS HAD thought carefully about their construction to make them durable; for example, their tripod design kept them stable in the wind. They sunk the poles deep into the ice using an ice drill, providing them a secure base against whipping winds. Since camping on an ice sheet is expensive and would be difficult in the winter, researchers rely on instruments that stay in the field year round and measure the Arctic environment over time.

217

The aerial surveys helped to fill in some existing holes in the data. GPS equipment can measure movement of the ice more frequently, but the area it measures is more limited. Satellite images, taken from NASA-launched or Canadian-owned satellites, offered the broader look at an area hundreds of miles wide, but could make those measurements only every twenty-four days. The combined information helped scientists piece together a larger picture of the ice sheet's movements and mechanics.

From the helicopter, deep meltwater channels on the ice became clearly visible. As the lakes fill, the channels overflow and become hidden from view when standing on land. Through an aerial survey these details become evident. But only by comparing satellite images with GPS positions with digital photographs could the scientists begin to piece together the behavior of these lakes.

After six nights at South Lake, it was time to move on to North Lake. We packed everything for the twelve-mile helicopter flight. As we unloaded the helicopter at the new site, we saw that the landscape was different. Instead of a moderately flat and gently sloping ice field, this area was broken up by hummocks and ridges up to four feet tall. A recent spell of warm, sunny days and clear nights had also created pitfalls: water-filled holes called cryoconites.

These holes form when dust blows in from land. The dark dust settles on the ice sheet, where it absorbs heat from the sun. This melts the ice underneath the dust and creates holes the diameter and depth of pockets on a pool table. The holes are filled with icy water. When snow covers the cryoconites, they are hidden from unsuspecting walkers.

While setting up camp, we frequently plunged into the cryoconites. As people misstepped and stumbled, shouts and the occasional barrage of curses filled the air as ice water filled our rubber boots. While the cryoconites were cold,

wet irritations, they also had a special beauty. Some contained frozen bubbles. Others were ringed by crystals.

We knew from an aerial survey several days earlier that North Lake had already mostly drained. Melted water continued to gush into at least one drain hole. Das was glad to find it. One of her goals while there was to locate a hole to perform an experiment to map the under-ice drainage system—to trace how lake water drains through the ice, over the bedrock, and out to the ocean. She planned to mix the red dye she had packed along into the water cascading down the hole.

Studying satellite data from previous years, she knew that the ice from the area where we camped flowed in a northwest direction to a fjord. Coincidentally, this was close to where another team of scientists, including one of Das's graduate students, would be doing their own research. They agreed to look for signs of the dye using a special instrument that could detect minute quantities of the fluorescent dye in the water.

The experiment on such a vast scale, she admitted, was a shot in the dark, not unlike putting a note in a bottle, throwing it in the ocean, and hoping a friend in the next coastal town finds it. But several things lined up that made it plausible to attempt. After studying satellite images, she saw that ice flowed along the same path from our spot on the ice near North Lake to the sea.

She estimated, based on others' work from dye-tracing experiments at polar locations, that the dye would take somewhere between thirteen hours to five days to flow from the point of release, under the ice, and into a fjord, about

AMY NEVALA

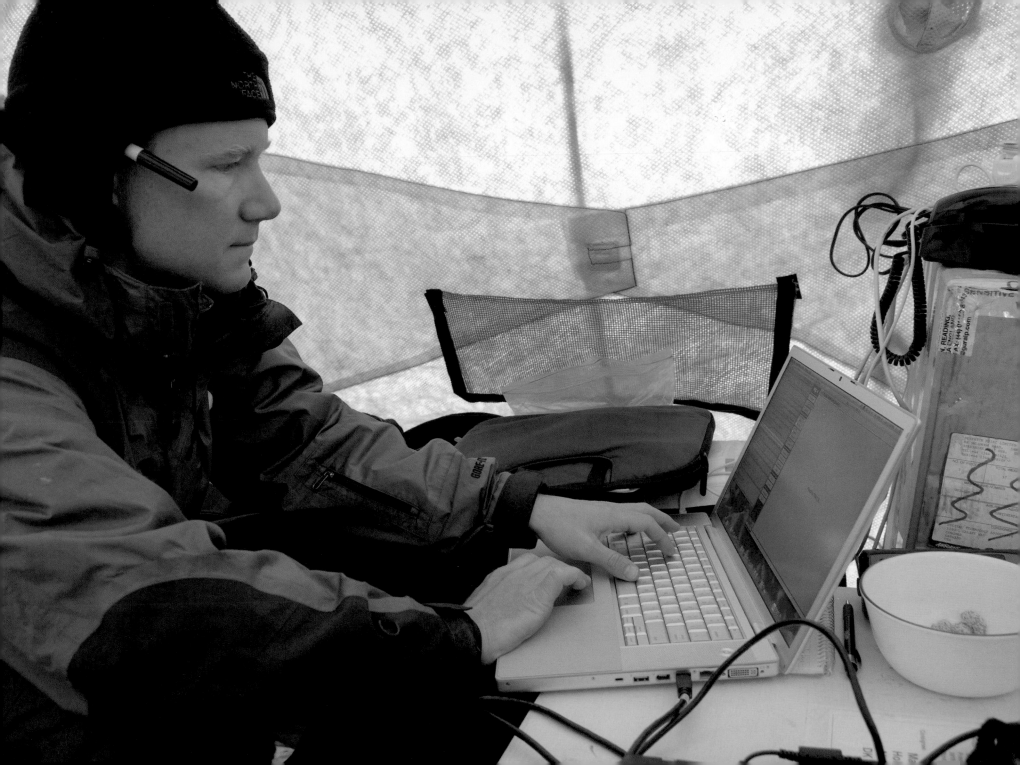

WHEN THE SUN NEVER SETS, IT IS EASY TO LOSE TRACK OF TIME, AND WITH A
short stay on the ice, scientists took advantage of the midnight sun to explore.

220

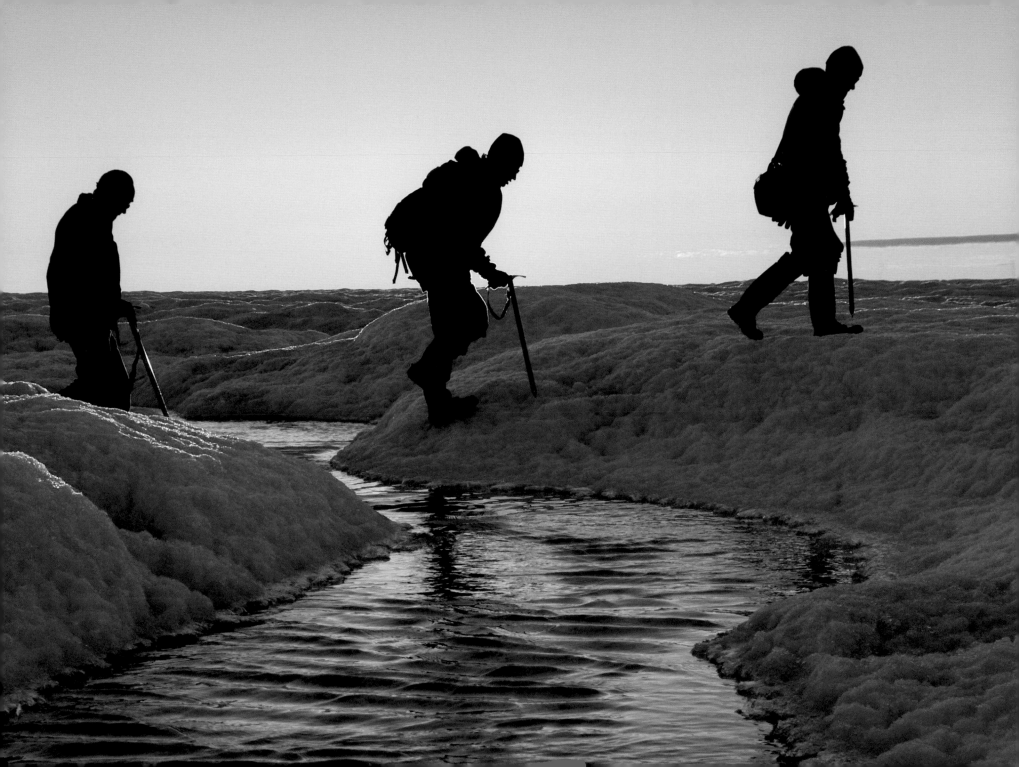

MILES OF HIKING IN hard plastic mountaineering boots took their toll on one researcher's feet.

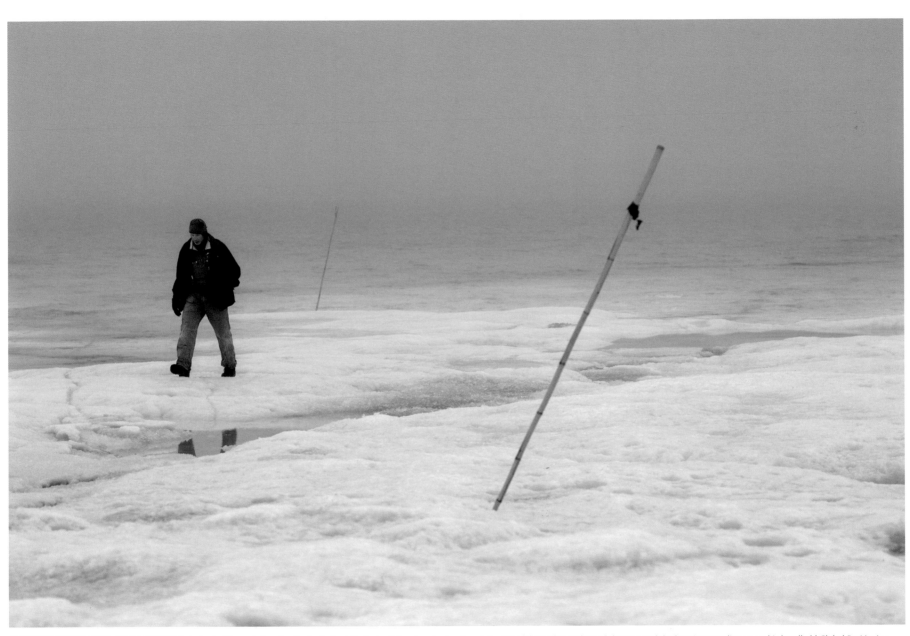

JOUGHIN SUSPECTED THAT SOUTH Lake looked lower before it actually drained. To find out, he placed a bamboo pole at the lake's edge and noted the time and the location coordinates on his handheld Global Positioning System. Indeed, water levels continued to lower around the pole.

IN FOG NEAR THE EDGE OF A LAKE, BEHN, JOUGHIN, AND DAS LISTENED TO thunderous booms and sharp cracks, like gunfire. Das speculated that the great volume of water that had been in the lake had finally made it all the way to the bottom of the ice and was shoving the ice upward. She surmised that the booms and gunshot sounds were caused by hundreds of tons of cracking and shifting ice.

225

with water and dumped in the powder, nine pounds in all, while Behn stirred the bright red sludgy mixture with his ice axe handle.

She tilted the bucket over the flowing water. The churning, blood-red water against the white snow and ice had a startling appearance. Behn said it looked like fifty pigs had been slaughtered. When the dye reached the hole downstream, about four minutes after it was dumped, it diluted into a bright pink shade.

After releasing the dye, we hiked back to camp for a late lunch of leftover tuna, cheese quesadillas, and couscous. There was nothing more to do for the experiment except to wait for any word from Bhatia of the dye's appearance in the fjord.

The next day we began packing for the journey home. Dismantling our tents, packing the scientific instruments and our camping gear, and carrying it all to our icy "helicopter pad" about two hundred feet from our camp took several hours. The following morning we stood ready for an 8:30 pickup.

But when Das called on the satellite phone to double check if it was coming, we learned that the helicopter had mechanical problems. We dug into the lingering supplies of dried apples and crackers and sat on top of a huge pile of luggage for half an hour.

The problem turned out to require just a quick engine fix, and at 9:32 we spotted the helicopter approaching from the north. Though we came in on separate runs on a small helicopter, we would leave as a group aboard a huge helicopter that can seat twenty-five people. Worried about finding a flat spot for landing, the pilot settled the helicopter on a large *H* that Das had drawn on

GREENLAND'S GLACIAL LAKES

THE EVENING SUN LIGHTS up a column of water spurting out of a crack in the center of a recently drained lake bed.

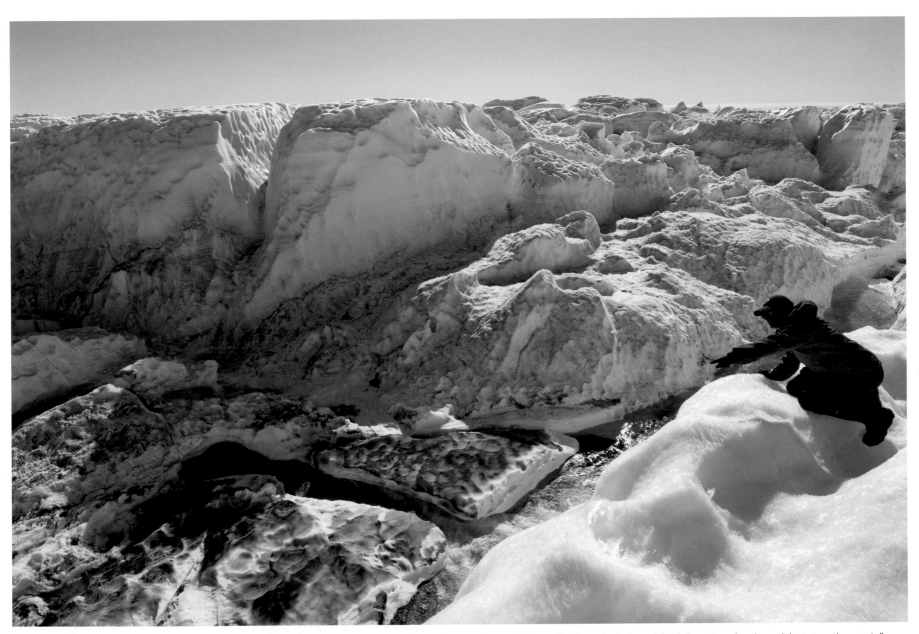

SCIENTISTS CAN'T PICK UP the ice sheet and look underneath it, so Das had to figure out another way to determine the speed of water flowing under the ice and decided on using a harmless red dye to trace the water's flow. This would help her learn what sort of water drainage system exists there. Was it a complicated series of interwoven capillaries, which might mean the drainage was slow? Or straight channels, like long drainpipes, that could mean the water may drain quickly from under the ice?

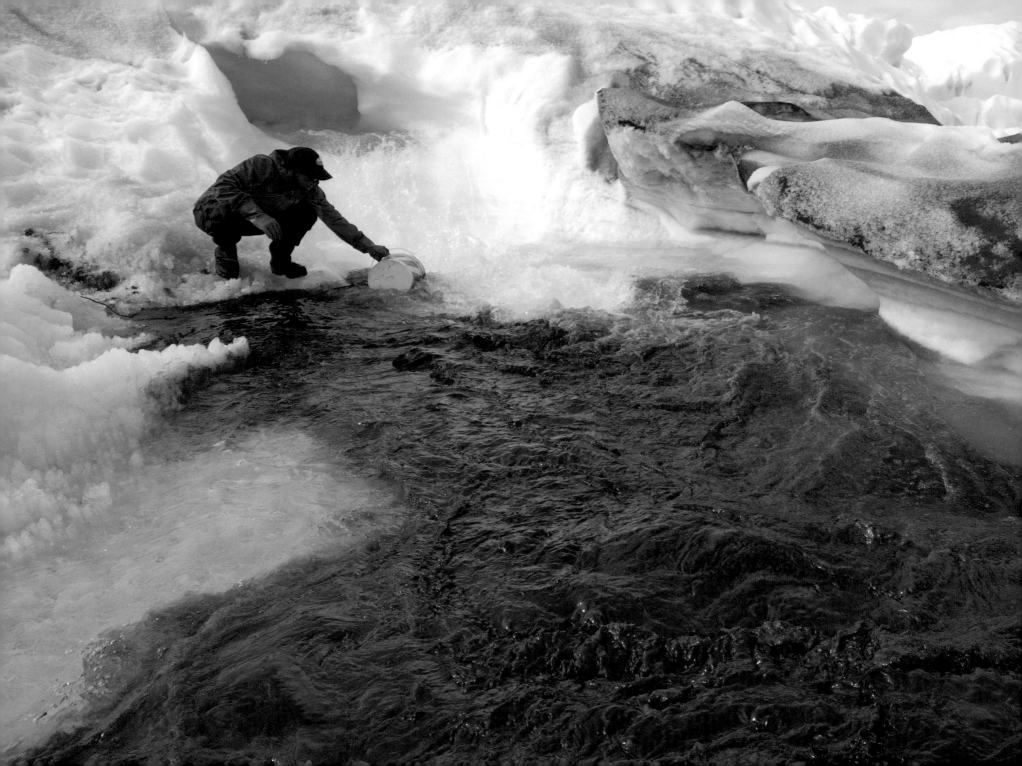

TO FIND OUT WHERE THE DRAINED WATER GOES, AND HOW FAST, DAS TRIED
an experiment. She dumped nine pounds of harmless red dye into a stream flowing toward
a hole in the ice sheet. The dye quickly dissolved and spread out, creating a pink river
that surged down a channel and disappeared into a hole that had drained the lake.

233

the ice using a spoonful of the dye powder scraped from its plastic container. As the helicopter landed, its rotors whipped up a dusting of fresh powder snow that blasted our faces. We loaded our gear with the help of the Danish copilot and several other crew members. Then off we flew toward Ilulissat.

We flew over the ice sheet, along roughly the same path that the draining lake water was supposed to follow under the ice sheet. Das watched out the window as we approached the boggy coastline and waved at Bhatia's camp next to the fjord. She knew that the dye had long since diluted and so it was unlikely that she would see the dye from the air; nevertheless, she squinted down as the plane banked and turned to Ilulissat. Nothing was visible.

After landing at Ilulissat's airport, we walked around on the pavement for a few minutes to readjust to the feel of walking on a hard, flat, and smooth surface. Then it was time to organize gear. We separated and packed science equipment for shipment to Das and Joughin's research labs, and camping gear that they needed to return to the logistics agent, located in Kangerlussuaq.

With their gear accounted for, Das and Joughin returned to the ice via helicopter to complete an aerial survey of lake basins directly east of North Lake. This gave them a chance to see if lakes were filling and draining on the higher, colder regions of the ice sheet.

While out on the ice, Das personally checked in with the team working at the fjord. Das had hoped that the dye would reach the coast by now, several days after pouring it into the drain hole on the ice sheet. Bhatia had not seen any signals that it had yet flowed into the fjord but assured Das that she planned to continue checking.

That evening we rested at the Hotel Hvide Falk (Greenlandic for "White Falcon"), located on Ilulissat's Disko Bay. For the first time in twelve days we showered, marveling at the feel of a completely fresh set of clothing. From our windows we watched local sled dogs chasing seagulls along the shore of the bay.

DAS'S GOAL WAS TO see if some of the dye would drain down through more than a half mile of ice, over bedrock, and out to the coast, about twenty-five miles away. She estimated that the dye would take somewhere between thirteen hours to five days to flow from the point of release, under the ice, and into a fjord, about twenty-five miles to the northwest, where another research team was poised to look for it.

In the bay, fishermen weaved their boats around car-sized icebergs. Tourists carrying picnics watched the boats then turned to hike along cliffs that afforded views of ice dropping into sea at the edge of the glacier.

I asked Das if she would be disappointed if the dye didn't turn up. She shook her head and said that not finding it could actually give them more to think about for the next attempt. Already she was considering aspects of the experiment that they could do differently. For example, instead of having someone crisscross the fjord in a boat, she would position moorings with attached instruments that could monitor the water at various depths, twenty-four hours a day.

She also noted how pleased she was with the knowledge that she and her colleagues have learned from three field seasons in Greenland by studying just two of thousands of lakes that form on the margins of the ice sheet. Through research they uncovered a very new understanding of how water flowed on the surface of the ice sheet, and eventually drained, quite dramatically, in just a few hours through cracks. They know that the fast drain has some effect on the local movement of the ice sheet. They were able to conclude that the speed up of the ice sheet during summer was widespread across Greenland, with the ice moving sometimes two or three times faster than it does in winter.

Das is motivated to continue her work, noting that every discovery has

lead to more questions. In years ahead, she hopes to probe the lake drainage processes more deeply and add to the data that then will be used to create ice sheet models. These computer versions of the ice sheet movement are what people can use to predict the future behavior of ice in ten years, a hundred years, or a thousand years.

As global temperatures continue to rise, research suggests that more lakes may form. More cracks may develop. And more draining may occur, leading to faster movement of the ice to the coast as the ice flows over this lubricating fluid layer. Often Das is asked for the bottom line: what does all this mean for people? She says it seems clear that global temperature changes are leading to amplified changes in Greenland's ice. In the sense that we as a society need to be concerned about increasing sea-level rise, she thinks we do need to worry.

After arriving back in Woods Hole, Das continued to check in with Bhatia. Exactly seven days after Das dumped in the dye, it was time for Bhatia and her colleagues to also return home. They never did find the dye. Das still wonders where it went.

THREE OF DAS'S COLLEAGUES, Alison Criscitiello, Maya Bhatia, and Matt Evans were working close to a fjord where Das suspected the dye might emerge. They looked for the dye using a fluorometer, a sensitive instrument that pumps in water and is able to detect even the tiniest traces of the dye, made up of a fluorescent chemical. After seven days of searching, slowly motoring back and forth across the fjord, they had to return home. They never saw a sign of the dye. Das said she plans to make modifications to the experiment and try again in the future.

AMY NEVALA

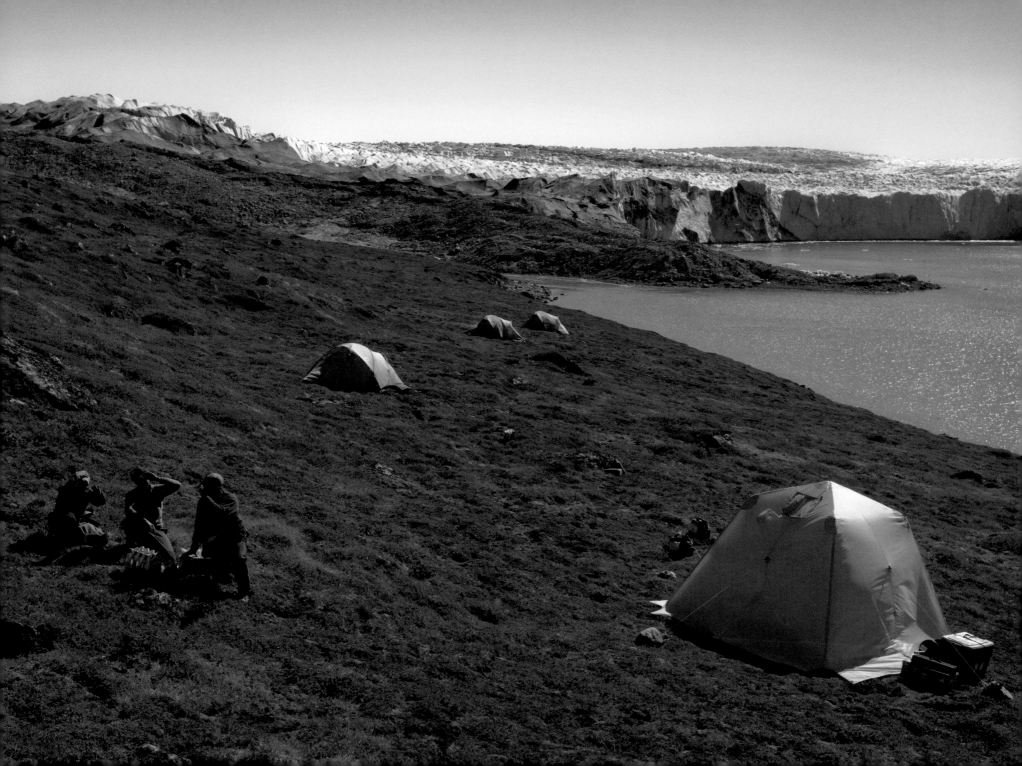

PHOTO NOTES

I'T'S ALMOST MIDNIGHT, AND THE SKY HAS JUST MELTED INTO THE ELECTRIC blue of twilight. I'm covered head to toe in fleece, but the wind still finds a way to sneak its chilly fingers down my back. Stretched out in front of me is 420 feet of U.S. Coast Guard icebreaker, and at my back is the ice-covered water of the Bering Sea. The crew has just turned on the icebreaking floodlights, their beams stabbing out into the night like dueling light sabers. All I need now is for the ice to cooperate. With too much sea ice, the vibration of the ship's hull crunching through the floes will destroy my six-second exposure. I wait, gloved finger on the cable release and my other hand on a tripod leg, until I feel the vibrations subside. As the ship turns, the full moon slips behind a cloud, and I trip the shutter release.

Of course, not every night was as perfect as that one in the Bering Sea. More often than not, the wind was blowing wet snow sideways, freezing it onto my cameras and exposed skin. Although photographing in the Arctic and Antarctic is incredibly rewarding, I endured some punishing weather conditions on the expeditions described in this book. At Cape Crozier, one of the windiest spots in Antarctica, we weathered storms that shredded the fabric on our tents and bent the poles that held them in place. Sleep was impossible with the whap-whapwhap sound of the flapping rain fly, and even walking was a struggle. I awoke on the Greenland Ice Sheet one morning to find that a few inches of snow had fallen, rendering the two- to four-foot-deep water-filled holes in the ice sheet (called cryoconites) nearly invisible. In my groggy, precaffeinated state, I stumbled out of my tent to use the latrine and took about seven steps before I was waist deep in icy water. Each skirmish with the environment made me appreciate even more the sacrifices scientists make to collect data in these climates.

Although I couldn't control the weather, being properly prepared helped me get the photographs I needed. Packing for each expedition started weeks beforehand. In a carryon-sized backpack, I loaded the essentials—two cameras, four lenses, a laptop, and hard drives—enough to get the job done if the airlines lost the rest of my luggage. I checked two rugged plastic cases: one loaded with cables, communications equipment, and more hard drives, and the other filled with tripods and more photography gear. Duffels were stuffed with clothing and survival equipment appropriate for the environment. On a typical expedition, I brought a laptop for photo editing, four external hard drives for photo storage, an assortment of cables and chargers, two to four digital camera bodies, an assortment of lenses (from fisheye to telephoto), accessories (teleconverter,

flashes, and gels), communications equipment (Iridium satellite phone or BGAN Inmarsat, data modem, and chargers), two carbon-fiber tripods with ballheads, and an assortment of other photographic tools. Once packed, I was ready to begin the tortuous journey to the field site, which usually required multiple flights and overnight layovers.

Photographing the expeditions was like working for a daily newspaper. In the field, I worked closely with a science writer. Together, we decided which story to cover each day and what photographs would be needed to illustrate it. Typically, the shot list consisted of scene-setting vistas, portraits of scientists in action, and close-up details. Throughout the day (or night, depending on the story), I photographed each concept from many different perspectives, often finding a unique angle to illustrate a mundane task. For example, on the ice-breaker *Healy*, I needed an image of the seabird observers at work on the ship's bridge. Rather than shooting from the confines of the bridge, I clambered up to the deck above, lowered my camera upside down on a monopod, and fired the shutter with a remote release. Once my subjects stopped laughing at the camera suspended in midair, I got exactly the shot I needed: an image of the observers at work from a bird's perspective. After dinner, the writer and I spent several hours pouring over the day's shoot of eight hundred to a thousand images, trying to narrow the unruly mass down to eight selects. Often, beautiful photos were cast aside if they didn't fit the story. Other times, the photos set the theme for the story. After we selected the day's photos, I sent them via satellite modem to our web designer at Woods Hole Oceanographic Institution while the writer drafted the story and captions. Although this editing process was time consuming, we were rewarded with photo essays that were not only visually appealing but also fun and educational to read.

Having a science background gave me a distinct advantage when photographing fieldwork. Time is a scientist's most precious resource in the field, so I never interrupted work in progress to stage a scene. I carefully researched each expedition's logistics and science goals so that I knew exactly what was going to happen, when, and why. Some events, like scientists harvesting copepods (tiny shrimp) for research in the Bering Sea, happened frequently, allowing me to wait for the optimum weather and lighting conditions to photograph the nets coming out of the water. Other events, like when glaciologists dumped nine pounds of Rhodamine dye into a glacial river, happened only once. To capture that photograph, I had only minutes to find the best position to capture the dye spreading through the water.

Photographing these expeditions, with all of the stress, sleepless nights, and cold fingers, has been the hardest but most exhilarating job of my life. But the polar bears and penguins don't make my job extraordinary; the people do. The scientists who kindly invited me to join their expeditions, the crews of the ships and field camps who kept me alive and happy, and the readers of the Polar Discovery website who sent in insightful questions and comments all reminded me why I was out there: to tell the stories of science on ice.

Chris Linder

PLUSH ACCOMMODATIONS on the Greenland Ice Sheet.

POWELL WRITES A DISPATCH from a snow cave in Antarctica.

CAPE CROZIER IS ONE of the windiest spots on earth. We had to tie our tents to lava rocks to keep them from blowing away.

ACKNOWLEDGMENTS

THIS BOOK IS A TRIBUTE TO SCIENTISTS EVERYWHERE. THEY SELFLESSLY spend their lives seeking answers to hard questions. They are my heroes. My supervisor at Woods Hole Oceanographic Institution (WHOI), Glen Gawarkiewicz, has always been a role model to me both as a scientist and as an educator. Thank you for being my mentor. Thanks to Bob Pickart, the chief scientist who offered a young photographer the opportunity of a lifetime on an expedition aboard the icebreaker *Polar Star*, and to the late Topsy Montgomery, without whose support that first education project would not have been possible.

The photographs in this book were created through the *Live from the Poles* project, funded by the National Science Foundation as part of its International Polar Year initiative (grant number NSF/DRL-0632219). The Richard King Mellon Foundation also generously contributed supplemental funding that enabled us to add the Bering Sea expedition. I would need a separate book to properly thank everyone who made the *Live from the Poles* project a success. Thanks to the countless scientists and technicians who patiently endured having a camera and notebook stuck in their faces. In particular, thank you to the scientists that allowed me to join their expeditions: Rob Sohn, Hanumant Singh, Mark Kurz, David Ainley, Grant Ballard, Sarah Das, Ian Joughin, Carin Ashjian, and Evelyn Lessard.

It would be impossible for me to calculate the debt I owe my partners in storytelling: the talented science writers who worked with me to create daily stories in the field. To Mike Carlowicz, Helen Fields, Lonny Lippsett, Amy Nevala, and Hugh Powell: it was a pleasure and an honor to haul bags, edit photos, shovel snow, laugh, shiver, eat pies, and tell stories with each of you. Thanks for everything you did to make *Live from the Poles*, and this book, a dream come true for me.

Thanks to everyone at WHOI who toiled behind the scenes on the *Live from the Poles* project: Matt Barton, Jim Canavan, Jack Cook, Jayne Doucette, Danielle Fino, Fritz Heide, Katherine Joyce, Jim Kent, Alison Kline, Kate Madin, Stephanie Murphy, Paul Oberlander, Dina Pandya, Kathy Patterson, Jeannine Pires, and Tim Silva.

Thanks to the museums and media partners that helped us reach a national audience: the Birch Aquarium at Scripps Institution of Oceanography, Carnegie Museum of Natural History, The Field Museum, Houston Museum of Natural Science, Liberty Science Center, Museum of Science, Boston, National Public

Radio *Science Friday*, Pacific Science Center, *Ranger Rick* magazine, *Scholastic* magazine, Smithsonian Environmental Research Center, Smithsonian National Museum of Natural History, and Teknikens Hus.

Thanks to the hardworking staff of McMurdo Station, Antarctica, and the crews of the icebreakers *Oden* and *Healy*, for getting us there and back and keeping our bellies full during those long weeks on the ice.

Thanks to the many people who followed the Polar Discovery website, came to the museum talks, and sent in such great questions. You are the real reason that I sacrificed sleep and personal hygiene to get the shot.

Thanks to Cristina Mittermeier and the International League of Conservation Photographers (iLCP) for their encouragement and support. You have welcomed me into a family of likeminded photographers and reminded me why these photographs are so critical to make.

Thanks to Christie Henry for believing in this book and to the wonderful team at the University of Chicago Press: Mike Brehm, Abby Collier, Kate Frentzel, Mark Heineke, Kristi McGuire, and Levi Stahl. Thanks to my talented sister Amy for editing my text and Jack Cook for the maps.

Most importantly, thanks to the person who suffered the most on these polar expeditions: my wife Meghan. You endured dropped satellite phone calls, lonely holidays, a rambunctious giant schnauzer, and a precocious toddler while I was off gallivanting around the poles. I couldn't have done it without your love, support, and those notes of encouragement you hide in my luggage on every trip.

A SNOW PETREL RIDES the wind at Cape Crozier, Antarctica.

ACKNOWLEDGMENTS

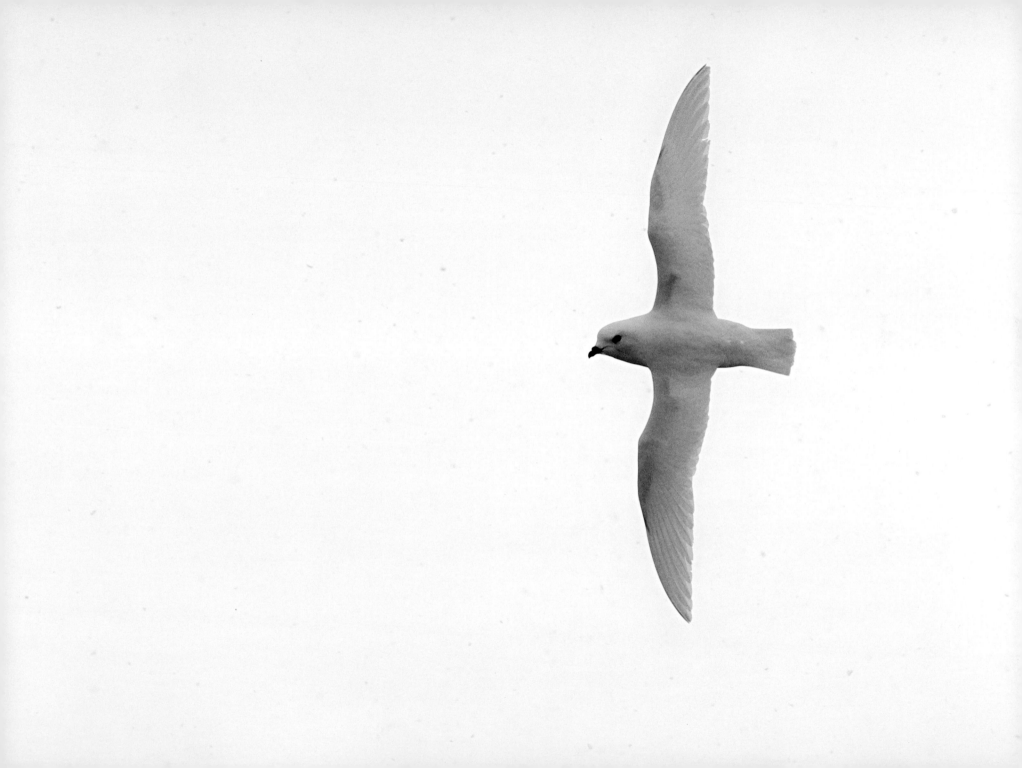

CONTRIBUTORS

CHRIS LINDER

Chris Linder communicates science in the field from the Congo to Siberia using photography and multimedia. After earning a master's degree from the Massachusetts Institute of Technology and the Woods Hole Oceanographic Institution Joint Program in oceanography, he spent three years in Spain working as a U.S. Navy meteorology officer and cultivating his photography skills. He then returned to Woods Hole, where his passions for science and photography came together. Since 2002, he has photographed two dozen science expeditions, including fourteen to the polar regions. His images have appeared in museums, books, and magazines, including *Geo*, *Nature's Best*, *Outdoor Photographer*, and *Wired*. His exhibit titled "Exploring the Arctic Seafloor" debuted at the Field Museum and traveled to the Carnegie Museum of Natural History and the MIT Museum. He is a member of the International League of Conservation Photographers. He lives in Seattle with his wife and two children.

HELEN FIELDS

On a Wednesday night in November 2008, Helen Fields got an e-mail about a photographer who was looking for a writer to poke around the Bering Sea on an icebreaker for six weeks. It sounded like the adventure of a lifetime, but she had a staff job at a magazine. Within twelve hours, a round of layoffs had freed her from the shackles of fulltime employment and put her on the road to the Bering Sea. As a freelance writer based in Washington, D.C., Helen writes about animals, psychology, space, oceans, molecular biology, and whatever else her editors can think of. She has written for *Smithsonian*, *Science*, and *National Geographic*. While on the *Healy*, she was known for her knitting and her naps, and she would like to reassure everyone that both these activities are as important to her life on land as they were at sea.

249

With both uncles, both parents, and both siblings all doctors, Lonny Lippsett's slot in medical school was bestowed at birth. But he was a changeling who delighted in words and stories. He took all the requisite undergraduate premedical science courses, but completed his degree in an even more arduous major: Not-Becoming-a-Doctor. After earning a master's degree in journalism at Columbia University, he worked as a reporter and editor at daily newspapers in Connecticut. Whenever stories with any science angle popped up, editors scanned the newsroom for a reporter who realized that some genes were stored in chromosomes, not closets, and they tapped Lippsett. He has been a fulltime science journalist at Columbia's Lamont-Doherty Earth Observatory and, since 1998, at Woods Hole Oceanographic Institution, where he is managing editor of *Oceanus* magazine and has tag-teamed with a scientist to teach a course for oceanographic graduate students called "How *Not* to Write for Peer-Reviewed Journals: Talking to Everybody Else."

Amy Nevala has written about science for newspapers and magazines in Seattle, Chicago, Washington, D.C., and most recently for the Woods Hole Oceanographic Institution on Cape Cod, where she lives. Her favorite stories have taken her into the field; she has accompanied scientists on research expeditions to the Pacific and Indian oceans, Nicaragua, and remote regions of Alaska. She once pedaled 3,254 miles across the United States as a bicycling storyteller for an American Lung Association fundraising project. Her four-year-old son often asks about her science reporting trip to Greenland and enjoys hearing about the helicopter rides and miles of hiking. But he deducted "cool mom" points after learning that she occasionally dropped her notebooks in the many slush-filled holes dotting the ice sheet.

Hugh Powell is science editor at the Cornell Lab of Ornithology. He writes about birds, ecology, evolution, and ocean science. After brief early careers as a tropical birder and a ski bum, he earned a master's degree studying woodpeckers, beetles, and fire ecology in the mountains of Idaho and Montana. He then studied science writing at the University of California, Santa Cruz. He has written for the Woods Hole Oceanographic Institution, the Monterey Bay Aquarium, *Smithsonian*, *New Scientist*, and the California Academy of Sciences. He recently returned from his second expedition to cover science in Antarctica with Chris Linder and is casting about for ways to go a third time. He lives in western Massachusetts.

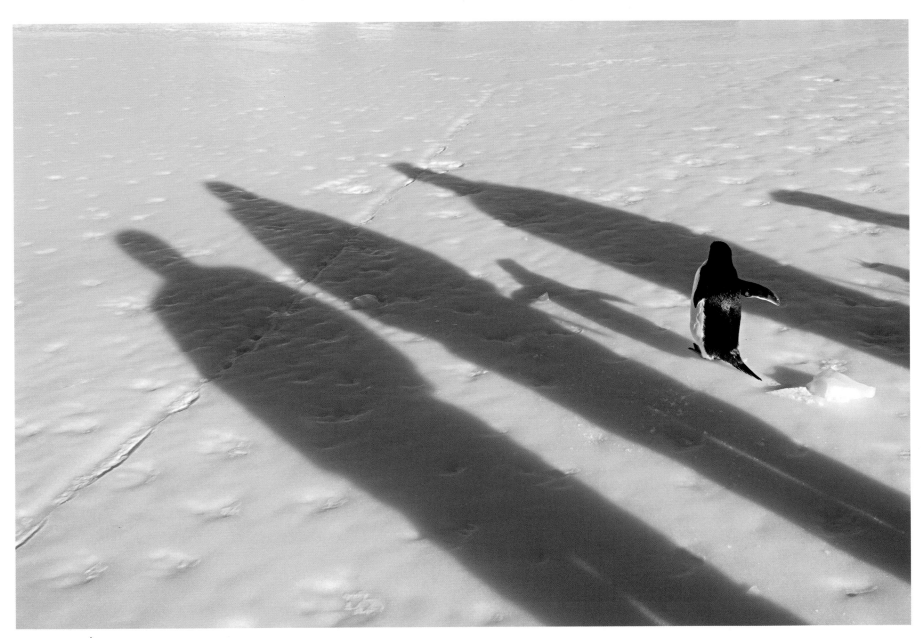

A CURIOUS ADÉLIE PENGUIN adds its shadow to ours.